Exposure

Digital Field Guide

Exposure

Digital Field Guide

Alan Hess

WILEY

Wiley Publishing, Inc.

Exposure Digital Field Guide

Published by
Wiley Publishing, Inc.
10475 Crosspoint Boulevard
Indianapolis, IN 46256
www.wiley.com

ISBN: 978-0-470-53490-8

Manufactured in the United States of America

10 9 8 7 6 5 4 3 2 1

For general information on our other products and services or to obtain technical support, please contact our Customer Care Department within the U.S. at (877) 762-2974, outside the U.S. at (317) 572-3993 or fax (317) 572-4002.

Wiley also publishes its books in a variety of electronic formats. Some content that appears in print may not be available in electronic books.

Library of Congress Control Number: 2009935828

WILEY

About the Author

Alan Hess is a San Diego based commercial photographer specializing in concert and event based photography, but has photographed everything from portraits to products. He is the author of two previous Digital Field Guides, the *Sony Alpha DSLR-A700 Digital Field Guide* and the *Sony Alpha DSLR-A200 Digital Field Guide.*

His concert and backstage images have appeared in numerous online and print publications and have been used for promotional purposes and music packaging.

He is a member of the National Press Photographers Association and the National Association of Photoshop Professionals and Nikon Professional Services.

Alan is a key contributor to the Lexar Pro Photographer Web site and has written articles on concert photography and technology. Alan has taught concert photography at Photoshop World and has taught photography, digital photography workflow using Adobe Bridge and Adobe Photoshop Lightroom at Essy's Studio in San Diego.

Alan can be contacted through his Web site www.alanhessphotography.com where he writes a regular blog.

Credits

Acquisitions Editor
Courtney Allen

Technical Editor
Haje Jan Kamps

Senior Copy Editor
Kim Heusel

Editorial Director
Robyn Siesky

Editorial Manager
Cricket Krengel

Business Manager
Amy Knies

Senior Marketing Manager
Sandy Smith

Vice President and Executive Group Publisher
Richard Swadley

Vice President and Executive Publisher
Barry Pruett

Project Coordinator
Kristie Rees

Graphics and Production Specialists
Carrie A. Cesavice
Jennifer Henry
Andrea Hornberger
Jennifer Mayberry

Quality Control Technician
Laura Albert

Proofreading and Indexing
Cindy Ballew
Ty Koontz

For Nadra

Acknowledgments

Special thanks to my wife for her amazing patience as I wrote this book. I know that I am not the easiest person to get along with when facing deadlines.

I would like to thank my parents, brothers, sisters-in-law, and all the nephews and nieces for being the supporting family that everyone should be lucky enough to have.

Thanks to all my family and friends for allowing me to always be pointing a camera at you and letting me use the photos in this book.

Special thanks to Brian Ross, David Baron, and Maya at PR Photo — you all opened new doors and shooting opportunities for me, and I thank you.

My deepest gratitude to Courtney and Cricket for all their guidance; this is our third book together and I am glad for all your help. Thanks to Haje Jan Kamps and Kim Heusel for all their hard work as well.

Contents

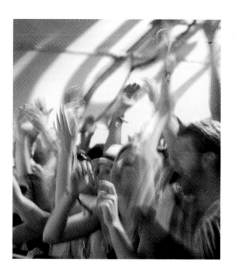

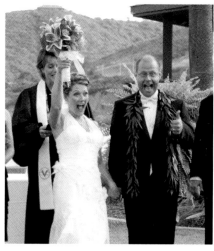

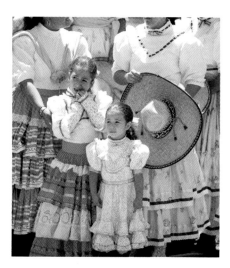

CHAPTER 5
ISO 77

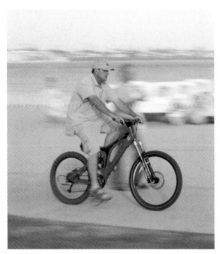

CHAPTER 6
Event Photography 87

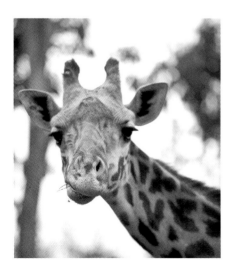

CHAPTER 7
Portrait Photography 107

CHAPTER 8
Landscape and Nature Photography 137

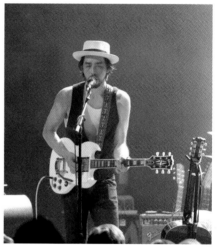

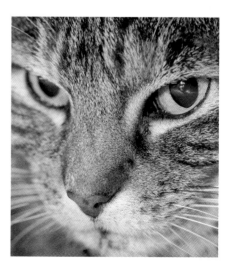

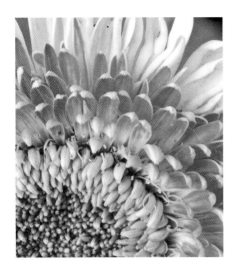

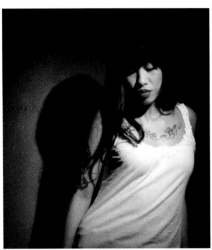

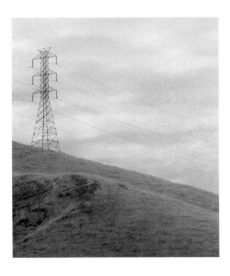

CHAPTER 12
Wildlife and Animal Photography 205

CHAPTER 13
Creative Exposure 223

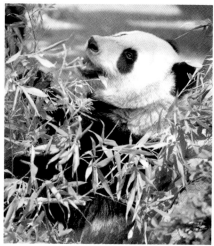

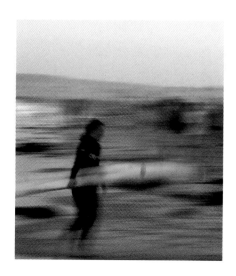

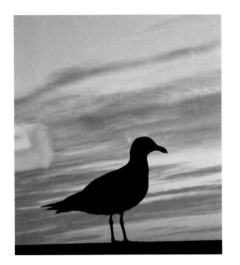

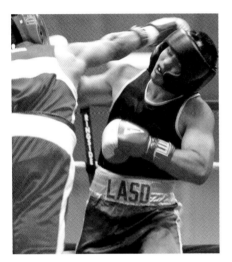

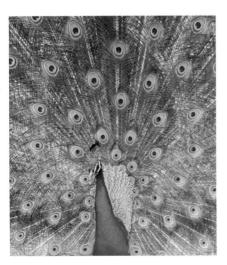

Introduction

This Digital Field Guide is not camera specific or even brand specific, it is all about exposure, but what does that actually mean? Exposure is a very simple concept — allow the light sensitive sensor (film) to be exposed to the light that is reflected from the scene you want to capture. That's the basics of taking a photograph. When you press the shutter release the camera opens the shutter and the light travels through the lens and is allowed to reach that sensor and you have a photograph.

As photographers you get to control the amount of light that reaches the sensor by controlling how long the shutter is open and how big a hole the light enters through. You also get to decide how much the signal from the sensor is amplified and it is those decisions that are the essence to taking photographs and getting a proper exposure.

I get a lot of questions about photography both through my blog at www.alanhess photography.com and in person when out photographing. Most of the time the questions are about how I managed to capture a certain image or what settings I use for my photos. The answer is pretty simple: I use the best exposure settings for the situation.

In this book, I start by covering exactly what an exposure is and what controls you have to adjust it. It explains how your camera measures light and what each of the settings mean, as well as which of the metering modes works best for different situations. It also covers the exposure modes found on most cameras and when the best time to use them is.

Next up is all about light. Because photography is capturing light, it is important to understand the direction, color, and intensity of light in any scene. It is only after you can see and understand the light, that you can really go about capturing it. Shutter speed, aperture, and ISO are also covered in detail. Each of these sections not only cover the controls you have at your disposal, but the pros and cons of each one.

After the generalities of shutter speed, aperture and light are covered, it is time to get a little more specific starting with event photography, which includes one of my favorite photographic subjects — concert photography. I also cover outdoor events, indoor events, and those that take place all day long. You will learn about the exposure considerations and what can be done to get the best images possible.

Next is all about shooting people, from individual to group portraits, from shooting outside to dealing with studio lights. How to deal with the exposure problems that arise when shooting portraits is covered along with the best ways to check your exposures are all covered here.

Shooting landscapes and nature is also covered — from the exposure considerations when shooting landscapes and nature photography to controlling the depth of field to make sure that the whole landscape is in focus and even what the best times to shoot landscapes are.

Low light and night photography is up next. By definition, low light and night photography deals with photography when there is minimal light. Photographing light trails and fire works as well as how to shoot those beautiful sunrises and sunsets are all covered, as well as a look at the best way to shoot a silhouette, a technique that will let you use silhouettes creatively from now on.

While you normally use long shutter speeds when photographing in lower light, when it comes to sports and action photography, the opposite is often true. You use very short shutter speeds to freeze the action. How fast of a shutter speed is needed and what are the consequences are covered in this chapter. It doesn't matter if you are shooting your kids playing a soccer game or if you are on the sidelines of a high school, college, or professional football game, the basics are the same.

Everybody loves a wedding; it is a time of joy and happiness…unless you are photographing the event. Wedding photography can be a very stressful experience for a photographer, with only one chance to get it right. Weddings can also be a real challenge when it comes to getting proper exposures due to the traditional bright white dress and dark tuxedos. In this chapter I cover the problems and the solutions with shooting weddings that will hopefully help if you ever find yourself as the wedding photographer.

Wildlife and animal photography is another favorite to photograph. It can range from photographing pets to taking a trip to the local zoo or an animal park, but the skills you need to get great shots are the same.

Finally, you get a look at some creative exposure options — the different ways to achieve your artistic vision and some fun ways to experiment during the image creation.

Because this book is all about digital photography I also spend some time at the end covering some of the software options and a bit about what can be done in post processing to adjust your exposure. However, even with the advances in software and the amazing things that can be done on a computer these days, remember it is still best to get the exposure right in the camera first.

This Digital Field Guide includes a new feature; a gray card/color checker that can be removed and used to help you get true and accurate colors in your images.

One quick note: this book is made specifically to go with you. It isn't some tabletop tome that can't leave the house, its made to go in your camera bag, so dog ear the pages, use a highlighter to underline the parts that are important to you, but the main thing is for you to take the book with you, use it as a guide when out shooting. And, if you really love the book and don't want to get it worn and torn, I have no problem with you buying two.

Understanding Exposure

Photography is the art of capturing light. You use your camera's lens to focus the light and the sensor to record the light, creating an exposure. As a photographer, your job is to decide how much light the sensor is allowed to record, how long the shutter is opened, and how big the opening is in the lens to let in light. You also get to decide how sensitive the sensor is to light. All these factors let you control the exposure. You need to understand the exposure modes and light metering to help get the proper exposures and how to use the histogram to check your exposures. Picking the right file type to store your image is also important because it can make a big difference if you need to adjust the exposure in post processing.

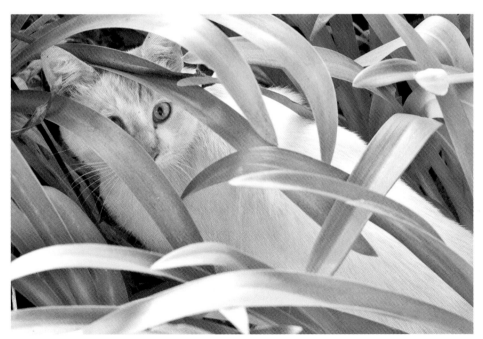

Using the proper settings enabled me to capture the light cat in the darker shadows without losing detail in either. 1/320 second, f/4.5, ISO 800.

Defining Exposure

The basic definition of exposure is very simple: The exposure is the amount of light that is allowed to reach the sensor in your camera to create a photograph. The amount of light that reaches the sensor is controlled by two main factors: the length of time the shutter is open (shutter speed) and the size of the opening through which it flows (aperture). A third factor — ISO — changes the sensitivity of the camera's sensor to light, which can be used to modify the exposure. The question becomes how much light is needed to create the look you want. No matter what settings you use, the sensor in your camera records the light being reflected at the camera. If too much light reaches the sensor, the image is overexposed or too bright; if too little light reaches the sensor, the image is underexposed or too dark. The goal is to let through enough light so the bright areas in your image are not too bright and the dark areas in your image are not too dark.

1.1 These three images were taken around the same time. The left image shows the calla lily in good exposure (1/160 second, f/6.3, ISO 200), while the middle and right images show the same flower when overexposed and underexposed. Notice the lack of detail in the light areas when overexposed and the lack of detail in the dark areas when underexposed.

When discussing exposure, a set of standard terms are used that help you to define the exposure. Shutter speed is described using time, aperture is described using size, and ISO has a standard numerical value. You also need to understand what happens when you change the shutter speed, aperture, or ISO and the relationship among these different exposure factors. The basic unit used when describing this relationship is called a *stop*.

 You can also use the Exposure Value to describe the settings used to achieve a proper exposure.

Stop

A *stop* is the change between one shutter speed and the next, where the change is exactly double or half the original shutter speed. The difference between a 1-second and 2-second shutter speed is one stop because the amount of light that is let in during the 2-second shutter speed is twice as much as the light let in by the 1-second shutter speed. There is a stop difference between 1/60 second and 1/30 second as well since 1/60 second is half as much as 1/30 and lets in half as much light. A stop also describes the change in aperture where the new aperture is double or half the current aperture and it is the change in ISO between one value and a value that is either double or half the current ISO.

Each time you double or halve the ISO, it changes the sensitivity by one stop. For example, the difference between ISO 200 and ISO 400 is one stop, with the image taken at ISO 400 needing half as much light as an image taken at ISO 200 because the sensor is twice as sensitive to light.

A one-stop difference in the shutter speed, aperture, or ISO will either double or halve the exposure, but most modern cameras allow you to set the shutter speed, aperture, and ISO in 1/2 or 1/3 stop increments allowing for more choices.

You may hear a photographer say things like opening up a stop or stopping down. Opening up a stop means increasing the light entering the camera by a stop by increasing the size of the aperture, While stopping down is just the opposite: it is used to describe decreasing the amount of light reaching the sensor by decreasing the size of the aperture,. So, don't let the fancy talk confuse you; using the word stop when talking about photography is just a way to describe adjusting the exposure.

Exposure value

Your camera indicates what the built-in light meter has determined to be the correct exposure. Cameras use a numerical value called the exposure value or EV to describe the exposure. The EV for a correctly exposed image has the value of 0. Negative values are scenes that the built-in light meter has determined are underexposed and need more light, while positive values are scenes that the built-in light meter has determined are overexposed and need less light. The values are measured in stops. When you look through your camera's viewfinder, you see a readout showing the exposure value.

When you use the Program auto exposure mode, Shutter speed priority mode and Aperture priority mode have an EV of 0. When the camera is set to Manual mode, you can use EV to determine if the settings you have entered are close to what the camera considers the correct exposure. You can adjust your settings according to what the EV shows.

For example, if the EV value shows a –1, then according to the camera you are letting in too much light and overexposing the image by one stop. You can correct this by increasing the shutter speed by one stop, stopping down the aperture by one stop, or reducing the ISO by one stop.

Equivalent Exposures

Equivalent exposures are an important part of getting the best exposure for each situation. The idea behind equivalent exposures is that different combinations of shutter speed, aperture settings, and ISOs can create the same exposure. This is because the three work together to create an exposure. For example, if you use a fast shutter speed and a wide aperture, you can get the same exposure with a slower shutter speed and narrower aperture.

1.2 This flower was shot at 1/400 second, f/1.8, ISO 200.

1.3 This flower was shot at 1/50 second, f/5.6, ISO 200.

Think of the sensor in your camera as a glass and the light coming in as water. You want to get the perfect amount of water in the glass, so you turn on the faucet and the water flows into it. If the faucet is opened all the way, it can stay open for a short period of time to get the desired amount of water. If the faucet is opened only partway, it must be open for a much longer period of time for the same amount of water to fill the glass.

The easiest way to explain equivalent exposures is to show how it works. Say that you have an exposure setting of ISO 100 with a shutter speed of 1/125 second and an f-stop of f/16. If you increase the shutter speed by one stop, which halves the time the shutter is open, you must double the size of the aperture. So, for an ISO of 100 and a shutter speed of 1/250 second, the f-stop must be f/8. This works in reverse as well; if you leave the shutter open for twice as long, 1/60 second, you need to make the aperture smaller, letting in half as much light, which is f/32.

As you can see, the flower in figures 1.2, 1.3, 1.4 and 1.5 looks the same in all four images because the exposure is the same for all four images, yet the images are not identical. If you look at the background, it changes drastically from being completely out of focus to being easily identifiable depending on the combination of shutter speed, aperture and ISO used.

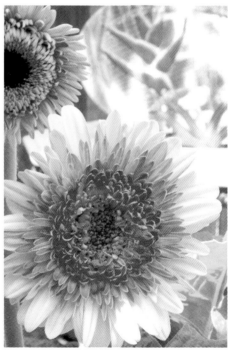

1.4 This flower was shot at 1/500 second, f/3.5, ISO 800.

1.5 This flower was shot at 1/3 second, f/22, ISO 200.

Exposure Modes

Today's digital cameras come with a fully automatic mode, and most consumer cameras have scene modes to help you get the right exposure under specific circumstances. For example, both the Nikon D90 and the Canon EOS Rebel T1i have five scene modes: portrait, landscape, close-up, sports, and night portrait. These scene modes help photographers get the best results in specific situations, but the other exposure modes give you the maximum control over your images, and control is what it is all about. The modes I focus on in this book are Program auto mode, Shutter speed priority mode, Aperture priority mode, and Manual mode.

Program auto mode

When your camera is set to Program auto mode, the camera decides the shutter speed and aperture, and in some cases the ISO. But what separates this from a full auto mode is your ability as the photographer to adjust the shutter speed or the aperture and let the camera adjust accordingly to make a proper exposure. This is a great mode to learn with because the camera is basically picking the starting point for both the shutter speed and aperture.

Shutter speed priority mode

This mode lets you pick the shutter speed and lets the camera pick the aperture to create a proper exposure. You use this mode when you want to control how long the shutter is open or when you want to control the motion in your images. Fast shutter speeds let in less light but will freeze motion while slow shutter speeds allow in more light but can cause blurring of moving objects in your image.

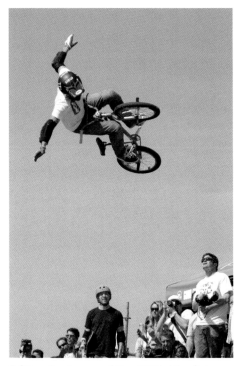

1.6 For the image of the BMX rider flying through the air, I used a fast shutter speed of 1/2000 second to freeze the moment. Taken at 1/2000 second, f/2.8, ISO 100.

 I cover using shutter speed to control the exposure and what effect that can have on your images in Chapter 3.

Aperture priority mode

Aperture priority mode lets you select the aperture, and then the camera picks the shutter speed to achieve proper exposure. Controlling the opening or aperture in the lens that allows light to reach the sensor also controls the *depth of field* (which is the area that is in front of and behind what you are focusing on that is in acceptable focus). Because this mode involves setting the size of the opening in the lens, and by doing so lets the camera decide on the best shutter speed, it is a great way to get blurry images. When used at the right time it offers a great deal of creative control over your images.

 Depth of field is covered in much greater detail in Chapter 4.

1.7 I used a shallow depth of field in this image to blur the background so the flowers stayed the center of attention. Taken at 1/320 second, f/4.0, ISO 200.

Manual mode

In Manual mode, you get to set the shutter speed and aperture. This mode gives you the most control over your exposures. Being able to set both the shutter speed and aperture allows you to determine what the sensor captures, but it also is the easiest way to underexpose or overexpose your image because the camera won't do anything to help you. The camera shows you what the built-in light meter believes is the correct exposure and whether your settings will produce an image that is lighter or darker than the camera's choice.

Metering Light

Metering light is simply measuring the brightness of the scene you want to capture. The best way to determine the amount of light needed to create a proper exposure is to use a light meter. All light meters work on the same basic principle: They convert the amount of light in a scene into a measurable form and then translate that information into a form useful to a photographer. The light meter uses that value to determine the shutter speed and aperture settings, given the ISO.

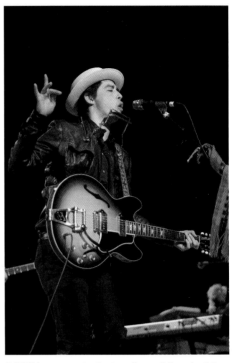

1.8 This concert photo of musician Jackie Greene was taken in Manual mode to counteract the rapidly changing lights. Taken at 1/200 second, f/2.8, ISO 1600.

In the past, light meters were an extra piece of equipment that photographers used to get the correct exposure settings to set the camera manually, but all the DSLR and point-and-shoot cameras today have built-in light meters. The built-in light meter measures the light coming through the lens, the same light that reaches the sensor when the shutter is moved out of the way. This type of metering is called TTL or Through the Lens metering and can constantly adjust to the changes in the exposure. The entire process now happens in the camera.

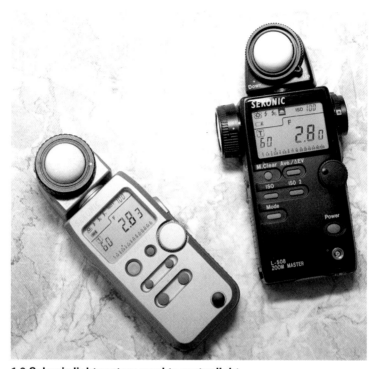

1.9 Sekonic light meters used to meter light

Sometimes it pays to have a separate light meter, and shooting in the studio is one of those times. Using strobe lights that fire only when triggered by the camera doesn't allow the built-in light meter to get an accurate measurement of the light. If you use a light meter that can trigger your studio strobes, you can get an accurate reading and input those settings into your camera using Manual mode. I use an older Sekonic L-358 along with a Pocket Wizard transmitter to trigger my studio strobes.

The light meter that is built into your camera is a reflected light meter; that is, it reads the light that is reflected from the subject back at the camera. The light meter then tries to determine the overall brightness of the scene, using the assumption that the typical subject reflects a middle or 18 percent gray. This averaging works for lots of situations but not all. When you take the darks, lights, and middle tones of an average scene, the 18 percent gray works well. Scenes that have lots of very light colors can cause the camera's light meter to underexpose, causing everything to look too dark, while very dark scenes can cause the light meter to overexpose, making the image too light.

Each camera manufacturer has a slightly different method of metering light, and I believe that each camera model has a slightly different way of metering light. But that doesn't really make any difference as long as you know what the camera is doing, which lets you adjust the settings to get the exposure you want for your photograph.

Camera Metering Modes

Camera manufacturers spend lots of time and money developing new and improved light meters for their cameras because an accurate light meter creates properly exposed images. Your camera has a very sophisticated light meter built right in, letting you set the camera on the fully automatic mode, so you can expect to get pretty good photos most of the time. The problem is that you won't get great photos, and in some situations you won't get anything like the image you wanted.

One of the first steps in taking control of your photos is to understand how the different metering modes in your camera work. You usually can choose from three methods of metering light: spot, center-weighted, and scene. It's like having three separate light meters built into your camera, and knowing how each one works will enable you to get the best results.

Spot metering

Spot metering is when the built-in light meter uses only a small spot in the center of the scene to calculate exposure. Spot metering uses the smallest amount of light to determine the exposure. Because the spot meter measures light only in a very small part of the overall scene, it is less affected by the surrounding brightness when the scene has lots of very dark or very light colors. Some cameras use the area around the selected focus point as the area to take the light reading from. This lets you move the spot metering circle to whatever focus point is being used, ensuring that you are measuring the light of the most crucial element in your image. This is very useful when shooting a subject against a very bright or very dark background because those areas are not used in calculating the exposure.

1.10 I used spot metering when taking this photo of Nicole. I didn't want the large expanse of bright sky to play any part in the metering. I photographed this at 1/125 second, f/5.6, ISO 200.

Center-weighted metering

Center-weighted metering uses light readings from the center spot-metering area and from the surrounding area, but it gives more importance to the center spot area. Some camera manufacturers allow the size of the center area to be changed to suit your needs. Center-weighted metering usually does not meter the top and bottom of the frame so that things like a bright ribbon of sky at the top or a very dark foreground are not taken into account when determining the exposure.

Center-weighted metering is useful when your subject is in the center of your frame and you are not very concerned with the outer edges.

Scene metering

Scene metering has different names depending on the camera manufacturer and camera model. For example, Nikon calls this Matrix metering, Sony calls it Multi-segment metering, and Canon calls it Evaluative metering, but these metering modes all do the same thing — try to be smarter light meters to get more accurate reading of

the brightness in a scene. This type of metering has come a very long way in a relatively short period of time. The idea itself is quite simple, let the built-in light meter look at the scene and work out the best exposure by determining what you are photographing. This has become easier to do as computer processing and memory have become faster, smaller, and cheaper.

For example, the newest Nikon metering system uses a 1,005-segment metering sensor to read the light in the scene; it compares the data to a built-in database of images and tries to predict what you are photographing. This happens so fast that you never even know it's going on. New technology starting to appear in cameras recognizes the subjects in your scene and adjusts the exposure accordingly. This is most noticeable in the new face recognition built into newer cameras. These smart scene-metering modes are getting better and better, causing fewer badly exposed images than ever before.

This mode generally does a fantastic job in just about all situations and is the mode I set all my cameras to by default. As new cameras are introduced, the camera manufacturers keep improving the metering capabilities of their cameras. But even with the best computers and biggest databases of images, yours is the only brain that really knows what is in your scene and what the subject really is.

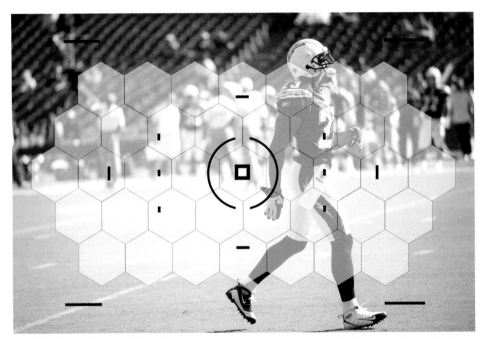

1.11 The Sony A700 multi-metering zones is shown as an overlay. Sony multi-metering divides the scene into 40 different areas, 39 grouped in the center with the last one taking up the border of the image.

Exposure Compensation

Sometimes you want to purposely underexposure or overexpose your images from what the camera believes to be the proper exposure by a set amount; this is when exposure compensation comes into play.

Exposure compensation adjusts the current exposure suggested by your camera, making your images either brighter or darker by a set amount. Exposure compensation can usually be set from between –3 to +3 stops in 1/3-stop increments, with some cameras even allowing the exposure to be changed by up to five stops in either direction. Check your camera manual for the exposure compensation range for your camera. Exposure compensation allows you to globally adjust your exposure when using Program Auto, Shutter Speed Priority, and Aperture Priority modes. Take a closer look at what exposure compensation actually does in each mode:

▶ **Program Auto mode.** In this mode, the camera sets both the shutter speed and aperture as determined by the built-in light meter. When you apply an exposure compensation of +2 stops, for example, the camera slows down the shutter speed and/or opens the aperture wider if possible. If the settings determined by the camera were a shutter speed of 1/800 second with an aperture of f/5.6 with +2 exposure compensation added, the settings become 1/400 second with an aperture of f/4.

▶ **Shutter Speed Priority mode.** When you use this mode, you set the shutter speed and the camera sets the aperture. So, when you apply any exposure compensation, the camera adjusts the aperture, not the shutter speed. This means that when you apply exposure compensation, the aperture is adjusted until it reaches the aperture limitations of the lens and you are changing the depth of field.

▶ **Aperture Priority mode.** When you use this mode, you pick the aperture and the camera selects the shutter speed based on the built-in light meter readings. Applying exposure compensation lets the camera adjust the shutter speed to match the new exposure settings. This means that when you apply a positive adjustment, the shutter stays open longer, and when you apply a negative number, the shutter stays open for less time.

Exposure compensation does not work when in Manual mode because in this mode the camera does not have any control over the shutter speed nor the aperture. If you want to make the image lighter or darker, you have to change either the shutter speed or aperture. In most cases, exposure compensation does not have any effect over ISO. For directions on how to set the exposure compensation, check your camera manual.

Exposure Compensation versus Flash Compensation

Flash compensation can be used to change the power of a built-in or dedicated external flash without adjusting the shutter speed, aperture, or ISO. This is very useful for adding just a little bit of light or when the flash seems to be overpowering the scene. It is important not to get the two confused, because they do very different things. Not all cameras have flash compensation, so check your camera manual to find out if yours does.

Flash compensation is adjusted in the same way as exposure compensation, by using stops. If you set your flash compensation to +1, it produces twice as much light, whereas setting it to −1 produces half as much light. When you increase the flash by using the flash compensation, you are increasing the amount of flash power which causes the recycle time for the flash to be increased, making you wait longer for the flash to be ready for the next shot. When you use negative flash compensation, the flash is putting out less light meaning that the recycle time will be increased. This is great if you don't want to overpower the main subject with the flash and just want a little fill light.

 For more on fill flash see Chapter 2

Bracketing Your Exposures

Bracketing is a way of dealing with a difficult exposure situation by taking a series of at least three images but could be as many as seven photographs, some below and some above the recommended exposure. Many of today's cameras have this function built right in and let you bracket by changing either the shutter speed or the aperture.

While bracketing seems to be a great way to deal with all exposure problems, it does have its problems. The biggest problem is that when photographing a moving subject, you could capture the best composition with the worst exposure or the best exposure with the worst composition because the composition changes with each shot. I would recommend not bracketing your shots in these situations but, if you do, take the bracketed images as close together as possible so that there is as little compositional change from one image to the next.

1.12 In this series of images, the left shows what the camera believes is the proper exposure; the middle and right are underexposed and overexposed by a full stop. The left photo was taken at 1/320 second, f/10, ISO 200, the middle at 1/640 second, f/10, ISO 200, right 1/160 second, f/10, ISO 200.

So when is the best time to bracket your exposures? Bracketing is best used for static subjects where the subject is stationary and each image composition is the same; all that is different is the exposure.

A good time to use bracketing is when the images are going to be combined using software to create a *High Dynamic Range* or HDR image. HDR photography combines multiple exposures of the exact same scene to create an image with a much wider exposure range than can be created with a single image. HDR imaging uses specialized software such as Photomatix or Photoshop to combine the bracketed images into a single image.

 For more on HDR images see the sidebar in Chapter 13.

Another good time to use image bracketing is when the scene you are photographing has very bright and very dark areas. You can then plan to use the correctly exposed parts of each image to create a whole image with good exposure in both light and dark areas. Again, this process uses software to combine parts of the different images to create a single image with more information than was available in a single exposure.

Using the Histogram

Histograms are useful in determining the exposure of the captured image. A histogram is simply a graphical representation that shows how many pixels in your image fall between absolute black and pure white.

Being able to read a histogram correctly is important when shooting because it gives you a true representation of what the camera's sensor recorded. Each camera displays the histogram a little differently, but the basic information is the same. Some

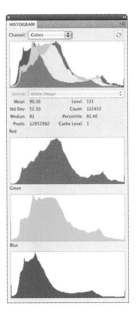

1.13 This young cowgirl photograph has lots of color in the middle tones with very little white or black, as shown in the histogram. Taken at 1/1600 second, f/2.8, ISO 200.

cameras also show separate histograms for each color channel of red, green, and blue as well as a overall representation of the image. The histogram lets you know immediately if the image data falls into the range that your camera's sensor can capture.

These three images have proper exposures, but the histograms are all different. Looking at the histogram can help you evaluate an image. If the image has large areas of lighter tones, then histogram has more info on the right; if the image has large areas of darker tones, the histogram has more info on the left. When you look at the histogram it should match up with what you see in the scene.

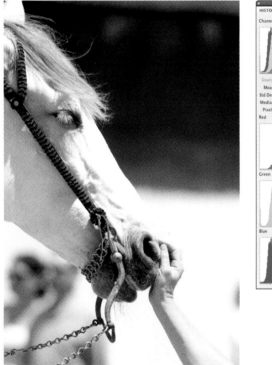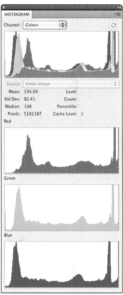

1.14 This photograph has very little in the mid and darker tones, as the histogram shows. The horse is white and the background is quite light as well. The histogram shows a big spike on the right side where the light tones are represented. You also can see a spike on the right representing the darker tones in the top part of the background. Taken at 1/1600 second, f/4.5, ISO 200.

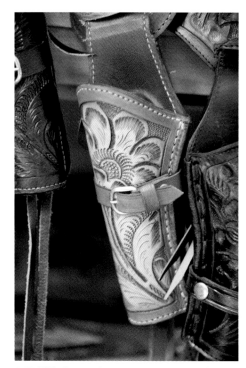
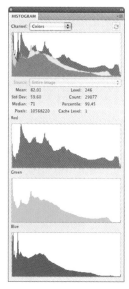

1.15 This image is made up mostly of dark tones that can be seen in the histogram by the amount of data on the left. These darker tones make up more of the image, so they make up more of the histogram. Taken at 1/50 second, f/3.5, ISO 200.

Using the Clipping Information

Most digital cameras have a preview mode on the LCD screens that show any areas in your images that are pure black or pure white. When an area has become pure white or pure black, no detail information is present. The preview modes on most cameras show this as shadow or highlight clipping by causing the clipped areas to blink between pure white and pure black. If you see blinking in any area on the back of your LCD screen, that area has no detail information and is either pure black or pure white.

When you have lots of shadow clipping, chances are good that the image is underexposed or at least has areas that are seriously underexposed. The same is true when you have large areas showing highlight clipping. When this happens, your whole image is overexposed.

Remember that these are just tools, and if your image happens to have a large area of black in it, you can expect a big shadow clipping area. However, when you have large areas of blinking white areas, the image is overexposed and you will want to adjust the exposure so that you are underexposing the image. This can be done by increasing the shutter speed, using a smaller aperture, decreasing the ISO.

File Formats

Your camera saves the image data from the sensor as a digital file. These files can be adjusted after they are saved by your camera and the exposure can be corrected using software. Numerous digital file types are used by computers today, but in digital photography the three main types are RAW, TIFF, and JPEG. Each of these file types offer different plusses and minuses including the ability to adjust the exposure at a later date.

RAW

RAW files differ from manufacturer to manufacturer and from camera to camera. These file types include NEF from Nikon, CRW and CR2 from Canon, just to mention a few. Check the manual for the file extension your camera uses when it shoots RAW. Some camera manufacturers also have created a compressed RAW format that takes up less space but keeps all the information from the RAW file.

RAW files are the closest that digital photography has to a negative — an unprocessed negative, that is. The RAW file stores all the information directly from the sensor with minimal processing, which gives you the most information. The biggest plus when saving your files in the RAW format is that RAW can store more information than the JPEG format and saves a wider tonal range and exposure latitude.

 You can fix a RAW file in post-production much more easily, although I want to emphasize that getting it right in the camera is always preferable.

If the RAW file format is so good, then why not use it all the time? Because RAW files cannot be used without first opening them using computer software. Also, because they are much bigger than their JPEG counterparts, they take longer to be written to a memory card, and the memory card can't hold many images. Some cameras allow you to save your images as RAW files and as JPEG files at the same time. This gives you two images each time you press the shutter release and lets you see the difference between the two. The downside is that it takes longer than shooting just RAW and takes up more space. I shoot RAW for everything, all the time. Sometimes when shooting sports, however, I switch to JPEG to increase the speed of the continuous drive shooting.

Adobe has created a universal RAW format called the Digital Negative or DNG file type. Adobe offers a free utility that converts the RAW format of other manufacturers to the DNG format and hopes that this universal format will be supported in-camera soon. I use the DNG format for all my photo editing and have my computer convert the camera's RAW files to DNG files when I import the files to the computer.

TIFF

The TIFF, or Tagged Image File Format, was created for the express purpose of storing images for desktop publishing. It made its way into digital cameras because it can save an uncompressed image with all the camera's settings applied. The downside is that this file type is usually uncompressed in the camera, making it the biggest file size of the three formats.

> **NOTE** TIFF images are considered *lossless*, meaning that even after multiple saves, they do not lose data, thus retain their quality. JPEG images, explained in the next section, are *lossy*. This means that each time you save a JPEG, it loses data and therefore image quality.

TIFF images are still the standard in publishing, and most computer software can use these files without any other processing. For example, all the images used in this book were sent to the publisher in TIFF.

JPEG

The JPEG file type is a form of image compression that was created by the Joint Photographic Experts Group in 1992. JPEG is the most common image file type, and every camera has a JPEG setting, usually quite a few JPEG settings. The advantage to the JPEG is that it is a universal file format that can be viewed, printed, and shared just about anywhere. Need to e-mail a photo or send one off to be printed? You want a JPEG for that.

When your camera stores the image information as a JPEG, it applies all the in-camera settings to the file. The different adjustments are detailed in your camera manual so check there for what is available on your camera. Correcting exposure problems on a JPEG is more difficult than when using RAW.

Because the JPEG file from your camera has already been compressed, if you open and edit it in editing software, and then save the file as a JPEG again, the file starts to lose quality, and each successive time the file is edited and saved, the quality is degraded. If you are going to shoot using JPEG, I recommend you use the highest quality and size available in your camera.

Working with Light

Without light, there is no photography, and because controlling the amount of light is the basis of all exposure, we can't discuss exposure without discussing light. In this chapter you learn to look at a scene and determine the direction and intensity of the light. And you learn to understand the color of light and what to do with white balance. Finally, you learn how to use flash, either built into the camera or attached to your camera's hot shoe — because it's all about working with the light in the scene.

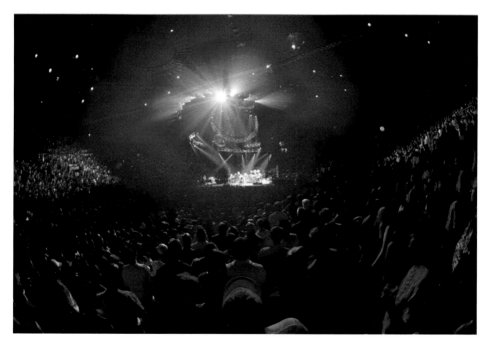

This image was lit solely by the stage lighting, but because multiple lights were moving in different directions, all with different colors, I had to take them all into consideration. Some of the lights ended up being overexposed, while others were underexposed. Taken at 1/20 second, f/2.8, ISO 1600.

Direction of Light

The direction of the light is important because it determines where the shadows fall in the scene. The shadows create the depth in a photograph; if everything were evenly lit, the photo would look flat. The direction of the light also determines what is hidden and what is shown in a scene. Light can hit a subject from any angle, and I discuss the four most common lighting directions in this section.

Front lighting

I'm sure you remember when you were photographed as a child and told to stand in the light; you often had to squint at the photographer because the light source was directly in your eyes. It's possible that you were taught that front lighting is the best lighting; however, the problem is that this type of lighting makes everything look flat and boring. Front lighting is most commonly used because the automatic settings in old point-and-shoot cameras knew how to deal with the exposure, and people were willing to have boring images as long as the people were in sharp focus and looked natural. The lenses used in point-and-shoot cameras just didn't let in much light, so they needed lots of light to start with. That's why the trend was to make sure that the light was brightest on the subject.

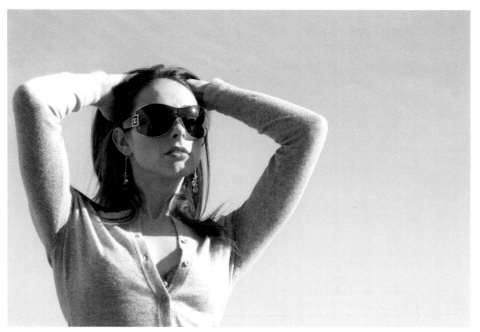

2.1 Mia was photographed in the late afternoon. You can see the sun reflected in her glasses and the hard shadow caused by her arm. Taken at 1/200 second, f/8 at ISO 100.

This trend is changing, thankfully. If the light is hitting your subject straight on, try to adjust your position or the position of the subject, even by a few degrees so the light strikes your subject at a slight angle. Using a straight flash on your camera is a variation of front lighting and can be very unflattering. I cover using the flash off the camera later in this chapter.

Back lighting

Back lighting can give you very dramatic photographs, but from an exposure point of view, it is one of the more difficult lighting scenarios. When the light is brighter behind your subject, getting an accurate meter reading is tough and capturing the detail in both the shadows and the highlights is impossible without adding another light source. A good example of back lighting is the classic silhouette, where your subject appears as a black shape against a bright background. Sunrises and sunsets are great times to take backlit photos and practice shooting silhouettes.

 You'll find much more on shooting sunrises and sunsets in Chapter 9.

One way to tell quickly if you have back lighting is to look at your subject's shadow; if the shadow reaches from the subject toward your camera, you have more light coming from behind the subject. When photographing with this light, the brightness of the light behind your subject causes your subject to be underexposed when you use the auto modes on your camera. The solution to this is to use Spot metering mode aimed on your subject and not on any of the bright background. This exposes the main subject correctly, but because the background is brighter than the subject, it is overexposed.

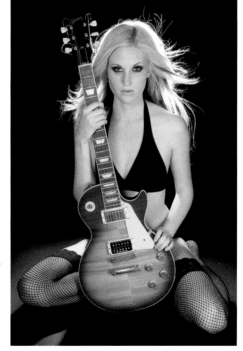

2.2 I shot this model using two studio lights, one facing her and the other light behind and to the side of the model, aimed back at the camera. You can see the shadows coming toward the camera at the bottom of the image and the bright halo around her head. Taken at 1/250 second, f/8, ISO 100.

Overhead lighting

This type of lighting occurs when your only light source is directly above your subject, like the sun at noon. When your only light source is from directly overhead, as can be the case when shooting landscape photography, your subject can have very little character due to the lack of shadows. A quick way to see if the lighting is directly overhead is to look at the direction of the shadows: You won't see any.

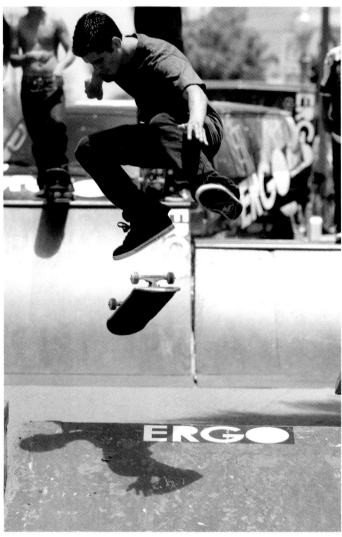

2.3 This skateboarder was shot in the middle of the day with the sun directly overhead. The position of the sun created a shadow directly below him and there is no detail in the pants and shoe that are in shadow. Taken at 1/1600, f/4, ISO 200.

Side lighting

When the light is off to the side and strikes an object from the side, this creates shadows that emphasize the form and texture of the subject.

2.4 This photograph of comic color artist David Baron was photographed with a single light from the left. The harsh side lighting was used to match the backdrop art. Taken at 1/250 second, f/9, ISO 100.

Intensity of Light

The intensity of light refers to how bright the light in your scene is. The intensity of the light depends on two factors: the size of the light source and the distance between the light source and the subject. The closer your light is to your subject, the higher the intensity (brightness); the farther away the light is, the more the intensity drops.

Controlling the intensity of available light is very difficult, especially the intensity of the biggest available light source — the sun. You cannot move the sun closer or farther away from your subject; you simply have to wait for the sun to move. There are ways to adjust the light using diffusers and reflectors, but you don't have any control over the actual light.

CROSS REF

For more on diffusers and reflectors see Chapter 7.

Supplemental light, of course, is a little easier to control. When the light is attached to the camera, as in the case of the built-in flash, just moving the camera closer or farther away can result in a big change in the intensity of the light. When using a studio, you can control the light output of multiple lights, giving you a great deal of control over the intensity of the light. In either case, it is up to the photographer to gauge how intense the light is. Is the light from the bright noonday sun or from a single table lamp? When the intensity of the light is high, you can use faster shutter speeds, lower ISOs, and smaller apertures to achieve the best exposure. When the intensity of the light is lower, you need to slow down the shutter speed, use a wider aperture, or raise the ISO.

Color of Light

Light has color and this color can affect your images. The color of the light can determine the mood and tone of your images. The more red or orange the light in an image is, the warmer the image feels, while the more blue the light is, the cooler the image feels. If the light has a green colorcast, people will look sickly and wrong. This is because of human perception we have come to learn that red is warm and that blue is cold. But how does the light actually get its color, and what can you do about it? Light gets color in three ways: from the color of the subject off which the light is reflected, from everything the light passes through, and from the source of the light itself.

You need to pay attention to the light sources in your scenes, not only the direct light but the reflected light. Shooting a portrait in a green room causes the light that is reflected off the walls to have a green cast and can ruin an image. It you are shooting outside and the sun goes behind a cloud, not only is there less light, the color of the light changes because it is passing through the clouds before reaching the camera.

Dealing with reflected light is usually done by either moving the object the light is being reflected off of or by moving the subject. What is more complicated is dealing with the different colors of light that are produced by different kinds of light sources. For this photographers have developed a color temperature scale that can be used to describe the various types of lighting.

Color temperature

The color temperature is used to describe the color of the light and how different it is from white based on the source of the light. While your eyes can adjust to these differences almost instantly, which is why a white piece of paper looks white to you outside in the sun and inside under fluorescent bulbs, there are differences in the color of light depending on the light source.

Have you heard the expression "red hot" or "white hot"? Those are ways to describe the light being produced when something burns. When something burns very hot, less red is emitted, and the color is bluer. Photographers took this information and created the Kelvin scale to describe the color of light produced by a theoretical black-body radiator. The lower the number on the Kelvin scale, the more orange and red you see, while the light on the higher end of the scale has a distinctly blue color to it. Table 2.1 lists some common light sources and their approximate color temperatures.

 Some light sources can cause huge color shifts in your images if they are not dealt with when photographing.

Table 2.1 Kelvin Scale of Color Temperature

Light Source	Approximate Color Temperature in Kelvin	Color Cast Seen
Candlelight	1900K	Very red
Sunrise/sunset	2000 – 3000K	
Household incandescent bulbs	2500 – 2900K	
Photographic tungsten bulbs	3200K	
Early morning/early evening	3500K	
Halogen lights	3200 – 3500K	
Fluorescent lights	3200 – 7500K	
Mid-afternoon sunlight	5400 – 5000K	
Average noon daylight	5500K	White
Electronic flash	5500K	
Overcast sky light	6000 – 7500K	
Shade	6500 – 8000K	
Clear blue sky	10,000 – 16,000K	Very blue

White balance

The white balance setting is the way to tell your camera what type of light is illuminating your scene. This is important because your camera doesn't know what type of light you are photographing with, and it must know so the colors in your image are correctly rendered. You can do this when you are taking the photograph, but if you shoot using the Camera Raw file type for your camera, you can change this setting later. Many digital cameras have a great automatic white balance setting. I rarely change this setting when shooting, but because I shoot mainly using the RAW, I know that I can adjust the white balance later in post-processing, which is a real advantage.

Each camera sets the Kelvin value depending on the white balance setting. For example, when you set the white balance on a Sony A700, Daylight sets the Kelvin temperature to 5400K, shade is 7750K, cloudy is 6200K, Tungsten is 2900K, Fluorescent is 4050K, and Flash is 6550K. When the same settings are used on a Nikon D700, Daylight sets the Kelvin temperature to 5000K, shade is 7300K, cloudy is 5700K, Incandescent (Tungsten) is 2950K, Fluorescent is 3950K, and Flash is 6150K. As you can see, these are similar but not the same. On some cameras, you can adjust each of these to fine tune them to your liking. Most cameras also allow you to make a custom white balance setting and even enter the color temperatures by inputting the Kelvin values directly. Check your camera's manual for more on setting the white balance. However, the following list outlines a bit about some white balance settings that are largely standard across dSLRs.

▶ **Auto white balance.** Most cameras have an auto white balance setting that lets the camera set the white balance of the camera on a shot-by-shot basis. The downside to using auto white balance is that the white balance is different from shot to shot as the camera makes slight adjustments. If you are taking a series of photos in the same place at the same time, this can cause each of the images to look a little different. Because Auto white balance is the camera's best guess, the actual color accuracy is not as good as when you choose an actual white balance. That said, I have found that Auto white balance mode works great in most situations. Camera manufacturers have improved the auto white balance setting so much that, unless I am trying to get a specific look in the camera or shooting a sequence in which all the photos need to look exactly the same, I usually have the camera set to auto white balance most of the time. This mode works just fine when used with a flash indoors and out.

▶ **Daylight.** The Daylight setting sets the white balance on the camera to around 5000 – 5500K. Although this gives you accurate color in direct noon sun, it can look a little cold. More details about Daylight and color temperature follow in the next section.

▶ **Cloudy.** The Cloudy white balance setting pushes the color temperature a little warmer than the Daylight setting. I have found that this is actually better to use in direct sunlight because it adds a little warmth to images that most people find pleasing.

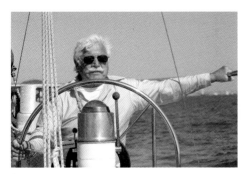

2.5 Daylight white balance, taken at 1/5000, f/6.3, ISO 640.

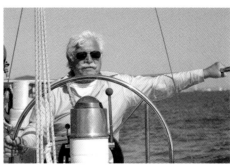

2.6 Cloudy white balance, taken at 1/5000, f/6.3, ISO 640.

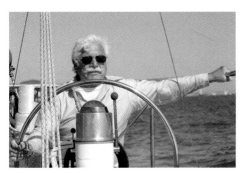

2.7 Flash white balance, taken at 1/5000, f/6.3, ISO 640.

2.8 Shade white balance, taken at 1/5000, f/6.3, ISO 640.

2.9 Tungsten/Incandescent white balance, taken at 1/5000, f/6.3, ISO 640.

2.10 Fluorescent white balance, taken at 1/5000, f/6.3, ISO 640.

▶ **Flash.** The Flash setting is a little warmer than the Cloudy setting, but usually the two are close to each other. This setting is used to match the on-camera flashes that tend to be on the cool (blue) side. This means that the white balance setting is a little more on the warm (red) side. This doesn't work well for studio flashes, which usually have a warmer light to begin with and can cause images to be a little too warm (red). The daylight white balance is a better choice when using studio strobes. I don't use this setting often, because I would rather use the Cloudy setting, which is a little warmer but not too warm.

▶ **Shade.** The Shade white balance setting pushes the temperature into the very warm zone. This makes the color very red/orange. This is the setting for shooting in the shade because the color in the shade is very cold and needs to be pushed back to the warm zone. This is also a good mode for shooting in very cloudy situations because the light coming through the clouds is much colder than direct sunlight.

▶ **Tungsten or Incandescent.** The Tungsten or Incandescent white balance setting is best used for indoor lighting where the light is much warmer than sunlight. This can make shots taken indoors look like they were taken in white light, which may not actually be a good thing. People expect photos taken indoors to look warm, and when they look too white, even if they are shot using the correct white balance, they can be perceived as being too cold. I tend to use the fluorescent setting to remove some of the warmth, but not all of it.

▶ **Fluorescent.** Fluorescent white balance starts to push the color temperature to the cooler side. This is used to counteract the warmer fluorescent bulbs, but as I mentioned earlier, fluorescent lighting can cover a wider range of colors depending on the bulbs, the power consumption, and the shutter speed.

Daylight

Daylight is the broad term that covers bright sunlight, as well as light available on cloudy days and in the shade. Although the light available during the first and last minutes of the day is technically daylight, it is vastly different from the light available at high noon. And the daylight available on a cloudy day or in deep shadows is very different from the light on a bright sunny afternoon. Daylight can range from very red in the morning to white in the midday back to very red in the evening.

The early morning and late afternoon sun is considered the best light to photograph with. This light is warmer than the light during the rest of the day; just look at most sunrise and sunset photos to see what I mean. The reason the light during these times is so great has to do with the angle of the sun and the direction and distance the light has to travel.

 For more on sunrise and sunset photography, see Chapter 9.

The position of the sun during sunrise and sunset allows less of the white light to pass through the atmosphere, which makes for a warmer light with more red, orange, and yellow hues. When the sun starts to set, the light must travel farther through the atmosphere and more of the light rays are reflected and scattered, causing the sun to look less bright. The actual color of the sun seems to change from bright white to orange and then to red.

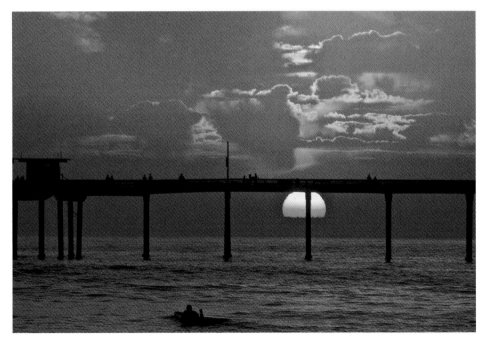

2.11 The sun has turned into a bright orange-yellow ball as it starts to drop below the horizon. I took a spot meter reading from an area of the sky that didn't have any of the actual sun in it. This underexposed the sky so the sun would be visible and the pier and surfer are both rendered nearly black. Taken at 1/160 second, f/16, ISO 400.

As the sun travels across the sky, the longer wavelengths pass right through the atmosphere and less of the orange and red light is affected. The shorter wavelengths are absorbed and radiated in all directions. This is why the sky looks blue and the light looks white. This light during the day is often too harsh to yield a great photograph.

The best thing to do during this time is to look for great places to shoot a sunrise or sunset. If you need to shoot during the middle of the day, be sure to meter correctly. When the sun is at its brightest, the difference between the sky and the subject can be so great that the built-in light meter on the camera can be tricked into underexposing the subject. Make sure you are using a spot meter reading on the actual subject so the bright sky doesn't affect the image.

Tungsten or incandescent light

Incandescent lights produce light by heating the filament inside the light bulb. The temperature of the light depends on the type of filament used. The most common for photographic purposes are lights made with tungsten filaments that burn at a constant 3200K. Household incandescent bulbs can vary in color temperature greatly, and the tungsten or incandescent white balance may not get you the desired results. There are differences in the manufacture of different wattage bulbs which can cause shifts in the color of the light between different wattage bulbs.

2.12 **These two images were taken moments apart; everything about them is the same except for the white balance setting. The left shot was taken using the Auto white balance, the right using the Incandescent setting, which rendered a more accurate color representation. Both images taken at 1/500 second, f/1.6, ISO 3200.**

Images shot in daylight using the Tungsten or Incandescent setting produce images that have a blue color cast. This can be very useful when shooting just after the sun has gone down because it makes the blue of the sky much bluer while anything lit with an actual tungsten bulb has the correct color.

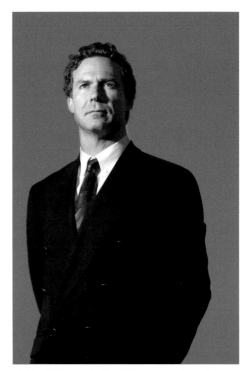

 To get the very blue sky in figure 2.13 I set the white balance in the camera to Tungsten/Incandescent, this intensified the blues. To make sure Tim didn't look too blue, I used a filter over the flash, which changed the color of the light into that of a Tungsten light source.

 To see where the flash was setup in figure 2.13, see Chapter 7.

2.13 This portrait of Tim was shot right after the sun went down using both the natural light and a flash unit. Taken at 1/250 second, f/5.6, ISO 200.

Fluorescent light

Passing an electrical current through a gas inside a sealed tube creates fluorescent light. The current excites the chemical phosphors that coat the inside of the tube causing them to emit light. Fluorescent lights can have different colors based on the chemical phosphors used when making the bulb. Bulb manufacturers use different chemical phosphors so the overall output of the light seems to be white to the human eye. The light from a fluorescent bulb may look white to you and me, but your camera's sensor doesn't see it that way.

When you photograph under fluorescent light, your image appears to have a green cast if not corrected. A bigger problem is that even slight fluctuations in the power cause slight fluctuations in the color of the light. This means the color of the light can

change from moment to moment. You can't get away from fluorescent lights because businesses and homeowners are switching from incandescent bulbs to fluorescent bulbs due to their lower cost to operate lower power consumption.

When shooting in fluorescent light, you can correct for the greenish color cast in two ways:

▶ **Set the correct white balance.** Make sure you set the white balance to Fluorescent. Some digital cameras have a dedicated White Balance button while others have a white balance menu. Check your camera manual for how to set the White Balance.

▶ **Shoot in RAW.** Photographing in RAW allows for adjusting the white balance using the software supplied by your camera's manufacturer or another photo-editing software.

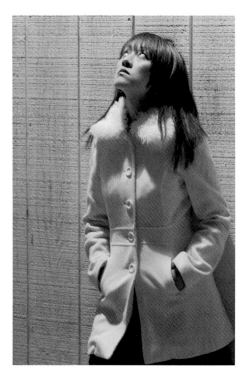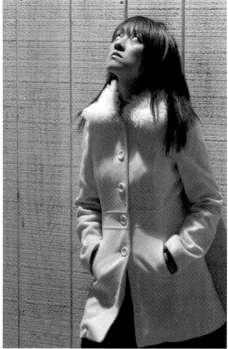

2.14 This portrait was taken outdoors at night under a large fluorescent light. As you can see on the left, the green color cast is very unnatural. On the right, the WB has been adjusted to compensate for the color cast. Both images taken at 1/20 second, f/2.1, ISO 640.

Using a Flash

Having a flash means that you always have a light source with you. This can range from the little built-in flash on the top of the camera to a dedicated flash unit that, if used correctly, can even compete with the power of the sun. Except for a few top-end professional cameras, digital SLRs come with a built-in flash housed on top of the viewfinder. I consider this an emergency-only type of flash, and unless I am using it to trigger an off-camera flash, I don't use it much. The problem is that the flash on the camera creates a light that doesn't look natural. When you see a photo lit by an on-camera flash, you easily recognize it, and it usually leaves a negative impression because you are not supposed to focus on the lighting, but on the subject. Only in very few situations do you want the light source striking the subject straight on, like a deer in headlights or when you get your passport photo taken.

2.15 This was taken with the flash aimed directly at the bear. You can see the direction of the flash in the hard shadow on the wall behind the bear. Taken at 1/30 second, f/6.3, ISO 100.

2.16 This photo of the same bear in figure 2.15 was taken with the flash aimed at the ceiling. This not only reduced the harsh shadows but also changed the color because the light was being bounced off the ceiling and walls. Taken at 1/30 second, f/6.3, ISO 100.

Flash units are made for every type of dSLR on the market today, and often more than one type. To find the best flash for you, check with your local camera shop or camera manufacturer's Web site. These external flash units have some serious advantages over the built-in versions. These are the biggest advantages:

▶ **You get more power.** Because the flash has its own power supply, it is more powerful, can be ready to fire faster, and doesn't use power from the camera.

▶ **They have adjustable flash heads.** Most of the external flashes allow you to adjust where the flash is aimed. This allows you to bounce the light off the ceiling or nearby wall, which gives you a softer, more natural light. If your subject is illuminated from a direction that looks natural, like from above, the light is believable and doesn't distract from the image.

▶ **You can use them off-camera.** One of the best things you can do for your flash photography is remove the flash from your camera and trigger it remotely. This allows you to change the direction of the light and place the flash where you need it most.

▶ **They have fun accessories.** Not only can external flash units use some of the regular lighting accessories like umbrellas, but some accessories are made specifically for flash units. LumiQuest and HonlPhoto are just two of the companies that produce light-shaping tools specifically for use on external flashes. I use products from both these companies and have been very pleased with the results.

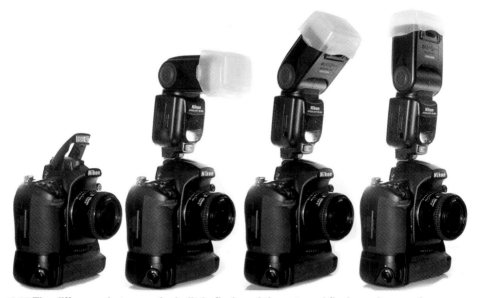

2.17 The difference between the built-in flash and the external flash can be seen here on the Nikon D700 with an SB-900 flash attached. The external flash can be used at a variety of angles. The SB-900 also has a diffuser dome attached that helps to diffuse the light.

Fill light

You can use a flash to illuminate the whole scene or even to light up a dark setting, but you also can add some light to areas in your photo that are in dark shadows, complementing the main light source (usually the sun). When your flash is used this way, it "fills" in the details in the shadow area with some light without overexposing the whole scene. Suppose you're photographing people outside, and the sun is causing unwanted shadows on their faces; this is when you need fill light. This is why you see wedding and portrait photographers using a flash on their cameras even when shooting outdoors in bright sunlight. It isn't that they don't have enough light; it's that they don't have enough light in the right areas.

Consider what happens when you shoot someone wearing a hat outside. The job of a hat is to keep the sun out of the person's eyes, but it also keeps that part of the face in the shade created by the hat's brim. When you take a photo of a person wearing a hat outside in bright light, the contrast between the dark shadows and the light sky causes either the dark areas to be underexposed or the light areas to be overexposed,

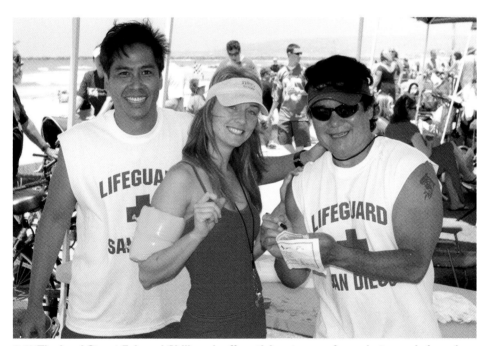

2.18 The local Street Fair and Chili cook-off participants pose for a photograph. I used a fill flash to add just a little light to combat the shadows from the hats. I reduced the power of my flash by two full stops to balance out the available light. Taken at 1/250 second, f/ 7.1, ISO 100.

depending on what you exposed the image for. The solution is to add a little light to the dark areas and decrease the contrast in the image. We don't want to remove all the shadows because that would leave us with a flat, boring image, but we do want to even out the light, especially when shooting people.

When using your flash as fill light, you want to reduce the power of the flash so the light produced doesn't distract or overpower the natural light in the scene. I have found that getting the right balance between the main light and the fill flash requires me to reduce the power of my flash by two-thirds of a stop all the way to one and a half stop. Some cameras have a fill flash setting where the camera tries to adjust the amount of flash used. My favorite technique is to change the angle of the flash head so it's not aimed directly at the subject, but instead over her head and add a diffusion dome to the flash, which produces a more diffused light. Then the power of the flash doesn't need to be reduced by as much, because very little of the light is actually reaching the subject. I have found that this creates the most natural fill light.

 For more on using a flash for portraits, check out Chapter 7.

Color gels

Gels are used to change the color of light as it leaves the flash. They are usually made from flexible sheets of colored plastic or acetate. Gels can come in many sizes and can be used on big studio lights and small dedicated-flash units. Some flashes come with gels, but great gel kits are available from LumiQuest and HonlPhoto, among others.

I use gels for two reasons: to add color to the light for creative purposes and to make the light match the color already present. This is especially important when shooting indoors under fluorescent or incandescent lights.

▶ **Matching fluorescent lights.** Fluorescent lights tend to be a little green, so the way to match the light from your flash is to use a green filter over the front of the flash.

▶ **Matching incandescent/tungsten lights.** When the room is lit with warm incandescent bulbs, the idea is to warm up the light coming out of the flash so it matches. The filter used for this is an orange filter called Color Temperature

Orange, or CTO for short. These filters come in various strengths and are referred to in terms of a full CTO. Sometimes I use a quarter-strength CTO gel to add a little warmth to whatever I am shooting.

When using a color-corrected flash, you must set the white balance to the same light specific setting to get the proper color.

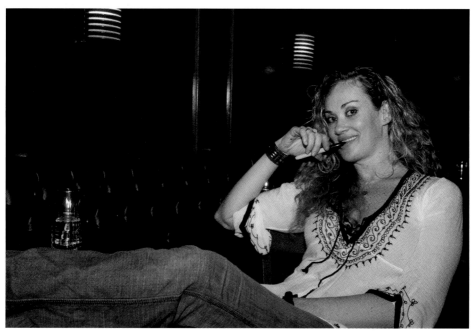

2.19 I used a half-strength piece of CTO over the end of the flash to balance the incandescent light already in the scene when shooting musician/actress Dana Fuchs after her show. I aimed the flash toward the ceiling so the light would be even. I also used a slower shutter speed so the ambient light would be present in the image. Taken at 1/15 second, f/5.6, ISO 100.

The other use for gels is to color the light directly; for this, you can use any color. This is mainly used to color a plain background and add some interest. You need to set the white balance to something other than Auto if you are going to use a gel to add a colored light to the whole scene. If you don't, the camera tries to counteract the color cast, and all your work is for nothing.

Shutter Speed

Photography can be described as capturing a moment in time, and the shutter speed is what controls how long that moment is. Think of the camera's shutter as a blind that hangs in front of the sensor; when the shutter is opened, the light can reach the sensor. The shutter speed is a description of how long you leave the shutter open, and in doing so it controls the amount of light that reaches the sensor. The shorter the amount of time the shutter is open, the less light is allowed to reach the sensor. I used to be more concerned with using the shutter speed to absolutely freeze the action in my scenes. After a time, I began to see the advantages of using a slower shutter speed in certain circumstances, now I set the shutter speed depending on how I want the images to look.

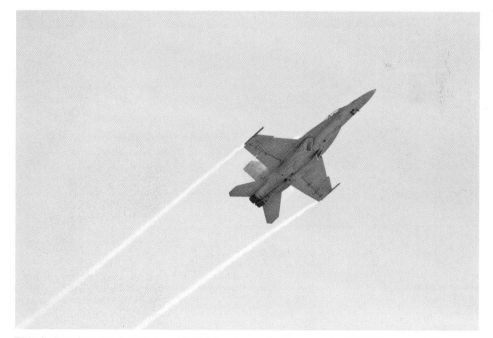

This fighter jet was frozen in mid-flight using a shutter speed of 1/2000 second. Even with plenty of light, I needed to boost the ISO to 640 to get the shutter speed necessary to freeze the jet in flight. I used the widest aperture available on the lens, which was f/6.3 to let in as much light as possible.

Controlling the Shutter Speed

Knowing how to change the shutter speed is just as important as knowing when to change it. The first thing to think about is why you're concerned about the shutter speed; what is it about the scene you're going to shoot that makes the shutter speed the priority? The first thing that comes to mind is that the subject of the photo is moving and you don't want it to come out blurry. Your kids are playing in their first soccer game and you want to catch them running after the ball, or you are watching a parade go by and want to make sure you have a blur-free image of the participants. These situations require a fast shutter speed, something that grabs a small moment of time, sometimes a very small moment in time, like 1/2000 second.

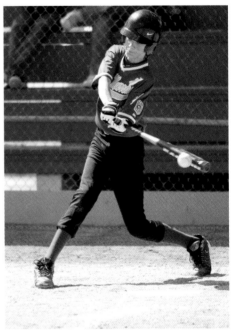

The second reason to control the shutter speed directly is that you want to stretch out time; that is, you want to capture something that happens over a longer period in a single image. This is how photographers create those images of waterfalls or rivers where the water looks smooth and soft and flowing. The motion of the water is captured instead of the actual water by using a longer shutter speed.

3.1 I used a fast shutter speed of 1/750 second to freeze the Little League player as his bat hit the ball. Even using that fast of a shutter speed, the bat is still moving so fast that it is still slightly blurred. Taken at 1/750 second, f/2.8, ISO 100.

Before you decide on a shutter speed, you need to know how to set the shutter speed and the consequences of your choice.

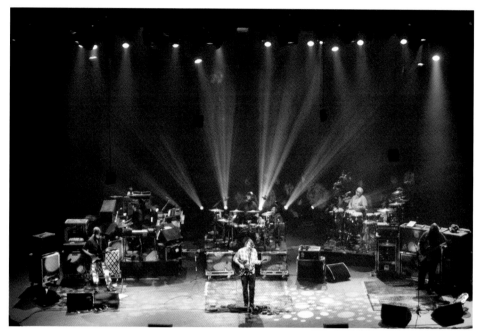

3.2 This concert photograph was taken at 1/20 second, f/2.8, ISO 200. I purposely used a longer shutter speed to catch the lights in the background. Because the band wasn't moving much, they are still in acceptable focus even with a relatively slow shutter speed.

Camera controls

Every camera has a slightly different control layout, but all dSLR cameras and many point-and-shoot cameras have the following modes: Program auto mode, Shutter speed priority mode, Aperture priority mode, and Manual mode. You might have to do a little investigating to find where to set each of these modes. You can find the information in the camera manual, or you can buy the *Digital Field Guide* for your specific camera.

Knowing how to set and change modes quickly is important when trying to get the best exposure. Look at the following modes as they relate to shutter speed.

Program auto mode

Program auto mode, not full auto mode, in most digital cameras lets you focus on the composition while giving the camera control over both the shutter speed and aperture. This mode lets the camera pick the shutter speed and the aperture, but you can make adjustments to the shutter speed and aperture on an image-by-image basis. As the photographer, you can quickly adjust the shutter speed and aperture combination. If, for example, you increase the shutter speed to freeze the action, the camera automatically use a wider aperture so the proper amount of light still reaches the sensor. This is a great mode to learn first, because the camera is picking a starting point for you, and you simply adjust one of the settings while the camera takes care of the rest.

This is my default setting when I put my cameras away after shooting, because if I need them in a hurry, they are set to give me a proper exposure in most situations. Will it be the best exposure for the scene? Maybe not, but it is a good starting point.

Shutter speed priority mode

This is the best mode when your only concern is using the shutter speed you select. In Shutter speed priority mode, you choose the shutter speed and the camera picks the aperture. As you increase the shutter speed, the camera uses a wider and wider aperture or smaller f-number. This works until the aperture is at its widest opening (which is determined by the lens attached to the camera), at which point you can still increase the shutter speed, but the image starts to be underexposed because not enough light is reaching the sensor. You can always increase the ISO, making the sensor more sensitive to light, but that can increase the amount of digital noise present.

 For more on digital noise, see Chapter 5.

I use the Shutter speed priority mode mainly when I am shooting sports, because I care more for freezing the action than anything else. I also use this mode when photographing children, because they just move so fast. I cover photographing both children and sports later in this book.

Manual mode

In Manual mode, you get to pick the shutter speed and the aperture. This is the mode that gives you total control over the exposure, but it doesn't mean the camera won't try to help. The camera's display shows what it believes is the correct exposure for the scene and whether your setting allows more or less light. I use Manual mode for the times when I believe I know better than the built-in light meter and especially when I am shooting concerts.

When Shutter Speed Is More Important Than Aperture

I hear one question time and again from new photographers: How do I get sharp images especially when the subjects are moving or in low light? Often, the folks taking these blurry images are using the wrong settings and are not setting the shutter speed high enough. When your images are blurry it is because there is movement either by the subject or of the camera while the shutter is open. It is these times that you need to be shooting with an eye toward adjusting the shutter speed and making sure you are in a mode that allows you to do this.

The thing to always keep in mind is that when you change the shutter speed the aperture will also be affected. As the shutter speed times get faster the aperture needs to get wider so that the proper amount of light is still reaching the sensor.

When you want a very fast shutter speed, you most likely are using a very wide aperture that can change the

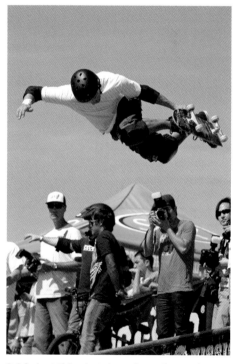

3.3 I shot this skateboarder using a shutter speed of 1/2500 second. I wanted to make sure the skater was frozen in place above the crowd. Taken at 1/2500 second, f/2.8, ISO 100.

whole look of your photo because aperture controls the depth of field. A very fast shutter speed can result in a wide aperture, which can create a shallow depth of field.

 I talk more about the relationship between shutter speed and aperture in Chapter 4.

One of the prime times when shutter speed is of utmost importance is when shooting sporting events. I usually start shooting in Shutter speed priority mode because freezing the action is more important than the shallow depth of field that can be created. Usually this works to my advantage, because it helps to make the subject stand out from the background.

Another situation where I control the shutter speed is when photographing children. They tend not to hold still for very long, and I sacrifice some depth-of-field control to ensure that the images are not blurry.

Freezing the Action

Freezing the action is what photographers want to do to avoid having blurry photos. When you look at a scene where either the camera is moving or the subject is moving, you need to determine how fast the shutter speed needs to be to freeze the action.

The first factor is to look at what you are shooting. How fast does a shutter speed need to be to freeze kids playing soccer? What shutter speed is needed to freeze the action in a high school football game? How about stopping a dog running on the beach or a horse running a race? Think about the problem logically, and you'll realize that you need a faster shutter speed to freeze a running horse than to freeze a person jogging.

Camera Shake

Camera shake is the blurring that can happen when you hand-hold a camera with too slow a shutter speed, which results in a softening of the image. The longer the focal length of the lens being used, the worse the camera shake is. The standard rule to avoid camera shake is to use a shutter speed that is at least 1 divided by the focal length. For example, if you are using a 200mm lens, the minimum shutter speed should be 1/200 second. Another way to avoid camera shake is to use a tripod that keeps the camera steady during the exposure.

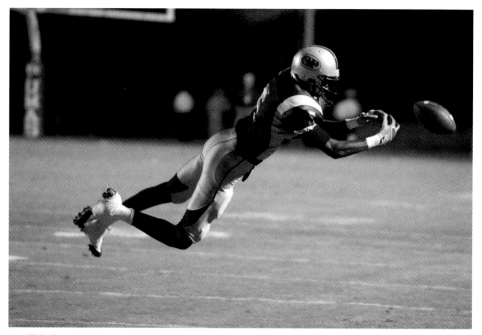

3.4 This football player valiantly tried to grab the ball before it hit the ground. He was frozen in mid-leap. Taken at 1/400 second, f/2.8, ISO 2000.

The second factor to consider is the direction of the movement. Subjects traveling toward or away from you need a lower shutter speed compared to those moving across the scene. So the direction and the speed of the subject determine how fast a shutter speed is needed to freeze the subject.

The third factor is to consider your distance from the subject and how much of the frame is filled by the subject you want to freeze. The more your subject fills the frame, the more the subject can travel across your frame in the same amount of time. Using same focal lengths, items moving very fast in the distance take longer to cross the frame than do those that are right next to you. This is true for the type of lens you use as well. Because a wide-angle lens covers more space, a subject moving across the frame takes longer than the same subject when shot by a telephoto lens using the same shutter speed.

Superfast shutter speeds

A superfast shutter speed is anything 1/1000 second or higher. These speeds can stop a surfer on a wave crossing in front of the camera and freeze the drops of water as they fly off in the air. To shoot at these shutter speeds, you need a couple of things

to happen. First you need lots, and I mean lots, of light. A super-fast shutter speed is best used on very bright days, outside, at high noon. Okay, I exaggerate, but you do need lots of light, because having the shutter open for only 1/1000 second lets in the light for a very, very small slice of time. Another thing that can be done to help achieve the 1/1000 or higher shutter speed is to increase the ISO to 400 or in some cases even higher. One more item that makes super-fast shutter speeds possible is a lens with a maximum aperture of f/2.8 or wider. The larger the opening in the lens letting the light in, the less time the shutter has to be open, so it stands to reason that using a lens with a very large opening lets you use superfast shutter speeds.

The surfer in figure 3.5 was photographed using Shutter speed priority with the shutter speed set to 1/1000 second. I used an 80-400mm lens that when zoomed to 400mm has a maximum aperture of f/5.6, which isn't very fast, but it worked here because it was a very bright afternoon. I was shooting toward the sun, so I used Spot metering mode to make sure the surfer was exposed correctly and the extreme bright areas of surf were not used in the exposure calculation.

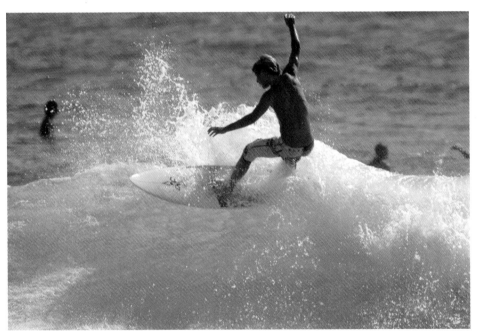

3.5 **A surfer having a great day surfing at Wind 'n Sea beach in La Jolla, California. Taken at 1/1000 second, f/5.6, ISO 200.**

Very fast shutter speeds

Very fast shutter speeds are speeds between 1/400 second up to 1/800 second, and they can freeze lots of action. The horses heading for the finish line in figure 3.6 were frozen using just 1/500 second shutter speed. Using very fast shutter speeds instead of super fast shutter speeds also lets you capture the action in slightly lower light without having to have the fastest lenses or using very high ISOs.

I wanted to make sure that I froze the horses as they came down the final stretch of the racetrack. Because I knew that the horses were moving fast, and were moving across the frame, I knew I would need a very fast shutter speed. I used the fastest lens I had, one with a maximum aperture of f/2.8, and set the shutter speed to 1/500 second. I kept the ISO as low as possible to avoid digital noise. I focused on the horses as they rounded the corner of the track and followed them as they raced past me. I started taking photos when I felt that they were close enough to fill the frame and, with a 1/500 second shutter speed, I managed to fire off four shots before the horses were past me.

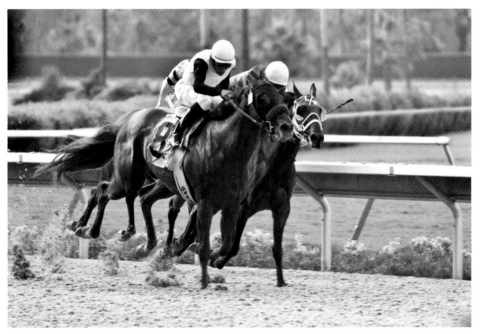

3.6 Horses running for the finish line, taken at 1/500 second, f/2.8, ISO 100.

Fast shutter speeds

Fast shutter speeds are generally considered speeds from 1/125 to 1/250 second. While these speeds don't stop all motion, they do a good job if the direction of the movement is directly toward or away from you. In figure 3.7, for example, the rugby players were running right at me when the tackle happened. Even at a shutter speed of 1/200 second, the action is frozen. I was able to use a slower shutter to freeze the rugby players compared to the football player in figure 3.4 because of the direction the action was moving. While the rugby players were coming directly at me, the football player was moving across the frame.

When shooting sports, a base shutter speed of 1/250 is a good place to start. I would rather shoot at too high a shutter speed than at too low a shutter speed when freezing the action is the most important goal.

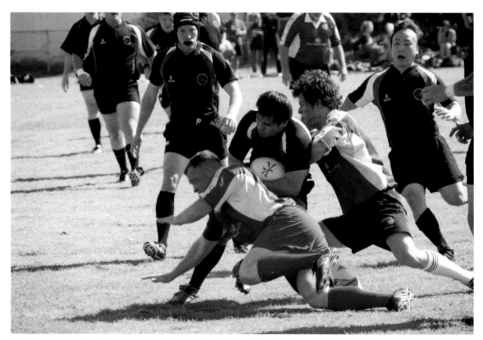

3.7 These rugby players were frozen in mid-tackle. Taken at 1/200 second, f/6.3, ISO 200.

Normal shutter speeds

1/30 to 1/125 second are considered normal shutter speeds. They are not really fast enough to freeze a lot of action and not really slow enough to be used very creatively. These are the shutter speeds I use mainly when photographing people who

are standing still for the photograph and for shooting still-life images. I also use these shutter speeds when shooting live music events, especially when the subject isn't moving much. Photographing using these shutter speeds can lead to blurred images if the subject is moving, especially when you get down to the 1/30 to 1/60 second range.

Many cameras use the 1/30 to 1/60 second range as the default when using a flash in low light. For the photo in figure 3.8, I basically just put a dedicated flash on the camera and aimed the flash straight up to bounce the light, and used the default camera settings to take the photo.

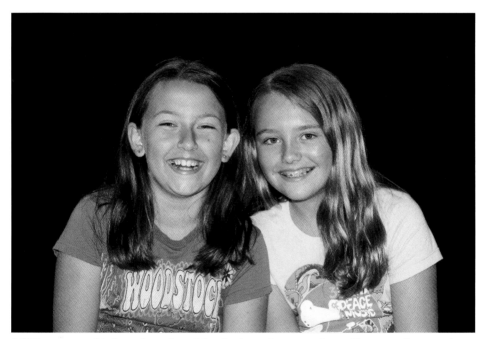

3.8 These two girls have been best friends since they were born. The portrait was taken against a simple black background at 1/60 second, f/5.6, ISO 200.

Slow shutter speeds

Slow shutter speeds are those below 1/30 of a second. When using these shutter speeds anything that moves, either the subjects or the camera will cause blurring. A shutter speed of 1 second to 1/30 second is really useful for conveying motion. If you practice, it is possible to handhold the camera without too much blur. Of course using a tripod to hold your camera steady works really well and is the best way to shoot using longer shutter speeds.

I cover tripods in much greater detail in Chapter 9.

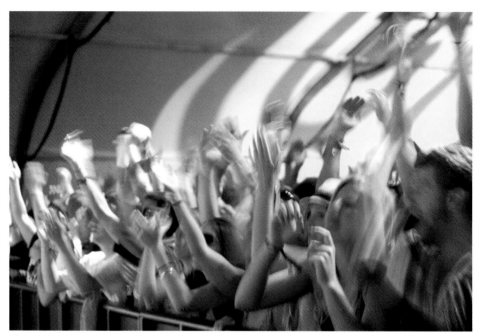

3.9 This image was shot at 1/5 second to get a feeling of movement into the image. These young fans were screaming, shouting, and waving their hands waiting for the DJ to take the stage. Taken at 1/5 second, f/2.5, ISO 800.

If using a tripod is not an option, here are three techniques that can be used to get the best shot possible at the slower shutter speeds.

▶ **Rest your camera on a stable surface.** This is a great way to use whatever stable surface is nearby to keep your camera steady during longer exposures. Any object that is wide enough to rest your camera on can be used. The roof of a car works great as do any table tops and even the floor for those low angle shots. Be careful not to let go of your camera when doing this as it could fall and get damaged.

▶ **Become a tripod.** When handholding the camera for long shutter speeds, you want to pretend that your body is a tripod. Stand with your feet shoulder width apart and turned slightly towards your subject. Use your left hand to support the camera and lens and tuck your left elbow into your body to give the camera as much support as possible. Breathe out slowly and press the shutter release button calmly to avoid as much movement as possible.

▶ **Shoot in burst mode.** Set your camera for continuous shooting and shoot in bursts. I like to shoot in bursts of three images at a time and it seems that the second and third images are steadier than the first.

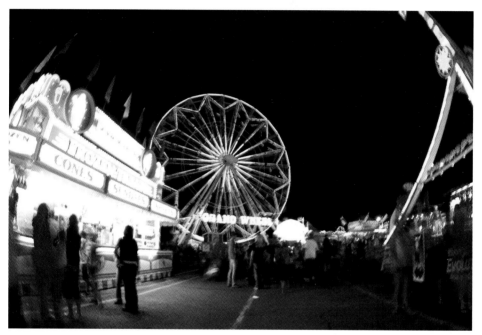

3.10 I wanted to capture the movement of the lights and the people at the local fair. I did not have a tripod so I leaned against a pillar and held the camera as steady as possible while shooting a sequence of photos. This was the second image in the sequence. Taken at 2 seconds, f/14, ISO 200.

Image Stabilization

Most of today's camera manufacturers have a form of image stabilization technology for use in their cameras. This technology can help to reduce camera shake and can help get sharper images at slower shutter speeds. This technology comes in two different forms — some cameras have the image stabilization built into the camera and some have the stabilization built into individual lenses. When the stabilization is built in to the camera body, it is available with any lens attached to the camera. When the image stabilization is built into the lens itself, then it is only available when using that specific lens. The lenses with image stabilization built in are usually more expensive than those without the stabilization.

Very slow shutter speeds

Using really slow shutter speeds allows us to compress time by capturing a longer period of time in a single frame. Now, I realize that this may sound strange, but bear with me for a moment. If you leave the shutter open, the camera records all the information in front of it. All the movement and light that happens when the shutter is open is recorded and saved as a single image so items that were never in the scene together can be in the same image. The key is to keep the camera steady during the exposure, which requires a tripod.

Slower shutter speeds offer a great deal of creativity by giving you the ability to capture everyday scenes in new and exciting ways.

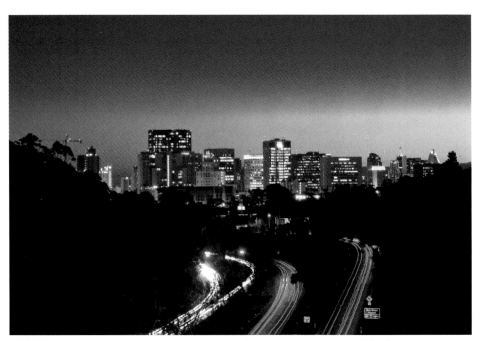

3.11 Using a shutter speed of 10 seconds let the cars all blur into solid white and red lines and allowed for the lights in the buildings of downtown San Diego to be seen. Taken at 10 seconds, f/11, ISO 100.

Photographing in low light is the most common time when you would use slower shutter speeds. This is because at most other times too much light is present to use slow shutter speeds without severely over-exposing the image. One important thing to remember when using slow shutter speeds is that no matter what you do, digital noise will be introduced into your image.

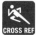 For more on digital noise, see Chapter 5.

Some cameras have a long-exposure noise reduction setting, which can help you get less noise when taking long-exposure photographs. The cost of this is much longer processing time when taking the photos. When shooting long exposures, you should shoot using RAW if your camera offers it so you have more information in the file, which helps if post-production noise reduction is needed.

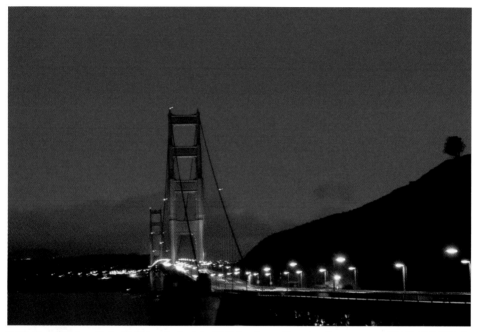

3.12 The Golden Gate Bridge shot at twilight using a 3 second exposure, f/5.6, ISO 250. I wanted to use a slower shutter speed, but the wind picked up, and even at 3 seconds with the camera on a tripod, I was starting to get a blur on the bridge.

Panning

Two types of motion require you to deal with slow shutter speeds: motion of the subject, which was discussed previously, and motion of the camera, called *panning*.

It is a great technique where you keep the shutter open while you follow the action with the camera. This blurs the background while keeping the main subject in relatively sharp focus and gives the image a sense of movement. When you pan a subject, it is best to

be directly parallel to your subject, which helps to produce an image where the subject stays in focus. As the subject enters the frame from either the left or right, press the shutter button and follow the subject with the camera while the shutter is open. Try to keep the subject in the same spot in the viewfinder for the duration of the pan.

For the image in figure 3.13, I used the aperture of f/22 to be able to use a slower shutter speed on a bright day. Because I was moving the camera during the photograph, I wasn't worried about a depth of field that was too deep. I purposely used a slow shutter speed of 1/30 second to capture the motion of the bike rider. I panned left to right as the rider traveled in the same direction.

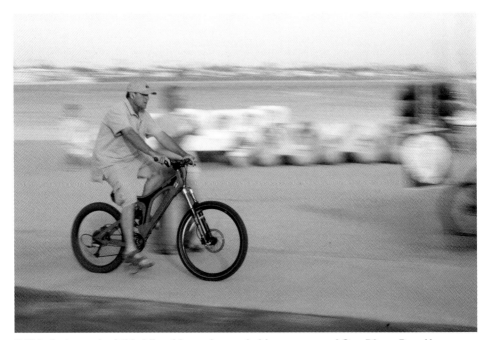

3.13 I photographed this bike rider as he made his way around San Diego Bay. He was traveling much faster than the person walking, and by panning the action, I could capture his motion. Taken at 1/30 second, f/22, ISO 100.

When panning, make sure the background of the image has enough color and texture so the motion is evident. Panning requires a shutter speed of 1/30 second or slower. One of the great things about digital cameras is that you can get instant feedback on your panning techniques without having to wait.

The technique is easy to describe and much more difficult to achieve. The best thing is to practice, but a word of warning: This technique can be a very frustrating exercise, but when it works, it's very rewarding.

Aperture

The aperture is the opening in the lens that light passes through to reach the sensor. By controlling the size of the opening, you can control how much light reaches the sensor. The bigger the opening, the more light is able to pass through. The size of the opening is notated using f-stops. While changing the aperture allows you to change the amount allowed light to travel through the lens, it also changes the depth of field. This gives you control over what is in acceptable focus in your image. Controlling the aperture controls the depth of field and mastering how that relationship works is important in getting the results you want. Because the aperture is in the lens and not in the camera, you need understand prime lenses and variable aperture lenses and the effects that each can have on your photography.

This chain link fence was shot on the streets in New York. I like this photograph because the fence is in sharp focus, but the walls behind them are blurred. Controlling the aperture created this effect. Taken at 1/400 second, f/2.8, and ISO 200.

Controlling the Aperture

With digital cameras, the aperture controls are part of the camera, usually a dial on the front or back that changes the physical size of the opening in the lens, but it usually doesn't physically change the opening until you press the Shutter release button. This allows the most light to pass through the lens making the image in the viewfinder brighter and making it easier to auto focus right until you press the shutter release button.

Understanding f-stops

Lots of mystique surrounds f-stops, and at times, photographers make the explanation more complicated than it should be. The most important part of the equation to remember is the smaller the number, the bigger the opening. I know that sounds backward, but it is this way for a reason. The f-number or f-stop is the ratio between the diameter of the opening in the lens and the focal length of the lens. The actual f-stop is one over the f-number and is shown as f/2.8 or f/5.6, for example; 1/2.8 and 1/5.6. Each f-stop allows in twice as much light as the previous f-stop. Many of today's cameras allow you to adjust the f-stops in 1/3 or 1/2 stop increments instead of a full stop, giving you more control over both the exposure and the depth of field.

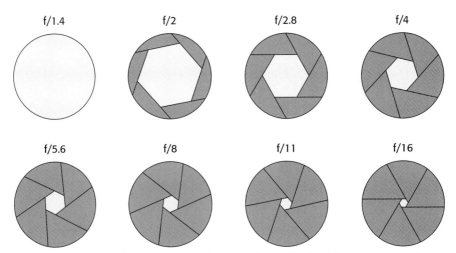

f/1.4 f/2 f/2.8 f/4

f/5.6 f/8 f/11 f/16

4.1 When the aperture closes, the f-number gets bigger. Each of these openings is one stop different from the opening next to it. For example, f/8 lets in half as much light as f/5.6 and twice as much light as f/11.

For example, if you were shooting with a 200mm lens, and you had the aperture set to f/8, the size of the opening in the lens would be 25mm, which is 1/8 of 200mm. To let more light in, you could change the aperture to f/4, which would create an opening of 50mm. The 50mm opening is much bigger than the 25mm opening and lets in more light. Again, the most important thing to remember is that the smaller the number, the bigger the opening.

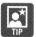 The smaller the f-number, the bigger the opening in the lens and the more light is allowed to reach the sensor.

Camera controls

Every camera is different, but they all give you control over the shutter speed and aperture. You must pick the best combination for any given situation. Many consumer and prosumer cameras include scene modes for different situations. These scene modes usually include settings for action, portrait, and landscape modes, but can include many more. All these give the camera control over your exposures, and although some do a good job, I recommend that you use them sparingly because you get better results using the modes described in the following section. Anything the scene modes can do, you can probably do better. The camera doesn't actually know what it is you are shooting; only you do. The modes addressed in the following sections let you set the f-stop so you control the size of the aperture and the depth of field.

Program auto mode

Program auto mode is very different from full auto mode. The difference is that you can make changes after the camera has selected the exposure settings. When you set your camera to Program auto mode, the camera picks the shutter speed and aperture based on the meter reading from the camera's built-in light meter. This is when it gets good; you simply adjust the aperture if you need to, and the camera automatically adjusts the shutter speed. If you want to get a deeper depth of field then you can adjust the aperture to a smaller opening (bigger f/number) and the camera will automatically use a slower shutter speed.

The advantage to using this mode over full auto mode is the ability to adjust the aperture from the camera's starting point. This is a great mode to use as a way to learn how to adjust the aperture because the camera gives you a starting point. Every camera is a little different; some keep your setting until the camera's exposure mode is changed or the camera is turned off, and others revert to the camera's settings after each shot. You need to check your camera manual to see how your camera handles this.

Aperture priority mode

Aperture priority mode is where many professional photographers have their cameras set the majority of the time.

This mode lets you set the aperture, and the camera then sets the shutter speed based on the meter reading. If you pick a wide aperture, the camera picks a faster shutter speed; if you pick a smaller aperture, the camera uses a slower shutter speed.

This is the mode to use when you want to make sure you control the depth of field, which is discussed a bit later in the chapter.

Manual mode

Manual mode gives you the power to decide the exposure by setting the aperture and shutter speed. I do lots of concert photography and have found that the fast moving lights that not only change direction and intensity but color as well tend to throw off my camera's metering systems. When shooting concerts, I start by setting the shutter speed fast enough to freeze the action and then adjust the aperture to get the exposure I want.

The camera doesn't stop metering even though it isn't picking the aperture or the shutter speed, and your camera will display what it thinks is the correct exposure. The camera doesn't get a say in what settings you use, and although this gives you the most control, it is really easy to overexpose or underexpose images especially in a quick-shooting or rapidly changing situation.

Depth of Field

Depth of field (DOF) is one of the most difficult concepts for beginning photographers to comprehend, and many people never really understand what it does and how to use it effectively. This happens for two reasons: First, most people set the camera on

auto mode and the results are usually fine, so they never bother to learn how to adjust the aperture and never realize the creative potential that they are passing up. Second, most kit lenses that come with new cameras don't open very wide, and beginning photographers never really see the difference between shooting at f/2.8 and f/8 and don't fully comprehend the advantages of controlling the depth of field.

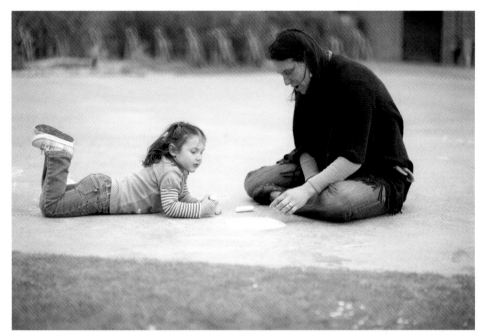

4.2 This shot was taken in a local park. I really wanted them to stand out from the background, so I shot this using 1/8000 second, f/1.6, ISO 200.

Defining the depth of field

In photography, you have only one plane of exact focus, but you have an area of acceptable focus on either side of that spot. The DOF is the distance in front of and behind your subject that is in acceptable focus.

The aperture is the main factor that controls the DOF. A larger aperture (smaller f-number) creates a shallow depth of field, and a small aperture (larger f-number) creates a deep depth of field.

There are two other terms that you will hear that relate to DOF: *circles of confusion* and *bokeh.*

▶ **Circles of confusion.** This has to do with what the human eye perceives to be in focus and at what point that focus starts to blur. What you actually see when you look at a photograph is the captured light that was reflected back at the camera from a subject. Think of the image as being made up of circles of light. When these circles are small, that part of the image appears to be in focus, and when the circles get bigger, the focus gets softer and that part of the image appears to blur. The depth of field is the distance in front of and behind that point where the circles are still small enough to seem to be in sharp focus. Because the circles of light slowly get bigger, you see a natural progression from focused to not focused.

▶ **Bokeh.** This is a term used to describe the quality of the out of focus areas in your image when using a shallow depth of field. It specifically refers to the shape of any points of light in the out of focus areas. This is not a quantifiable description, but a qualitative one. The word is from the Japanese word boke, which means blur and is often used when describing the characteristics of a lens. When a lens is said to have a good bokeh it has a pleasing shape to the out of focus areas.

Controlling the depth of field

The depth of field is controlled by changing the aperture, or the size of the opening in the lens. The smaller the opening in the lens, the greater the depth of field; the bigger the opening, the shallower the depth of field.

Depth of Field Preview Button

Some digital cameras have a dedicated depth of field preview button. When you attach a lens to your camera body, the view through the viewfinder uses the widest available aperture on that lens no matter what you set the aperture to. The depth of field preview button changes the aperture in the lens temporarily to what you have selected so you can actually see the scene with the selected aperture.

The first thing you'll notice when you press the DOF preview button is that the image gets darker. Unless you are checking the DOF at the widest aperture of the attached lens, less light is allowed to reach the sensor and the image gets darker. You'll have more difficulty seeing what's in focus and you may need a few moments for your eyes to get used to the darker view.

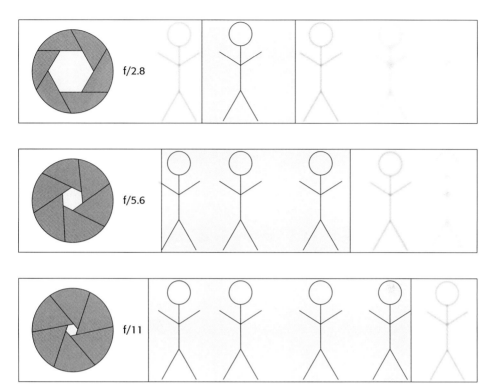

4.3 As you can see from the diagram, the depth of field for f/5.6 is greater than for f/2.8 but less than for f/11. More of the image is in focus (the gray zone) when the opening is smaller.

Two other factors can affect the depth of field: the focal length of the lens and the distance between the subject and the camera.

Shallow depth of field

A shallow depth of field is when only a small amount of the image in front of or behind your main subject is in acceptable focus. This is very useful in making your subject stand out against a background because the viewer's eye is drawn to the parts of your photograph that are in focus. The term *shooting wide open* refers to photographing using the largest aperture possible on your lens. Shooting wide open results in the shallowest depth of field.

Using apertures from f/5.6 result in a shallow depth of field. If your subject is close to a background, one that is within a few feet, you can increase this effect, by moving the subject farther away from the background. You also can get closer to the subject, by moving closer or by using a longer focal length. Either way, the depth of field is

further reduced. For example, in figure 4.4, the depth of field is so narrow that the body of the dog is starting to blur.

Shallow depths of field are also great when shooting sports because you can use faster shutter speeds and make the subject stand out against the background. When you see a great football photo in a magazine or newspaper, you rarely see any background at all, and if you do see any background, it is usually blurred into an unrecognizable mass of color because the photographer used a wide-open aperture.

The negative side of a shallow depth of field is that you often get blurry images. Because the depth of field can be very small, chances are good that the important parts of your image will be out of focus. This is particularly true when using very wide apertures, like f/1.2 through f/2.8. This effect is exaggerated when your subject fills the frame.

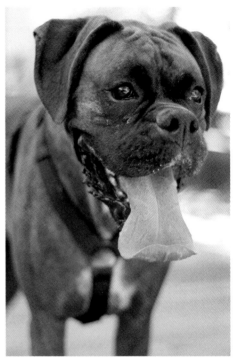

4.4 I really wanted to make sure that the focal point of this image was that long tongue hanging down. I used a very wide aperture in Aperture priority mode to make that happen. Taken at 1/125 second, f/1.8, ISO 100.

Middle depth of field

The middle depths of field are the safe depths of field, meaning that these f-stops — ranging between f/6.3 and f/11 — do not create a shallow or deep depth of field. These apertures are really useful when you want the subject and the background in focus and they are close to each other. This is also useful when you are shooting people who are not standing directly next to each other but one is a little behind the other, as in figure 4.5.

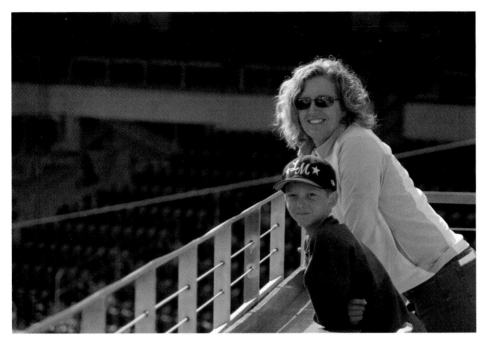

4.5 To get both people in this photograph in sharp focus, I used a middle depth of field. But I also wanted to make sure the background wasn't in sharp focus. You can see how the depth of field changes as the guard rail starts out blurry and ends up in sharp focus. Taken at 1/250 second, f/6, ISO 100.

Deep depth of field

A deep depth of field is created when you use a small aperture. The area of acceptable focus can range from the foreground to the background of your scene. You need to use a deep depth of field when you want everything in your image in acceptable focus. The most common use is in landscape photography, where you want the whole scene in focus. The downside is that using this very small aperture means you need either a very brightly lit scene or slower shutter speeds (which means you need to use a tripod).

For more on landscape photography, see Chapter 8.

4.6 For this image taken in Colorado, I wanted the rocks and fence in front of me and the mountains in the background all in focus. I used Aperture priority mode to make sure the depth of field was deep enough. Taken at 1/125, f/16, ISO 100.

Aperture versus Shutter Speed

Sometimes selecting a certain aperture is more important than picking the shutter speed, so you can control the depth of field for the photo. This is particularly important when you want to have either a very deep or very shallow depth of field. For example, when shooting landscapes it is preferable to get large amounts of the scene in focus, everything from the foreground to the background, so using a small aperture to create a deep depth of field is the only way to do this.

The other side of the equation is that when you adjust the aperture, the shutter speed or/and the ISO has to change as well so that you still get a proper exposure. For example, you want to shoot a landscape early in the morning. Because it is a landscape, you want a very deep depth of field so, you set the camera to Aperture priority mode and set the aperture to f/16, because you are shooting in the early morning this causes the shutter speed to drop to 1/15 of a second. This low shutter speed means that if anything is moving in the scene it will be blurry and, if the camera is not steady

the image will be blurry. It might be possible to increase the shutter speed if you increase the ISO to be able to have the deep depth of field and a fast enough shutter speed to freeze any action.

Other times you may have good reasons for making the background as blurry as possible by using a shallow depth of field. This is particularly true when shooting people in areas that have very busy and cluttered backgrounds. By using a shallow depth of field, you can blur the background to the point where it is unrecognizable, which makes the subject really stand out. When you do go with a very shallow depth of field, you will find that the camera is going to use a very short shutter speed.

Understanding Lens Limitations

The lens is what determines the apertures that are available when photographing. Even though you control the aperture on the camera, the actual opening is in the lens. It is the lens that will determine what range of apertures is available. There are differences in prime lenses, that is those with a single focal length and in variable aperture zoom lenses. Luckily, each lens manufacturer marks its lenses with the maximum aperture or a range of maximum apertures in the case of variable aperture zoom lenses. This allows you to know what apertures you will and won't be able to use with each lens.

Lens speeds

You often hear photographers discussing fast glass. This refers to the maximum aperture of any lens. Lenses that have a maximum aperture of f/4 or wider are considered fast lenses. If you want to know the speed of your lens, just look at the maximum aperture. For example, an 85mm f/1.4 lens is a fast lens with a speed of f/1.4. Suppose you hear a photographer say, "I was glad to have such fast glass, because it let me shoot wide open in the dark church." He means that he was happy to have a lens with a large maximum aperture because it allowed him to photograph even in the low light, as in figure 4.7.

Fast lenses are great for two reasons: First and most important is the ability to shoot in lower light at higher shutter speeds and lower ISOs. Because I shoot lots of concerts, I want and need fast lenses that allow me to use a wider range of shutter speeds in low light. Second, the faster the lens, the brighter the image is in the viewfinder. The viewfinder is much darker when you are using a lens with a maximum aperture of f/6.3 than when you are using a lens with a maximum aperture of f/2.8.

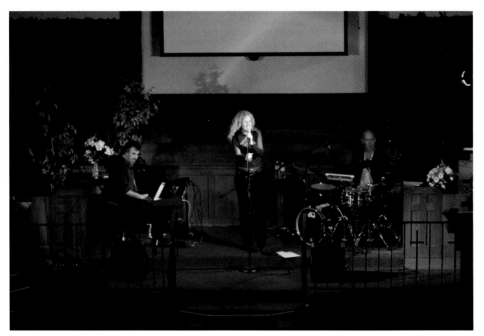

4.7 Using a combination of a very wide aperture and a high ISO allowed me to take this from the balcony of a darkened church. Taken at 1/80 second, f/2.0, ISO 800.

One thing holds true: The faster the lens, the more expensive it is. So you have to decide how important lens speed is to your photography.

When it comes to slow lenses, there are two advantages over fast lenses: the price and the size. Because these lenses are cheaper to make, they are cheaper to buy.

Lens Sweet Spot

To get the best results from any lens, you must know the lens's sweet spot. This is the aperture or range of apertures that results in the best image quality. These sweet spots are different from lens to lens, but most lenses are usually sharpest at the middle apertures and not at the maximum or minimum apertures. That means that although your lens may be able to open all the way up to f/1.4, the sharpest aperture is actually f/4 or f/5.6. Lots of Web sites and publications test and rate lens sharpness, so if you want to know the absolutely sharpest f-stop possible for your lens, consult some of these ratings.

Diffraction

Diffraction is an optical effect that occurs when you use very small apertures. The light, which usually travels in straight lines, gets squeezed when it has to go through a very small opening. The light rays start to interfere with each other, and the image can become slightly blurry.

Photographers use small apertures, such as f/16, to get deep depths of field, such as in landscape photographs. At the smallest apertures, the diffraction effect can cause the focus to be soft. To avoid this I recommend not using the smallest aperture (big f/numbers like f/22) unless you absolutely have to. It also depends on where you are going to show your images. If you are shooting images that will only be seen on a screen or printed at 8 × 10 or smaller then the diffraction won't have a great deal of effect on your images.

Variable and constant aperture lenses

Prime lenses or single focal length lenses have one focal length and a constant maximum aperture. For example, a 35mm f/2 lens has a focal length of 35mm and a maximum aperture of f/2. When it comes to zoom lenses, however, there are two types: those with a variable aperture and those with a constant aperture.

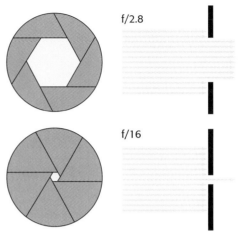

f/2.8

f/16

4.8 As you can see, the light rays have a much smaller space to get through when a smaller aperture is used.

4.9 This 75-300mm lens is a variable aperture lens with a range from f/4.5 at 75mm focal length and f/5.6 at the 300mm focal length.

Understanding the Lens Crop Factor

Today's dSLRs use two sizes of sensors: full-frame and cropped. Full-frame sensor cameras have a sensor the same size as a 35mm piece of film. The images produced by these cameras are the same as the images produced by older 35mm cameras. The other type of sensor is smaller than a traditional 35mm piece of film and is referred to as a cropped sensor. Cropped sensors appear to create an image larger than the equivalent image taken using the same lens on a full-frame sensor camera. Actually, the smaller sensor is recording less of the frame. The question becomes how much less of a frame and what does this mean in practical terms?

To calculate the equivalent focal length between a cropped sensor and a full-frame sensor, divide the diagonal of a 35mm frame by the diagonal of the cropped sensor and then multiply the result by the focal length of the lens. For example, if the sensor diagonal is 1.5 times smaller than the diagonal of the 35mm frame, the quick way to work out the equivalent focal length is to increase the focal length by half. Thus, a 200mm focal length gives you the same image of a 300mm lens, and a 50mm has the equivalent focal length of a 75mm lens.

Telephoto lenses have a real advantage because your lenses used on a cropped sensor camera now get you closer to the action than they would if mounted on a full-frame sensor camera. The disadvantage occurs when using wide-angle lenses. Because they no longer cover all the area that they would on a full-frame sensor, a 20mm lens becomes a 30mm lens.

Variable aperture lenses

Variable aperture zoom lenses have a maximum aperture that changes depending on the focal length used. These lenses use a range of apertures, and that range is marked on the lens itself. For example, a 75-300mm f/4.5-5.6 lens has a focal length range from 75mm to 300mm and a maximum aperture range from f/4.5 to f/5.6. This means that when the lens is used at 75mm, the maximum aperture is f/4.5, and when the lens is used at 300mm, the maximum aperture is f/5.6.

This also happens if you are shooting in Aperture priority mode and you set the aperture to f/3.5 to use the widest available aperture. For example, you want a shallow depth of field to make sure your subject stands out from the background. So you set the aperture to be wide open, but as you zoom in for a slightly closer shot, the aperture

changes, and in doing so, the depth of field changes as well. The image with the nice blurred background is now the image with the background in focus, and again, all you did was zoom in and use a longer focal length.

4.10 Figures 4.10 and 4.11 were taken with the same lens. This one was taken at 1/60 second, f/3.5, at ISO 200, with the lens at 24mm.

4.11 Here, you can see that as I zoomed in, the aperture changed from f/3.5 to f/5.6 automatically. Taken at 1/10 second, f/5.6, ISO 200.

If variable aperture lenses can cause so much work for photographers, why are they so popular and why do camera and lens companies keep making them? The answer is twofold: The first part is straight economics — the variable aperture lenses are cheaper to make and cheaper to buy. The creation of these cheaper zoom lenses has put more lenses in the hands of more people than ever before. No longer are you limited to expensive prime lenses or very expensive constant aperture zoom lens. The second reason is the size of the lens. The variable aperture zoom lenses are also called compact zoom lenses. They take up much less space than the constant aperture equivalent. I can tell you from personal experience that carrying around the 18-200mm f/3.5-6.3 lens is much easier than carrying around the 17-35mm f/2.8, the 24-70mm f/2.8, and the 70-200mm f/2.8 lenses that would give me close to the same focal length coverage.

When using a variable aperture lens, keep these things in mind to get the best exposure:

▶ When zooming in closer, raise the ISO to keep the shutter speed high enough even when the aperture is made smaller.

▶ When a shallow depth of field is important, keep the lens at the widest focal length, and instead of zooming in, try to physically get closer.

▶ Use a tripod and slower shutter speeds with the smaller apertures to get the exposure you want with low ISOs to avoid digital noise.

Landscape photography is the one place where you can use the variable aperture lenses to the best of their ability without worries. When shooting landscapes, you want a deep depth of field, so the aperture setting you are using is usually much smaller than the widest aperture available on a variable aperture lens.

Constant aperture lenses

All prime lenses are constant aperture lenses; that's one of the advantages to prime lenses. Some zoom lenses also are constant aperture, meaning that the maximum aperture of the lens stays the same no matter the focal length of the lens. Most of these lenses are also considered fast glass and usually have a maximum aperture of f/2.8 or f/4.

Constant aperture zoom lenses are usually considered professional lenses. They usually have better build quality and are bigger (to be able to have a maximum aperture of f/2.8) and heavier. And they are usually much more expensive. So why do the pros use these lenses?

▶ The constant aperture throughout the range of focal lengths means that the exposure settings are the same throughout the range of focal lengths if the light is the same.

▶ They work better in low light because they usually have a wider aperture than the variable aperture lenses.

▶ The image in the viewfinder is brighter and the camera can autofocus more easily because of the amount of light that can reach the camera through the wide aperture for all the focal lengths.

Depending on what you shoot, these lenses are either a necessity or a luxury. If your photography tends to take place in low-light situations, like concerts or weddings, or if you are going to be shooting fast-moving subjects that are not really close, like sporting events, then you want to use a constant aperture zoom lens.

4.12 I used a 70-200mm f/2.8 zoom telephoto lens to get up close and personal with a giraffe at the local zoo. I also wanted to keep the background as blurred as possible to remove any distracting background elements. Taken at 1/1000 second, f/2.8, ISO 200.

One of the most widely used constant aperture zoom lenses is the 70-200mm f/2.8 lens. Canon makes one, as do Nikon, Sony, Tamron, and Sigma. As you can see from figure 4.13, the size difference between the Nikon 70-200mm f/2.8 and the Sony 18-200mm f/3.5-f/6.3 is huge. This is just a matter of what is convenient and easy to use. Carrying around a lens that size when on vacation or just out for a walk is a commitment.

4.13 Here are the Nikon 24-120mm f/3.5-f/5.6 and the Nikon 70-200mm f/2.8 compared to the Sony 18-200mm f/3.5-f/6.3. Even when the Sony lens is zoomed out to 200mm, it doesn't come close to matching the size and weight of the 70-200mm lens.

Macro lenses, aperture, and depth of field

When it comes to close-up and macro photography, even when using very small apertures, the depth of field can be less than an inch. Because the distance between the lens and the subject is so close and the magnification is so great, the depth of field is incredibly shallow.

You need to use a much smaller aperture to get the deepest depth of field possible. The problem with this is that using a small aperture means you have to use a slower shutter speed, which means that you could get blurry images.

Suppose you are going to shoot a macro of a flower. You set the camera to Aperture priority mode and set the aperture to a safe f/11; the camera meters the light and selects a shutter speed of 1/60 second. This shutter speed is fine, as long as your camera is set on a tripod and the flower is not moving much. Because you are working very close to the flower, even the slightest movement will translate into a blurry image. Now you realize that because you are taking a macro photograph, the depth of field really needs to be increased as much as possible to get the image in acceptable focus from near to far. When you adjust the aperture to a smaller opening, you have to leave the shutter open longer. These slower shutter speeds can cause you to get a blurred shot because during the time the shutter is open, the camera and flower need to be absolutely still. For figure 4.14, I had to wait until no breeze was blowing because of the slow 1/8 second shutter speed. I actually had to increase the ISO to 500 to get that shutter speed.

4.14 This macro of a flower was taken with a very deep depth of field to get all the petals in sharp focus. Taken at 1/8 second, f/45, ISO 500.

When you increase the depth of field in macro photography, you also increase the odds that the background will start to come into focus. When the subject is very close to the background, which means that as the subject comes into the depth of field, so does the background.

You can't do anything about this except to recompose the photo in a different way that avoids getting a bad background.

ISO

What is ISO, and how does it affect exposure? Changing the ISO doesn't change the amount of light reaching the camera's sensor; rather, it changes the sensitivity of the sensor to the light that is reaching it. In simple terms, the ISO defines how sensitive your camera's sensor is to light. Understanding what ISO is and when to change it is very important, yet for many photographers. Using the wrong ISO can have devastatingly negative effects on your image; while picking the right one can help you capture images better than ever before. Understanding the relationship between the ISO and light sensitivity, digital noise and more importantly, how to reduce it are all covered here along with the best times to use the high ISO capabilities of your camera.

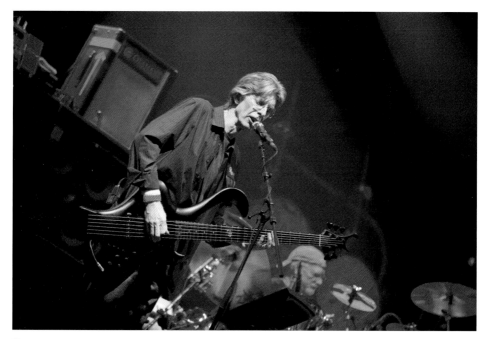

To get this photograph of Phil Lesh, bass player for the Grateful Dead, I made sure I was using a shutter speed fast enough to freeze the action and still get a good exposure. This meant shooting at 1/200 second, f/2.8, ISO 1600.

Understanding ISO and Light Sensitivity

To discuss ISO properly and the light sensitivity of a digital camera's sensor, we have to go back to the days of film, and more importantly, we need to discuss the different film speeds and their sensitivity to light. The ISO (International Organization for Standardization) rating that replaced the older ASA (American Standards Association) rating measures how sensitive the film is to light. The higher the ISO number, the more sensitive the film is. This rating was based on the same stop values as shutter speed and aperture, with each doubling of the ISO being one stop more sensitive to light. For example, ISO 400 is twice as sensitive to light as ISO 200, and ISO 800 is half as sensitive as ISO 1600. This was accomplished in film by changing the silver halide in the film's emulation. The bigger the grains of silver halide were, the more sensitive to light the film was. This method had two downsides: The bigger the grains were, the more you could see the grains in the final product, and the faster or more sensitive to light the film was, the grainier it was. Fast films were used to shoot in low-light areas or when really fast shutter speeds were needed.

The exact same principles apply in digital photography as in film photography, but instead of rating the film in the camera, the ISO refers to the sensitivity of the sensor. Changing the ISO from 100 to 200 doubles the sensitivity of the sensor to light. But how does it do that?

Because the sensitivity of the actual sensor can't change, the camera manufacturers came up with a different way to change the ISO. The computer in the camera amplifies the signal from the sensor, creating the range of ISOs. The more the signal is amplified, the less light is needed on the sensor.

The amount the signal is amplified is calculated to match the characteristics of film. So the settings used when taking a photo using ISO 200 film are the same when using a digital camera set to ISO 200. When it comes to ISO, some technology is important to getting the best results.

In the same way that fast films were very grainy, high ISO settings require the signal from the sensor to be amplified quite a bit, creating images with lots of digital "noise." Digital noise and ISO are directly linked. The higher the ISO, the more noise is present. Digital noise is covered later in this chapter, including different ways to minimize its effect on your images. If the camera sensor measures at ISO 200, and you have selected ISO 800, the camera has to multiply every bit of information by 4 to get the right light strength. However, because the sensor is imperfect, chances are one of the measuring pixels might be off by a fraction unnoticeable at ISO 100, but very obvious at ISO 800. The light is multiplied by 8, meaning the tiny imperfections are also amplified 8 times.

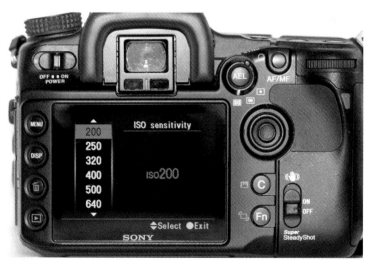

5.1 Each roll of film is clearly labeled with the film speed or ISO, with choices of ISO 50, 100, 400, 800, 1600, and 3200. Each time you wanted to change the ISO, you needed to change the roll of film. On today's cameras, you can change the ISO with the press of a button as shown here with menu choices on the Sony A700.

Two different types of sensors are used in digital photography: CCD, or Charge Coupled Device, and CMOS, Complementary Metal Oxide Semiconductor. Both have plusses and minuses, and both have digital noise. The difference is that the CMOS sensors use less power than the CCD sensors, which helps to keep the digital noise to a minimum. This doesn't mean that you should avoid all CCD sensors or that all CMOS sensors are better, but if everything else is equal, the CMOS sensor has less noise at higher ISOs.

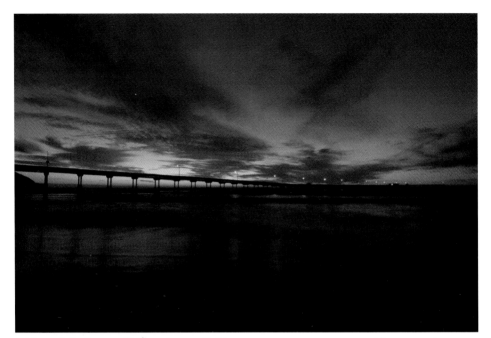

5.2 I used the lowest ISO setting available on my camera to capture this sunset. I wanted to use a slow shutter speed, so I used a small aperture and low ISO. Taken at 3 seconds, f/16, ISO 100.

The sensor chip in your camera is covered with pixels that record the light that strikes them; actually, they measure the photons that reach the sensor, and the bigger the pixel, the more light (or photons) it captures. This doesn't make the pixel more sensitive to light, but it does decrease the amount of noise.

The bigger the sensor, the more space is available to use the bigger pixels and spread out those pixels so the heat created on the sensor is dissipated quickly. This also helps in reducing the noise and is one of the reasons that cameras with the best high ISO/low noise capabilities are full-frame sensors, but not the leaders in the mega-pixel race.

One of the biggest advances in digital cameras has been reducing noise in the high ISO range. When Nikon announced the D3 in 2007, the photography world was amazed at the ability of this camera to shoot at very high ISOs with relatively little digital noise. The range of ISO on the D3 is from ISO 200 all the way to ISO 6400, and the camera has the option of a Lo-1 and Hi-2 giving the camera an expanded ISO range from ISO 100 all the way to ISO 25,600. Images taken using ISO 25,600 have a tremendous amount of noise, but these ISOs were not even possible a few years ago. Other camera companies have also improved the high ISO capabilities of their cameras, and the digital noise that was so prevalent a few years ago has been vastly reduced. Canon has followed up with EOS 5D Mark II, which many pros love for its low light/high ISO capabilities.

Being able to change the ISO on your camera makes setting and changing the ISO really easy; you can change the ISO between every shot if you want. This wasn't possible before, but the convenience has a downside: The ISO characteristics are built into the camera and can't be changed.

Digital Noise

Digital noise is the by-product of amplifying the sensor information and has very few redeeming qualities. When digital noise is introduced into your image, unwanted color spots appear, especially in darker areas and in places with smooth tones.

Digital noise varies from camera to camera and can be produced from a variety of sources. These things can introduce digital noise into your image:

- ▶ **ISO.** Increasing the ISO increases the noise; the higher the ISO, the more noise you get.

- ▶ **Exposure time.** The longer the shutter is kept open, the more noise is introduced into the image. This is particularly true when the exposures are over a few seconds.

- ▶ **Sensor size and megapixels.** A higher megapixel count means more light sensors are crammed onto a sensor chip, and your chances of getting noise are greater. Smaller sensors tend to have more noise than the larger sensors.

- ▶ **Sensor type.** Different types of camera sensors have different noise capabilities.

5.3 These three images show the different amount of noise that can be present as the ISO increases. The top image was taken at ISO 6400, the middle at ISO 1600, and the bottom at ISO 200. The noise is especially noticeable in the dark areas of the image taken at ISO 6400.

High ISO Noise Reduction

Sometimes you have to use high ISOs because you can't capture the image in any other way. This is particularly true when shooting in low light, where you can't reduce the shutter speed or the image will be blurry, and when you use a wider aperture because the lens doesn't open any wider or you absolutely have to have a certain depth of field. You can reduce the noise in your image both in the camera and using software during the post-processing of your images. This section covers things you can do to minimize noise when taking photos.

Noise reduction through exposure

The most important thing to understand is that digital noise is more visible in the dark areas of your image. You can use this information to reduce the effects of digital noise in your images, especially those using long exposures.

5.4 I purposely overexposed this image just a little to reduce the noise that results from using a very high ISO. Taken at 1/500 second, f/14, ISO 3200.

Slightly overexposing the image helps to reduce the noise in the darker areas of your images. That helps with the noise, but it may not be practical. You likely are using the higher ISO setting because of a low-light situation.

Noise reduction using software or camera settings

Many digital cameras come with settings to help reduce the noise while the file is still in the camera. This in-camera noise reduction can usually be applied to those images taken at high ISOs and when using slow shutter speeds. Not every camera has these settings, so be sure to check your camera's manual.

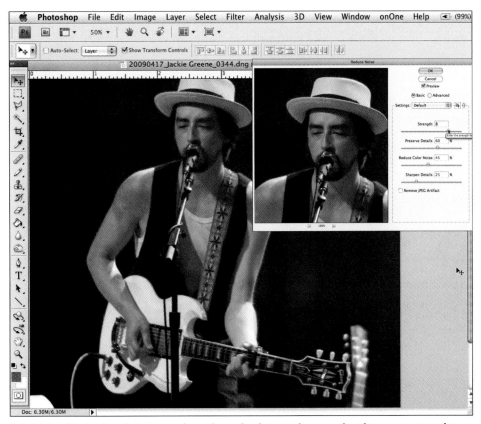

5.5 Adobe Photoshop lets you reduce the noise in your images, but it comes at a price, usually sharpness. As the noise is reduced, so is the fine detail, and you must determine the balance between the two.

The built-in noise reduction comes with a cost; it uses more battery power and takes longer for each image to be processed by the camera. The noise reduction also can cause degradation to the sharpness of the image. It is a personal choice whether to use the built-in noise reduction, and will depend on how you process your images. The built-in noise reduction is designed to produce usable images at high ISOs directly from the camera when using the JPEG file type.

The built-in noise reduction also has the advantage of being applied directly to the information from the sensor. Even with the built-in noise reduction turned on, you may want to use a software noise-reduction program.

Noise-reduction software is big business. Adobe Photoshop has noise reduction built in, as does Apple's Aperture and Adobe Lightroom. Separate software packages like Nik Software's Dfine and PictureCode's Noise Ninja software are available.

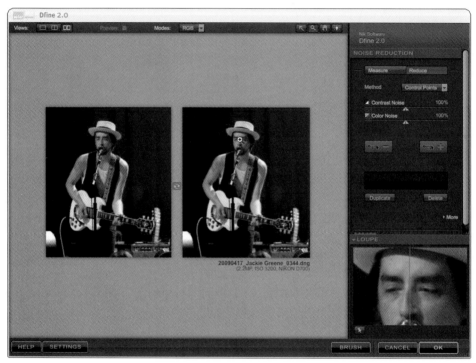

5.6 Nik Software's Dfine 2.0 measures the noise in your image and automatically applies noise reduction that can then be adjusted. You still have a trade-off between image quality and noise reduction; the more the noise is reduced, the more the image quality suffers.

Using a Higher ISO

I like keeping my ISO as low as possible because I want to keep my images as noise-free as possible, but sometimes noise just can't be helped. The most common time to increase the ISO is when you have no other choice, unless you are purposely using the ISO noise creatively.

 For more on creative ISO usage see Chapter 13.

The simple answer of when to boost the ISO is this: when you need to. When light is too low to use the shutter speed you want or you need to freeze your subject or you want to choose an aperture, you can boost the ISO.

Suppose you want to photograph a group of children playing outdoors in the bright sun. You can use ISO 100 and a shutter speed of 1/100 second and an aperture of f/16.

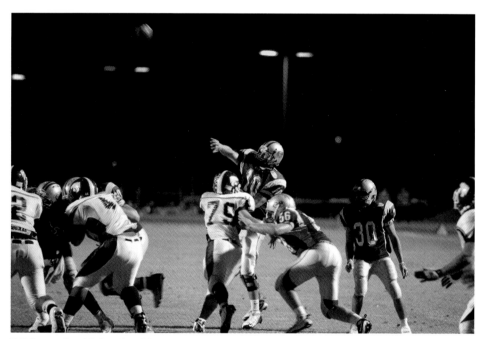

5.7 Capturing high school football on a Friday night meant I had to push the ISO to use fast shutter speeds to capture the action. Taken at 1/250 second, f/2.8, ISO 2000.

As the sun goes down, you can start using wider and wider apertures to compensate for the falling light. You don't want to lower the shutter speed since your goal is to photograph the children running and playing, and a slower shutter speed results in blurry photos. When you have opened the lens to the widest it can go, the only way to still use a 1/100 second shutter speed is to increase the ISO. Each time you double the ISO, you need half as much light to get the same exposure.

As mentioned, different cameras have different high ISO capabilities, and deciding the highest usable ISO for your camera is a personal choice. Some photographers rarely shoot

above ISO 400 while others routinely use ISO 1600 and higher; I often shoot at ISO 800 or higher, sometimes much higher, when photographing concerts.

All cameras are different, and you may be able to get away with higher ISOs and still have low noise, but keep these guidelines in mind for your best chance at getting good shots:

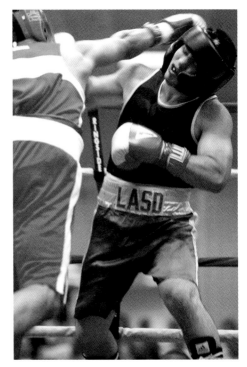

▶ **ISO 100–200.** Really low noise; not noticeable at all; great ISO for portrait, landscape, and general photography.

▶ **ISO 300–400.** Low noise; not really noticeable unless seen at very big sizes; good general photography.

▶ **ISO 500–800.** Noise is present but generally acceptable; good for shooting low-light situations where faster shutter speeds call for higher ISOs.

5.8 I shot this using a camera on which I couldn't go higher than ISO 1250 because the noise became too pronounced. Taken at 1/250 second, f/1.4, ISO 1250.

▶ **ISO 800–1600.** Noise is present and can be acceptable depending on the camera, but is noticeable in the whole image. This range is usually used for darker situations and times when using a flash is not possible and slow shutter speeds do not work. This is the ISO range I often use when shooting live music events.

▶ **ISO 1600 and higher.** Noise is very noticeable, and unless done on purpose, it needs to be reduced with software or in-camera settings. This ISO range is used for very-low-light situations, and in nearly every case, you need to use extensive noise-reduction to get a usable image.

The good news about ISO settings is that camera manufacturers are working hard to decrease the digital noise present at higher ISOs. I am absolutely amazed at the difference in the cameras today compared to those of a few years ago. It will change the way photographers shoot in low light and in any light.

With these changes in ISO, you can use shutter speed and aperture combinations that just a few years ago would have seemed impossible. Shooting outdoors, you can use fast shutter speeds and deep depths of field no matter what the light.

Event
Photography

Event photography runs the gamut from shooting family birthday parties and local parades all the way to covering large conferences and even photographing concerts. And though the events may be very different, the planning involved to photograph them is very similar. I approach each event in the same way, with the goal of capturing the excitement of the event with my images. To get the best images, you need to adjust for the changing light and conditions automatically because you usually don't get second chances.

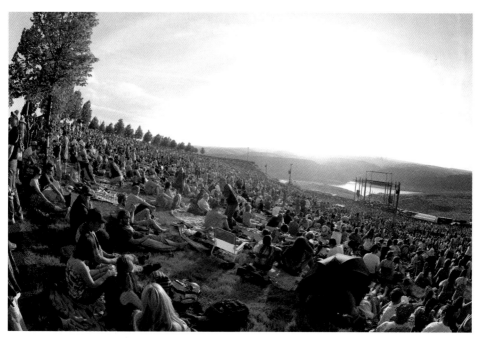

This great outdoor venue in the Pacific Northwest was photographed at 7 pm, but because the venue faced west, I was shooting directly into the sun. I used spot metering on the crowd and avoiding the bright sun, I got the exposure right on. Taken at 1/250 second, f/8.0, ISO 200.

Exposure Considerations

In most types of photography, you can control when to shoot, and in doing so, you get to pick the best light. With landscape photography, that's early morning and late evening; with portraits, you have control over the light by using studio strobes or light shaping tools or by shooting in that great early morning/late evening light. When it comes to shooting events, you have no control over the time or light, and you don't get second chances. This makes most event photography quite stressful. The key behind shooting events — and it doesn't matter whether it's a parade or a birthday party — is to be prepared for the light at the event. If you know you are going to be shooting in the middle of the day, you must deal with different problems than when shooting in the evening. Knowing that you will be indoors or outdoors makes a huge difference in how you shoot. You may run into lots of restrictions when shooting certain events; knowing these helps determine your approach.

Shooting outdoors

Lots of events happen in the great outdoors: parades, street fairs, concerts, and parties, to name a few. These events can be categorized according to when they take place; some happen in the middle of the day and some in the early evening. For example, our local holiday parade starts at sunset, and by the time the last float has made its way down the route, the sun is long gone and the sky is dark. Each of these lighting conditions needs to be addressed because even though it all takes place outside the techniques for dealing with the different lights are different.

Using available light

Shooting during the day, especially in the middle of the day, means you likely will have tons of bright light. Actually, because you are shooting during the brightest time of the day, you may have too much light. The very bright light makes for problem exposures if not dealt with correctly. There are two important parts to dealing with the bright light, the first is to use the best metering mode for the job and the second is to pick the right exposure mode.

Your camera's built-in light meter tries to set the exposure to get an average for the whole scene, which causes the subject to be underexposed so the bright sky is properly exposed. The secret to getting a good exposure in these situations is to meter only for the parts that you care about and pick the best metering mode for the situation.

The same scene metered with Spot metering, compared to Center-weighted metering compared to the Scene metering will all give different results. Picking the right metering mode can make all the difference as can be seen in the difference between the following two images.

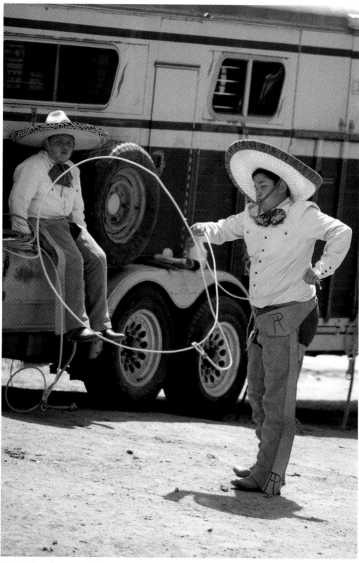

6.1 This photograph was taken at 1 pm, when the sun was nearly directly overhead, as you can see from the shadow around the young cowboy's boots. I positioned myself so the background would be anything other than the sky. Taken at 1/640 second, f/3.2, ISO 100.

For more on the metering modes, see Chapter 1.

Picking the best metering mode is only half the equation; the second and possibly more important part is the exposure mode that you use. Program auto mode seems like the easiest, and most of the time, this gives you great results, especially when shooting in bright sun. I like to set the ISO to 200 and the camera to Program auto, and just shoot away. This mode starts to give undesired results when the shutter speed drops too low to freeze the action. When a camera is set to Program auto, the camera tries to use middle of the road apertures and shutter speeds, so it picks 1/250 at f/5.6 over a higher shutter speed and wider aperture. That's when I switch to Shutter speed priority and make sure I am using a shutter speed fast enough to freeze the action. Then the camera picks the aperture based on the metering mode.

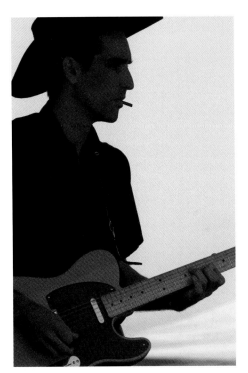

6.2 This guitar player was photographed at an outdoor concert where the background was very bright. When I used the Program mode and the Scene metering he is very dark but the sky is blue. Taken at 1/160 second, f/6, ISO 100.

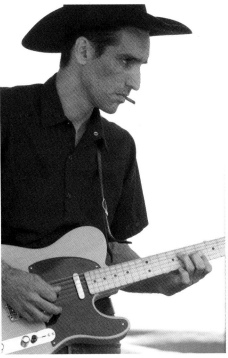

6.3 The same guitar player shot a few moments later but using the Spot metering mode yielded a better exposure of the player, but the sky is severely overexposed. Taken at 1/125 second, f/5.6, ISO 100.

Using a flash

Events taking place outdoors during the day are perfect for using a little fill flash to help reduce the harsh shadows that can form with direct overhead lighting. I know using a flash in very bright lighting seems like an odd choice, but the point of the flash light is not to fully light your subject. Its purpose is simply to even out some of the harsh shadows.

CROSS REF

Fill flash is covered in more detail in Chapter 2.

I don't use the built-in flash on my camera very often; I prefer to use a dedicated flash unit so I can adjust the angle of the light and diffuse it if needed. When I am close enough to use a flash outdoors as fill light, I use the scene metering mode and Program auto exposure mode with the flash compensation turned down by a full stop. I don't want the flash to overpower the subject, just help a little with the shadows. By adjusting the angle of the flash, I can control how much light actually reaches the subject.

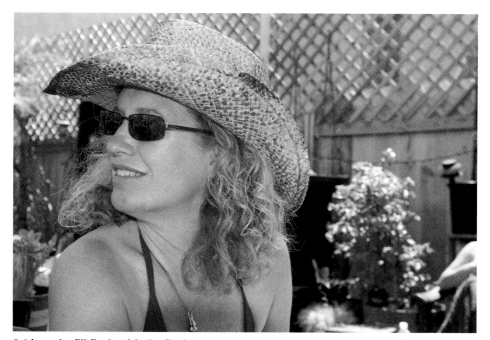

6.4 I used a fill flash with the flash exposure set to –1 stop to get the even light on Nadra's face. The shot was taken outdoors in midday, and the shadows from her hat covered her whole face. Taken at 1/320 second, f/5.0, ISO 200.

Some events can offer great photo opportunities, and you need to be ready so you can take advantage of them. When I shoot at a party or event, I make sure I always have the flash mounted and fresh batteries loaded.

Shooting in low light

Shooting events outdoors in the evening and at night means less light and more of a balancing act when it comes to your exposures. Using a flash may be possible, but sometimes you are not allowed to use a flash or your distance from the subject makes a flash useless. The dedicated flash units are powerful, but even they can't reach far and wide enough to light up a whole parade, so you should try to get the best exposure without using a flash. You do this by using a wider aperture, reducing the shutter speed, or raising the ISO — or a combination of all three.

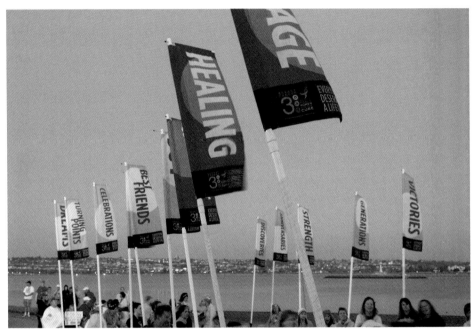

6.5 The 3-Day Breast Cancer Walk for Susan G. Komen for the Cure and the National Philanthropic Trust Breast Cancer Fund takes place around the country every year. I captured these inspirational banners at the end of the first day's walk. Taken at 1/5 second, f/3.5, ISO 320.

The first thing to know is how high you can set the ISO on your camera and still get an image that has an acceptable level of digital noise.

The newer cameras allow for higher ISOs and lower noise, so setting the ISO to 1600 is now something I do all the time instead of only in emergencies. With an ISO of 1600, I can still use a fast enough shutter speed and get a pretty good depth of field. I set the camera to scene metering and Shutter speed priority to make sure the subjects don't look blurry. As the light fades, the camera uses wider and wider apertures until it has reached the widest available aperture of the lens attached to the camera.

 Digital noise is covered in more detail in Chapter 5.

 When using a variable aperture lens, keep in mind that the widest aperture can change depending on the focal length used.

Shooting inside

You usually have less light indoors than outdoors, which makes getting a proper exposure more difficult. You can shoot photographs inside in two ways: using the available light and supplementing that light with a flash or two.

Using available light

Getting the best exposure inside using the available light can be really tough. I wish I could tell you what settings to use, but it doesn't work that way. Every situation is different, and you must determine the most important part of the photo.

For figure 6.6, I wasn't focusing on the leader of the seminar but on the size of the crowd. I needed to make sure that the whole room was lit, and the only way to do that was to increase the ISO and use a slower than normal shutter speed. The people are slightly blurred with the 1/4 second shutter speed, but the goal was to show the room. Because the folks were sitting and not moving much, the slower shutter speed worked great.

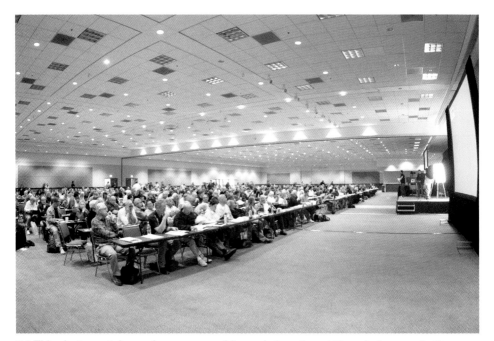

6.6 This shot was taken using a super-wide-angle lens to get the whole room in the shot. The white balance was adjusted to make the colors seem natural. The scene was too big to light with a flash, so I needed to handhold the camera and use a higher ISO and the widest aperture available to get the whole room properly exposed. Taken at 1/4 second, f/2.8, ISO 640.

Using a Flash

Sometimes when shooting inside, you can use a flash. Controlled use of a flash can really help produce great event and party photos, but you must make sure that the white balance is set to match the ambient light and that you use a gel on the flash to match the ambient light. Three things can improve your images when using a flash with your indoor event photos.

Checking the exposure

When you shoot portraits, you can check the exposure and shoot again if necessary. When it comes to shooting events, you can check the exposure of your subjects, but the event keeps moving. You need to get the exposure right the first time or learn how to check the exposure and make adjustments quickly.

6.7 This informally posed photo was taken during a party for the Billy Idol *Idolize* album. I used a dedicated flash with a diffuser dome angled over their heads to get more natural light. Notice that no hard shadows appear on the wall behind them. Taken at 1/30 second, f/5.6, ISO 400.

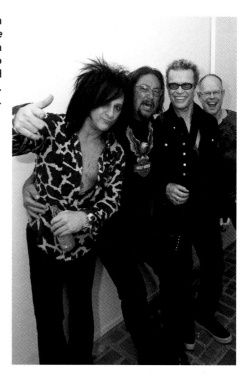

Using the different modes available on the histogram preview lets me focus on the important areas quickly and lets me know if I need to let more or less light in. When I shoot people, I want to make sure they are properly exposed; when shooting in the middle of the day, the chance of overexposure is always present. This is the best time to use the highlight warning. With this feature turned on, the areas of your image that are too bright or pure white blink white and black. If this happens, the quickest and easiest way to fix it is to increase the shutter speed.

Another great way to quickly check the exposure is to see if the histogram matches the scene the same way you actually see it.

For more on histograms, see Chapter 1.

Concert Photography

Concert photography is all about capturing the energy produced by the musicians on stage. The rush as the house lights go down and the stage lights come up is great. However, the limited amount of time allowed and the rapidly changing lights and fast moving subjects make for a very difficult shoot.

Getting the correct exposure in concert situations is a five-part process:

1. **Use manual exposure mode.** Set the camera to Manual exposure mode. This gives you total control over the exposure settings and keeps the camera's built-in light meter out of the equation.

2. **Set a base exposure.** Set the ISO to 1600. I used to start at ISO 800, but with the improved ISO capabilities, I have found that 1600 is a great compromise between the low light capability and acceptable noise. I set the shutter speed to 1/160 and the aperture to f/2.8.

3. **Shoot and check.** The biggest advantage with digital photography to concert photographers has been the ability to quickly check your image on the camera before taking the next shot.

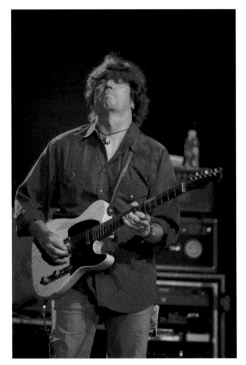

6.8 Guitarist Mark Karan plays lead guitar during a New Year's Eve show. Taken at 1/100 second, f/2.8, ISO 1600.

Right as the music starts, I take a quick frame and preview the image on the camera using both the image preview and histogram. The whole image preview is easier to determine if the exposure settings are close, and the histogram is better when determining whether I have any really overblown highlights.

4. **Adjust and shoot.** If the main subject of the image is well lit, I shoot away until the lighting changes. Then I go back to Step 3. If the image is underexposed, I usually drop the shutter speed by a stop and shoot again. If the image is overexposed, I increase the shutter speed. I keep shooting and checking until I have the exposure I like for that lighting setup.

5. **Change with the lights.** When the lights change, I try to judge the intensity compared to the previous lighting setup. Brighter light means faster shutter speeds; dimmer light means wider apertures, slower shutter speeds, and higher ISOs. The key is to get fast at deciding how much to adjust the current settings. This is where practice helps, because the more you shoot, the better you get at figuring out the best settings for the current light.

Keep in mind that concert photographers get, on average, the first three songs to take all their photos, and that time can go by really fast. Some other things to keep in mind when shooting concerts include:

▶ **Fast lenses.** These are not a luxury but a necessity when it comes to shooting concerts. Maximum apertures of f/2.8 are needed to deal with the low lighting situations. I usually carry at least two lenses, a 70-200mm f/2.8 lens and a 24-70mm f/28 lens. This allows me to cover the focal range from 24mm through 200mm all with a maximum aperture of f/2.8.

▶ **Photo credentials.** People often ask how to get those elusive credentials that allow cameras into venues. The best advice I can give is to start at the local level by shooting bands in smaller venues where cameras are allowed. This does two things: It helps you build a portfolio, and because the light is usually terrible, it also helps you get better at determining the correct exposure settings in low light. After you have a portfolio, you can approach local magazines and papers and work on getting credentials.

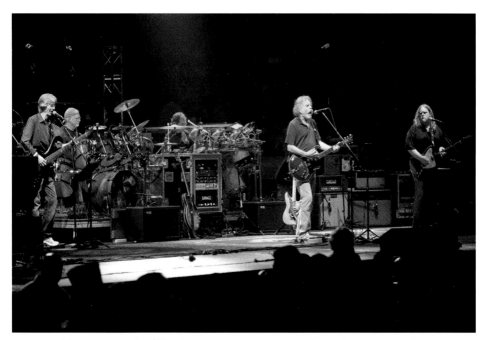

6.9 I got this photograph of The Dead in concert, but not from the photo pit. I wanted to get a different perspective, and I didn't want to be in front of the folks who had managed to get those front-row tickets. Taken at 1/200 second, f/2.8, ISO 1600.

▶ **Know your camera.** Concerts typically have very little light to let you see what you are doing, so you must know your camera and its controls and be able to use it in the dark. You need to be able to change the settings and know how to change lenses and the memory card. Remember that you typically have only the length of three songs to shoot, and you don't want to spend that time fumbling with your gear.

▶ **Respect the concert-goers.** The most important thing is not to get in the way of the people who paid to go to the show. The audience is the most important thing at the concert, so you need to make sure your work doesn't interfere with their enjoyment of the show.

The Right Equipment for the Job

In the opening paragraph of this chapter, I said that one of the most important things that an event photographer can do is be prepared. Many times when you're shooting events, your photo opportunities are limited due to physical barriers or other rules that limit your photography. Knowing what the rules and limitations are before you even pack your camera bag can help make the shoot a success. And knowing what you are going to photograph lets you pack the right gear.

If you know the subjects you want to shoot are close up or far away, you'll be prepared to bring the right lenses, and knowing whether it takes place inside or in low light helps you know to bring a fast prime lens or an extra flash. Knowing how long the event lasts and how many images you think you will be taking lets you make sure you have enough memory cards and batteries for the whole event.

Camera

If you are going to shoot low light events, events in the evenings or indoors where flash photography is not allowed, or concerts, get a camera that has low noise at high ISOs. Shooting in low light and freezing the action means using high ISOs; you just can't get around it. The bright side is that camera manufacturers have improved and continue to improve their cameras in this regard, and the cameras available now are much better than ones released just a few years ago.

When shooting events, it is nice to have a camera with a large buffer capacity so that you can keep shooting and not miss a shot. The buffer in your camera is a special holding area where the image data goes after the sensor captures it and before it is written to the memory card. This buffer is plain old computer memory, and its basic function is to allow the camera to take more photos as the previous images are written

to the memory card. This is how your camera is able to take photos in burst mode. The first digital cameras didn't have this, so you had to wait until the image data was written to the memory card before you could take the next photo.

The bigger and more efficient the buffer, the more photos you can take before you have to stop and wait for the buffer to empty to the memory card. You should know how long this is because you don't want to miss a shot while waiting for the buffer to empty.

Lenses

Event photography covers a wide range of situations, and which lens best matches your needs is determined by two factors: the distance between you and your subject and the available light. Picking the right lens is important, and knowing about fast lenses and telephoto, zoom and prime lenses is important.

Fast lenses

These lenses allow you to shoot with wider apertures, letting you use faster shutter speeds in lower light. They also are more expensive, bigger, and heavier than their slower counterparts. Fast lenses are usually better than slower lenses in just about every way except for the price. The real question is whether you actually need a fast lens. You don't need fast lenses when shooting events that take place in bright lights, and you can easily use one of the variable aperture lenses with ease.

If your event photography is going to take you into situations where you will be shooting in low light, you want to get a fast lens. Beginners often ask how to shoot a child's play or musical recital and get sharp photos. This is a tough task because most people don't have lenses fast enough and don't set the camera properly. The first thing to understand is that the variable aperture zoom telephoto lens that came with the camera is not well suited for this task. The narrow opening is just too small to let in enough light at the faster shutter speeds, so you need a fast lens. The second part is to get close so you don't need a long telephoto lens. Try to photograph from as close as possible, and respect the other parents by staying to the sides of the room. This way, you don't disrupt their view.

When shooting in a darkened auditorium, these tips can help you get the best results:

▶ For most plays and recitals, set the ISO to 1600; you'll get some digital noise, but it can't be helped. If the lights are really low, you may even have to raise the ISO to 3200.

▶ Set the metering mode to Spot metering and the exposure metering to Shutter speed priority mode.

▶ Set the shutter speed to 1/120 second or something close to it.

▶ Focus on your subject's face, and take the photo. This forces the camera to use an aperture wide enough to get the best exposure on the child's face. Check the image on the LCD. Zoom in on the face, and see if it is in good exposure. If it is, keep shooting; if it isn't, increase the ISO and/or decrease the shutter speed. Remember that you are trying to get a sharp photo, so you don't want to slow the shutter speed too much.

6.10 A sixth-grade graduation is probably not the most glamorous photography, but it is important to the parents and graduates. Getting a good shot here takes a real balancing act between shutter speed, aperture, and ISO. For this shot, I waited until the moment with the least movement. Taken at 1/50 second, f/5.6, ISO 1250.

Having a faster lens would have helped me with figure 6.10 because I could have lowered the ISO and increased the shutter speed. The lens I used had a maximum aperture of f/5.6 at the chosen focal length. It would have been great to have a telephoto lens; a fast 50mm prime would have worked, especially in this smaller school auditorium, and they are much smaller, lighter, and cheaper than the slower zoom lenses.

Telephoto and zoom lenses

Telephoto lenses let you get close to the action without having to move closer your-self. When you have to shoot an event from a distance, a telephoto lens is a neces-sity. When shooting during the day, I like to use a telephoto zoom lens that covers a wide range of focal lengths so I can switch from wide angle to close up without chang-ing lenses. Some great lenses cover a huge range of focal lengths, like the 18-200mm lens available from Nikon, Canon, Sigma, and others. Some of the newer lenses go all the way out to 250 or 270mm, but they come with a price. These lenses are variable aperture lenses, which means they get slower as the focal length increases.

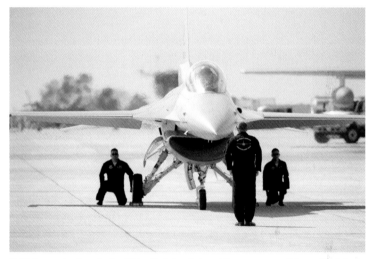

6.11 I wanted a shot of the fighter jet getting prepped for a flight at a local air show. The show was on a military base, which had strict rules regarding where you could and couldn't be. Photography was allowed, but I was back quite far, so I used an 80-400mm lens to get in close. Taken at 1/2000 second, f/5.6, ISO 200.

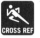

For more on variable aperture lenses, see Chapter 4.

When it comes to shooting events during the day, you just can't beat the convenience of a lens that covers a huge range of focal lengths and doesn't weigh much or take up much camera bag space. Even with the smaller apertures at the longer focal lengths, this is still a lens that finds its place in my camera bag every time. When it comes to using the lens at the longer focal lengths, you can increase the ISO and still use the shutter speed needed to freeze the action.

If you are shooting in the evening or in low light, the best solution is to use the lens at the widest focal lengths, which allows the lens to use the widest apertures.

Prime lenses

I love using prime lenses — especially those in the 35 to 50mm range — for event photography. Depending on whether I am using a full sensor or cropped sensor camera, the 35mm or the 50mm focal length is considered a normal view.

Prime lenses are usually really fast with maximum apertures of f/2.8 and faster and are small, light, and relatively inexpensive. The 50mm focal length is considered "normal" because this focal length most closely corresponds to our natural view. When the viewers of your images see photographs taken with this focal length, they feel as if they were there because the view matches their natural view.

Accessories

Many great photographic accessories are available, but when it comes to shooting events, two important accessories are designed to make your life easier: camera bags and photo vests.

Camera bags

I am addicted to finding the perfect camera bag, which doesn't exist. A good camera bag is important to keep your gear close and safe, but the problem is that each event needs a different set of cameras, lenses, and accessories, and that means a different bag. Also, picking a bag is a personal choice, but keep these things in mind when picking your bag:

▶ **Size.** Camera bags come in all sizes, from fanny packs that hold a single camera body and small lens to bags that need rollers and can hold numerous camera bodies and lenses. You need to make sure that the bag you are using has enough space for everything you need.

▶ **Protection.** A camera bag needs to protect your gear. I like to make sure my cameras are protected with plenty of padding, especially on the bottom and the sides.

▶ **Easy to use.** The worst mistake I ever made when buying a camera bag was to get one that was difficult to open and get the camera out. Make sure the buckles, clasps, and zippers don't hinder your access to your camera.

Because camera bags come in a variety of sizes and designs, from the traditional shoulder bags to modular belt systems, I suggest going to your local camera store with your gear and trying out the bags before buying one. Here is a list of camera bag manufacturers you might want to consider before you buy or when upgrading:

- ▶ **Crumpler.** www.crumplerbags.com

- ▶ **Domke.** www.tiffen.com

- ▶ **Kata Bags.** www.bogenimaging.us

- ▶ **Lowepro.** www.lowepro.com

- ▶ **Tamrac.** www.tamrac.com

- ▶ **Thinktank.** www.thinktank.com

Photo vests

Photo vests may seem unfashionable and old-fashioned, but nothing can beat them for convenience when running around shooting an event. Photo vests are designed to hold tons of equipment in easily accessible pockets, which makes them perfect when you need something fast.

Consider these things when picking out a photo vest:

- ▶ **Weight.** A fully loaded vest can weigh a ton. The key is to not pack items you won't be using, even if you have the space for them.

- ▶ **Comfort.** This is a personal choice, and you need to make sure you try the vest on, preferably with some gear stashed in the pockets, to see how it feels on your shoulders.

- ▶ **Construction and color.** Buy the best vest you can; the wear and tear on the vest causes cheaper fabrics to rip and tear. Because a vest is used to carry your gear, you want one that keeps your gear safe.

- ▶ **Comfort.** Part of the beauty of a photo vest is the multiple pockets and areas to store gear. Be sure to distribute your gear so as not to weigh down any one pocket or pouch.

Shooting Events

Shooting events is all about telling the story of the event to the people viewing your images. This means you have to be part reporter and part artist and tell the story in the most interesting way possible. I love taking photos of events so people feel like they are back at the event. It is even better when they look at the photos and wonder how they missed what I not only saw but also managed to photograph. Public events are held just about every weekend in most cities, and they are easy to find by checking the local newspapers and community Web sites. Many organizations have their own Web sites where you might find not only info on their events but also images from past events.

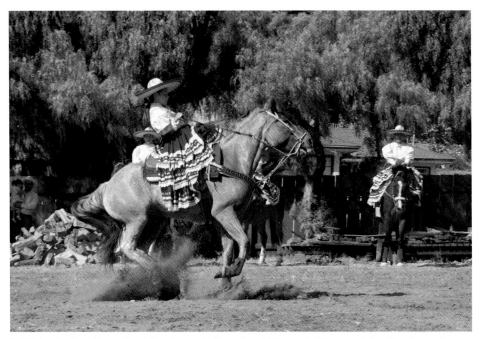

6.12 I looked up the schedule of events for a local Cinco de Mayo celebration to make sure I would be there for the horse riding exhibition. I arrived in plenty of time to set up and get a great spot to shoot the event. Taken at 1/400 second, f/5.6, ISO 100.

Every time I lift the camera to look at a scene, I try to challenge myself to find a way to make the plain and ordinary look extraordinary. One way I have found to do this is to look at small details that are representative of the whole. For example, instead of trying to get the whole crowd at a local street fair, I look to shoot one person enjoying

herself in the sun. Event photos need to tell a story or have a unifying theme. Each photo needs to be able to stand on its own merits and tell a story or evoke a feeling that relates to the event.

If the event is based around a person, like a retirement dinner or birthday party, make sure you photograph the person of honor. You can't have birthday party photos without photos of the birthday boy or girl. Knowing when certain events are going to take place helps you get into a good position to shoot them and helps capture the moment. Look to the decorations, food, and other surroundings that can add to the feel of the whole event.

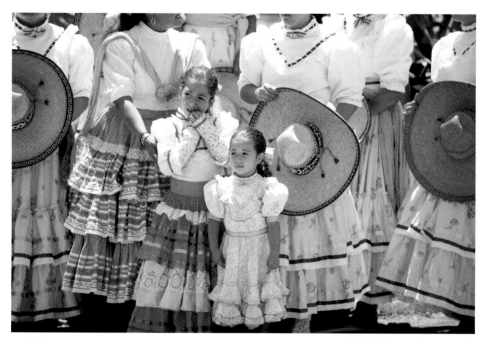

6.13 These two girls were getting ready to perform in a dance recital. The excitement and nervousness is clear on their faces; by zooming in close, I keep the attention on them and not the rest of the troop. Taken at 1/1600 second, f/2.8, ISO 200.

Shooting events can go on all day and yet seem to pass in a minute. That's why I like to keep a checklist of photos I want to capture. I make a list on a 3 × 5 note card before even packing my camera bag. This lets me pack the right equipment for the job and keeps me on track when shooting. I keep the note card in the front breast pocket of my photo vest so I can check my list when shooting to make sure that I am not missing any of the shots I need.

Shooting Tips

These tips will help you along when you're out shooting events:

▶ **Practice without a flash.** This is very important when shooting concerts. Most bands, venues, and promoters do not allow flash photography, even if you have credentials to shoot the show. It is better to learn how to get the correct exposure without relying on a flash.

▶ **Know your gear and where it is packed.** When shooting in low light, you need to be able to change settings, lenses, and memory cards without fumbling around. Knowing where you put the extra batteries and memory cards in your bag can save you precious minutes. This is really important when shooting concerts or any other event that takes place in low light, indoors or out.

▶ **Pay attention to your surroundings.** When you shoot any event with special permission or access, you need to make sure you stay out of the way of the folks working. The quickest way to get your credentials removed is to get in the way of the folks putting on the show.

▶ **Arrive early and do your homework.** Find out if any special displays or presentations are at the event. If you are shooting a parade, find out where the judges, if any, are going to be and try to set up close to that point. Each float tries to impress the crowd at that location.

▶ **Plan for the changing light.** Outdoor events take place under the changing sunlight. Be aware of the movement of the sun. A great place to take photos in the morning can change in the afternoon. Be prepared to move around to make the most of the changing light.

▶ **Change angles.** Try to move around and shoot from a variety of positions and angles. Shooting from low angles is great for parades; it makes the whole event seem larger than life.

Portrait Photography

Ever since photography was invented, people have been taking photographs of other people. Taking portraits seems pretty straightforward, just have the subject smile, point the camera, and press the Shutter Release button. But to get a really good portrait, it is important to understand what apertures and shutter speeds to use, how to work indoors and out, and how to pose your subjects. There are also some differences when working with groups and children and how to get the best from both. All you really need for a portrait is a camera, lens, and a subject, but it is important to know about the different lighting choices available and some accessories such as diffusers, reflectors, and backdrops that can not only improve your photos but can also open up your creative side.

This portrait was shot outdoors using a diffuser to soften the light. Taken at 1/250, f/5.6, ISO 200.

Exposure Considerations

Most portrait photography takes place in environments where you can control the light, giving you a wide variety of options when picking the aperture and shutter speed. Because you can have your pick of apertures and shutter speeds, it is important to use the best ones for the situation. Want to blur the background but keep the model in sharp focus? There is an aperture for that. Want a shutter speed for shooting with a flash? That's covered as well.

Aperture

The aperture controls the depth of field, and the depth of field controls how much of your image is in focus, so picking the right aperture is very important in portrait photography. You want to make sure the depth of field is shallow enough so the subject stands out from the background and deep enough to get in focus what needs to be in focus. For this reason, when I am shooting portraits outside, I like to shoot using Aperture priority mode, and because the subject is usually standing still, I don't have to worry about freezing the action.

The first thing to take into consideration is how close the subject is to the backdrop and how out of focus you want that backdrop. If you want the background to show, you need a much deeper depth of field. If the background is totally unimportant and you want the subject to really stand out, you need a much shallower depth of field.

7.1 This was shot during the late afternoon from a deck overlooking a busy town. I used an aperture that would blur the background, making Nicole really stand out. Taken at 1/500, f/4, ISO 200.

When you are doing headshots and filling the frame with your subject, make sure the aperture you use creates a depth of field that is deep enough to get all the facial features in focus. As you start to fill the frame with your subject, the depth of field range

is reduced. This means that an aperture of f/5.6 may have been great when doing group shots outside, but as you get closer and closer, you need to make the aperture smaller and smaller (bigger and bigger f/numbers) to keep the same depth of field. This also means you need to leave the shutter open longer or raise the ISO, or increase the amount of light.

I can't tell you the perfect aperture to use for portraits every time, because it doesn't exist. It all depends on the lighting, the subject, and the goal of the portrait. I find that using an aperture of f/5.6 to f/11 is a good place to start. The bigger f-numbers are needed as you get closer to the subject, increasing the depth of field.

Shutter speed

When shooting without strobe lights, you can use whatever shutter speed you want. When using strobe lights in portrait photography, either the bigger

7.2 This portrait was shot with the sun in the background, as you can see on the bottom left. I used a fill flash and a very small aperture to balance the light. Taken at 1/320 second, f/16, ISO 100.

more powerful studio strobes or the smaller portable flashes, you're limited in the shutter speed you can use, usually 1/250 second. This is called the flash sync speed.

To understand this limitation look at how cameras actually work. In the majority of cameras, the shutter is a focal plane shutter. This type of shutter has two shutter curtains, usually called the front and rear curtain. These two curtains work together to reveal the sensor when the shutter release button is pressed. After the shutter release is pressed, the front curtain opens across the sensor followed by the rear curtain depending on how long the shutter is open. When a very fast shutter speed is used the front and rear curtains are so close together that only a slit between the two lets in light. This method is used to overcome the limits of a mechanical shutter. The maximum flash speed is the fastest shutter speed that can be used where the light from the flash can reach the whole sensor. If the shutter speed is too high then the slit formed by the front and rear curtain moves too quickly across the sensor for the flash

to light the whole scene. This is why the flash sync speed is 1/250 second on most dSLRs. Some cameras can use a faster shutter speed while others need a slower shutter speed. To find out the sync speed of your camera, check your camera's manual.

So with all this talk of flash sync speeds and flashes, what is the actual use of all this information? The main thing is that to use a flash in sunlight, you have to keep the shutter speed at the sync speed or slower, which means you have to use a very small aperture so you don't overexpose your image.

You can use a flash outdoors in very bright light, and sometimes it's preferable to do so. As you can see in figure 7.3, I set up a small external flash on a light stand to fire through an umbrella to soften the light. Because I was shooting outdoors in bright sunlight, I purposely underexposed the scene by a full two stops and then used the flash to fill in the light where I wanted it. This let me use the sun as a light source and the flash as a light source, producing the photograph shown in figure 7.4. I could only do this by using a shutter speed of 1/250 second and an aperture of f/16. This aperture made the background appear in sharp focus, as shown in figure 7.3, but I composed the image so that the only background was the sky, making Nicole really stand out. To get the correct setting, I did the following:

1. I set the camera to Shutter speed priority mode and the shutter speed to 1/250 second, which is the flash sync speed for my camera.

2. I used spot metering and took a reading from the sky behind the model's head; I noted the aperture the camera said would give me the best exposure.

3. I changed the exposure mode to Manual and set the shutter speed at 1/250 second and the aperture at what the camera determined was the correct exposure.

4. I made the aperture smaller by a full stop and turned on the wireless flash control.

5. I composed the photo, and with the focus point set on the model's eye, I took the photo. The sky was underexposed, but the model was exposed correctly.

When shooting in the studio, shutter speed does not matter very much; as long as the shutter speed is at the flash sync speed or slower, the studio strobes work just fine. And because the flash produced by most strobes is around 1/1000 second, that's plenty fast enough to freeze a subject during the time the shutter is open.

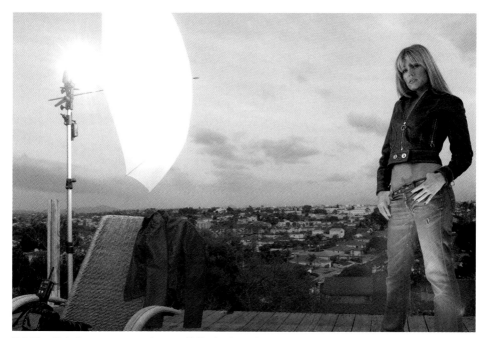

7.3 The lighting setup used a small flash shot through an umbrella to help balance out the light of the sun.

7.4 This image was created by the setup shown in figure 7.3. Taken at 1/250 second, f/16, ISO 100.

You must consider one more thing about shutter speed when shooting portraits: Use a very slow shutter speed to have some of the ambient light illuminate parts of your image. To do this, you need to set the camera to Manual, set a slow shutter speed, and set the flash to fire at the end of the exposure or rear curtain sync. This means the flash fires right before the rear curtain closes at the end of the exposure.

Considering Lighting and Location

Portrait photography is the one type of photography in which you have control over the shutter speed, aperture, ISO, and the intensity of the light. When working indoors, using strobe lights or continuous lights, you can adjust these sources to output more or less light. When working outdoors, you can diffuse the light and reduce its intensity, and you can use strobes to help balance the sunlight. You can also control the light to create different tones in your portraits, resulting in more creative images.

Indoors

In your own studio, you have control over the light, the background, and the weather. You can easily build a small home studio with a simple backdrop and a couple of lights. Lighting companies like Westcott lighting (www.fjwestcott.com) have lighting units starting under $1,000 and full lighting kits for just a little more. But when you shoot indoors on location, your challenges are likely going to be the amount of space available to work with and the light.

Here are some tips to keep in mind to help you get the best portraits possible:

▶ **Diffuse the light.** You can diffuse the natural light that comes in though windows and doors by using a simple white bed sheet taped over the window. Because that light is sunlight, it is constantly changing as the sun moves across the sky. Not only does the intensity change, but the color of the light changes as well, getting more orange around sunrise and sunset.

▶ **Avoid mixed lighting.** If the scene is lit via a variety of light — the sunlight from a window and a table lamp, for example — the white balance will be off and your image could have an unwanted colorcast that is very difficult to remove later. Try to light the scene with one color of light. You can use gels on your portable flash to match the color already present if you need some extra light.

▶ **Watch out for reflections.** Glass reflects light and can cause unwanted highlights to show up in your images. Position yourself so the light is falling on your subject and not reflecting off a window, desktop, or other reflective surface.

▶ **Bounce the light.** For more even light when using a flash, bounce the flash off the ceiling or nearby wall, which turns the surface into a large diffused light source instead of a small bright one. Remember that any color on the ceiling or wall will show up in your image as a color cast, and often an unwanted color cast.

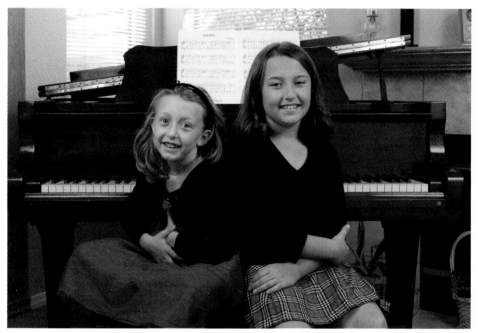

7.5 These sisters were photographed in their living room so the piano could be used as a backdrop. I let some light come in from the windows and supplemented it with a flash shot through a large umbrella. Taken at 1/60 second, f/5.6, ISO 200.

▶ **Drag the shutter.** If you want to have some of the light from the environment illuminate your scene, use a slower shutter speed. For this type of portrait, I like to use a shutter speed of 1/30 second with an aperture of f/4 or f/5.6 and a flash aimed over the heads of the subjects, set to fire when on rear curtain sync. This allows some of the environment in the background to be seen, but the flash lights up the subject and freezes any motion. If you want none of the background to be seen, increase the shutter speed so none of the ambient light is used.

One of the biggest problems with shooting inside can be the lack of space; consider moving the shoot outdoors as a possible solution.

Outdoors

Photographing portraits in the great outdoors can produce some stunning images. I started shooting portraits in the comfortable and controllable studio setting and have recently started to shoot more outdoors. One reason is the great light that is available, especially in the early morning and late afternoon. On the negative side, that light changes constantly and the sun is a very bright, very small light source that creates very hard shadows.

The best light for working outdoors is when some low cloud cover is present, which acts like a giant diffuser creating a much larger light source closer to the subject. Some great accessories can help you shape and control the light outside, and I cover these diffusers later in this chapter.

When shooting portraits outside, keep these things in mind to help you get the best results:

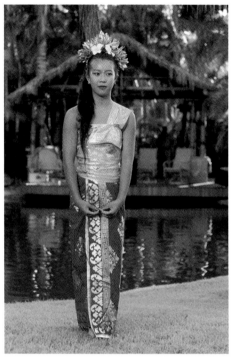

7.6 I made sure the model was placed in the shade and the depth of field was shallow enough to blur the background. Taken at 1/200 second, f/5, ISO 200.

▶ **Watch the background.** Nothing ruins a photo like an errant tree sprouting out of the head of your subject. You can use a shallow depth of field to minimize the background, but simply recomposing the scene so the background doesn't distract from the image is often easier.

▶ **Shoot in the shade.** One great way to diffuse the light is to shoot in the shade, either using a diffuser or the natural shade present from a tree. This helps turn that small bright light source into a bigger, softer light source.

▶ **Use your flash.** Using your flash to help add some light to your subject can help to avoid bright spots and harsh shadows.

▶ **Watch the position of the light.** Direct sunlight can be very unflattering and should be avoided at all costs. To get the best portraits outside, be sure that no light strikes your subject directly in the face. Move your subject so the light is striking him at a 45-degree angle, the same way you would set up an indoor studio light.

Outdoor settings also work really well when shooting groups. The added amount of working space helps you get the whole group in the frame without using a very wide-angle lens.

Getting the best exposures when shooting outdoor portraits is all about picking the right modes — both the exposure mode and the metering mode. I use Aperture priority mode because I want to control the depth of field and make sure the subject of my portrait stands out. I usually use a scene metering mode unless my subject is backlit, in which case I use Spot metering and make sure I have a fill flash if needed.

For more on metering modes, see Chapter 1.

Portrait tones

When shooting portraits, they can fall into three tones or keys, depending on the lighting you use. Each of these keys presents a different exposure problem but each can be solved and the results can make for great portraits.

High-key portraits

High-key images are those with a light overall tone. This means you must have a background that is lighter than the foreground and is usually pure white or very close to it. To achieve this type of image, you need to over-expose the background and keep the subject in proper exposure. When this type of image is done properly, you get a clean, bright background and simple, striking image.

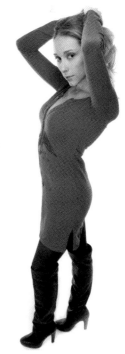

7.7 This full-length portrait of Mia was photographed against a roll of white seamless paper. The background was lit with two lights while Mia was lit with one large softbox. The light on the backdrop was two stops brighter than the light on the model. Taken at 1/250 second, f/8, ISO 100.

For this type of portrait, you need a set of lights that light only the background and can be adjusted to output more light than the lights that are illuminating your subject. If the background is not lit evenly or brightly enough, the background looks

muddy and gray. You can do this type of shot with as few as three lights, but I often use four or five. The simple three-light setup gives you the basic idea of how this works: One light lights your model while the other two light the background.

I position my model as far from the backdrop as possible so I can get some separation between the backdrop and the model, which helps control any light spilling from the background lights. I then light my model without worrying about the background. I like using a large softbox placed at about 45 degrees from the model so the light wraps around the model's face.

Now for the high-key part, you need to evenly light the white background (I like using white seamless paper), but it needs to be two stops brighter than the light(s) lighting the model. These two background lights need to be positioned on either side of the background facing across the backdrop so that the backdrop is evenly lit. For example, if you use a light meter and the reading on the model without the background lights is f/8, then the reading on the backdrop needs to be f/16.

If you look at the histogram for a high-key portrait, you'll see a preponderance of data on the light side, with some areas of the image being pure white.

 For more on histograms, see Chapter 1.

Mid-key portraits

Mid-key portraits are those that fall in the middle ground; they are not overly dark or light and use a backdrop that is close to an 18 percent gray. In this situation, having the model close to the backdrop is fine because both are usually lit by the same light and you want some of the light to reach the backdrop. These portraits are easy to take because you can do so with one light and a simple backdrop.

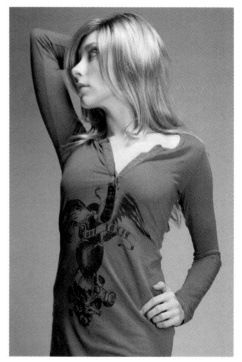

7.8 For this portrait of Mia, I changed the backdrop paper from white to light gray and used one light to illuminate both the model and backdrop. Taken at 1/250 second, f/10, ISO 100.

These portraits work great when using continuous lights; you can use any metering mode to get an accurate reading because the background is a neutral tone. When using strobes, use a separate light meter, or pick a safe starting point, use the LCD on the back of the camera to check the exposure using the histogram, and adjust accordingly.

Low-key portraits

Low-key portraits combine dark backgrounds and dark clothing with minimal lighting to create a style that dates back to the portraits painted by the masters like Rembrandt.

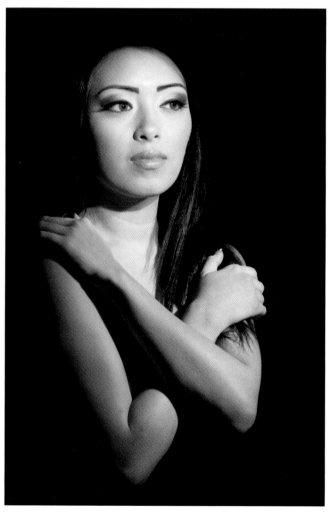

7.9 This portrait was shot in the studio using a black seamless paper background. The model was lit with one light angled down to create the deep shadows under her arms. I used a fast shutter speed to make sure no ambient light entered the scene. Taken at 1/250, f/5, ISO 200.

Low-key photos are traditionally shot in a studio against very dark backgrounds. One way to keep the backgrounds dark is to make sure the light being used to light the model doesn't reach the backdrop. To do this successfully, you need to have plenty of space between the model and the backdrop. If the model is right up against the backdrop, then the light that reaches the model is going to reach the backdrop as well.

You need to experiment with the placement of your lights to get the look you want, but a good place to start is with a light placed at 45 degrees to your model. I like to use a softbox for a softer light, but you also can use a harder light to create harder shadows and a more dramatic portrait.

When shooting low-key portraits, you need to use a faster shutter speed to reduce the chance for ambient light to illuminate any of the scene. To get the correct exposure, take a spot-meter reading from the most important part of the image — most likely the face of your subject. You do not want to take the background into account at all.

Working with People

Portraits are photographs of people, so working with people is an important part of the portrait process. Most adults follow directions fairly well; the real challenge is dealing with children and when you have more than one person. Posing a person or posing a whole group so they all look good is an important part of portrait photography. There are some tips to get the best poses from the whole group and also some helpful information on fixing some of those pesky posing problems.

Children

Children can be tough to photograph because they rarely stop moving and they don't like to spend lots of time standing still — especially waiting to have their photo taken. Child portrait photography can be a real challenge, but one that can bring lots of pleasure to family and friends and clients.

Most people think babies are cute, and they're even cuter if the baby is related to you. They make great models, they can be placed exactly where you want them, and because they can't walk off, they stay put. Until they start to crawl, that is, and then all bets are off.

When it comes to shooting young children, the Boy Scout motto comes to mind: Be prepared. Children have their own personalities, so some sit quietly and play while

others tear around until they run out of energy. Photographing children in their own environment, doing what they want to do, helps you capture them at their happiest. This lets the personality of the child come out in your images.

When you are photographing a child running around, use a shutter speed fast enough to freeze her action. I like to use Shutter speed priority mode and spot metering to make sure I am using a shutter speed fast enough and the camera meters the critical area of the scene.

Groups

Group portrait photography consists of photographing two or more people, and the more people involved, the bigger the challenge is for the photographer. If lighting and posing a single person is tough, doing the same for a group is much tougher.

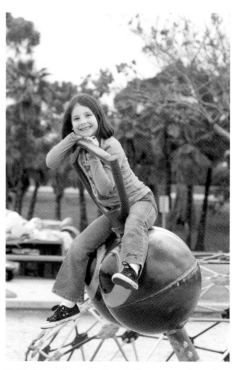

7.10 Shooting at a local playground made for some happy subjects. I tried to use an aperture that would blur the background and still keep the subject in focus. Taken at 1/1000 second, f/5, ISO 200.

You can do the following things to pose a group so the light reaches all the people in the group:

▶ **Stagger the heads.** Set people up so that the heads of the people in the second row are not directly behind the people in the front row. This allows the light to reach all the faces in the group.

▶ **Group people around a center point.** Instead of posing your group in a straight line, place them around a central point or person. This works well for family portraits and small groups. For example, when shooting a family portrait, have the oldest members sit in the center and the family gather around. This not only staggers the group, letting the light reach everyone evenly, but it also adds a feeling of togetherness that a family standing in a straight line doesn't.

▶ **Light the whole group as evenly as possible.** Pay attention to where the light falls. If one part of the group is in deep shadow and the other is in bright sunlight, achieving proper exposure is very difficult.

▶ **Shoot intimate couples.** When shooting a couple, have them get close. It works best if they are so close that there is no gap between them. Have them move toward each other, not just lean in. This makes for a more intimate shot.

▶ **Make sure the main subject is the center of attention.** Certain events like weddings, birthday celebrations, and so on have main subjects in the group photos that should be the center of attention. Pose the important people in the center of the group, and build the group around them. This doesn't have to be as close and intimate as a family portrait and can be a straight line. Another technique is to place the important folks a little forward of the others, but make sure you are using a deep enough depth of field to keep the whole group in acceptable focus.

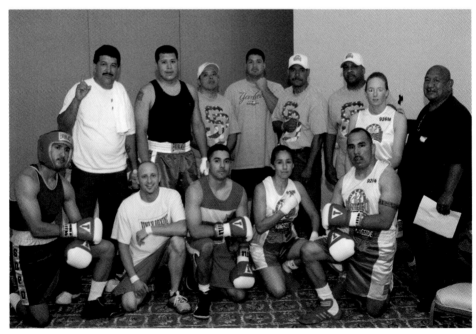

7.11 I made sure that the whole boxing team was visible when setting up this shot. I would have preferred to take it outside to have more space, but sometimes you have to shoot in specific locations. I used a flash on the camera aimed at the ceiling and made sure the flash had a gel to match the light in the room. Taken at 1/60 second, f/4, ISO 200.

One of the biggest problems with shooting groups is keeping the group's attention on you, the photographer. You need to get everyone to smile at you and look at you and not get distracted by the person standing next to him. The more people in the group, the harder this is. You need to find that sweet spot between too laid back and too firm. I talk to the group the whole time so their attention is on me. I have found that telling them what I am doing keeps their attention on me and help them understand what I am looking for. I find the more directions I give, the better the results are.

The Right Equipment for the Job

I can't tell you that one magic piece of equipment will let you create stunning portraits, but some things can help

7.12 Nicole and Glenn were photographed at the site of their future wedding. I used a wide aperture to get a shallow depth of field to have them stand out from the background. Taken at 1/80 second, f/2.8, ISO 200.

with capturing the best possible portraits. I believe that any dSLR camera on the market today is perfectly usable for taking portraits. What can make a difference is the lens you have mounted on your camera, the lights you use, and the accessories that are used to change the quality and direction of the light.

Lenses

Traditionally lenses used for portrait photography have been between the 85mm and 100mm focal length. These lenses allow the photographer to work about 12 feet away from the model and still fill the frame with the subject. When talking about focal lengths, consider the lens crop factor.

CROSS REF For more on the Lens Crop Factor, see Chapter 4.

An 85mm lens, when used on a cropped sensor camera, has an equivalent focal length of roughly 125mm, and a 100mm focal length lens has the equivalent focal length of 150mm. This makes the traditional lengths difficult to work with unless you have more working space. It also means that a lens with a focal length of 50mm can make a great portrait lens on a cropped sensor camera because it has an equivalent focal length of about 75mm. The easiest way to get a good portrait lens is to buy a medium-range zoom lens that covers a wide range of focal lengths — the 24-120mm lens, for example. Not all lenses are great for portraits due to the distortions they can create.

▶ **Wide-angle lenses.** Wide-angle lenses can cause unflattering distortions when used for portraits, especially when used close to your subject or when the subjects are placed too close to the edge of the frame. This can be a problem when shooting group portraits, where it seems that using a wide angle makes it easier to get everyone in the frame, but a better choice is to physically move farther away from the group and use a longer focal length. Sometimes, you can use a wide-angle lens in a portrait, but knowing that the distortion is present and more prevalent at the edges of the frame can help you avoid ruining your photograph.

▶ **Telephoto lenses.** Using really long focal lengths can cause a different type of distortion. They tend to flatten out the image. Items that are in the far background seem to be closer and can distract from the portrait. This effect can actually be used to your advantage, especially when shooting in the studio, if you have enough space between yourself and the model. The longer focal lengths can cause the features on the model's face to slightly compress, which is more flattering.

Lights

Sunlight is great for taking portraits and can even be used effectively indoors as it streams through open doors and windows. Many portrait photographers believe that this natural light just can't be beat. Because you can't always count on the sunlight being where you want it, you have other lighting options.

Two types of studio lights are available: studio strobes and continuous lights. Each has pros and cons. You also can use small portable flash units as studio lights.

Studio strobes

Studio strobe lights illuminate your model by firing a very short burst of light when triggered. They are like larger, more powerful, versions of the flash you put on your camera. These types of lights come in two styles: flash heads that are connected to a central power supply, and lights that are self-contained units, usually referred to as

monolights. Most studio strobes need to be plugged into the wall for power. Some come with battery packs, but these are big, heavy, and usually expensive. These types of strobes can be used on location, but the lights need a power source bigger than a few AA batteries.

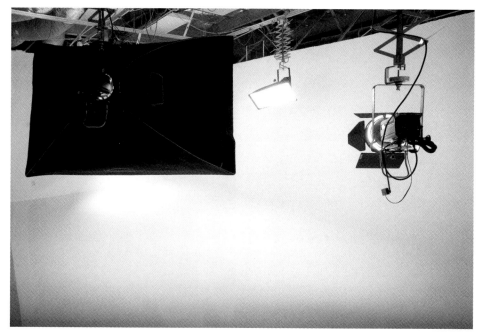

7.13 This is the interior of Essy's Studio in San Diego. Multiple strobes are attached to rails in the ceiling, making them easy to adjust.

Studio strobes need to be connected to your camera in order for them to fire when you press the Shutter Release button. There are two ways to do this, the first is with a cord from the camera to the lights, the second is with a wireless transmitter/receiver system. Both methods will cause the studio strobes to fire when you take the photograph.

Working with studio strobes has some limitations; you need to use a shutter speed of 1/250 second or slower. This is a technical limitation and can be bypassed when using small portable flashes, but when using a sync cord or wireless sync, the top shutter speed is usually 1/250 second. These strobe lights fire a very short, intense flash of light when triggered. This burst of light is so short that it will freeze any motion even though your shutter speed is 1/250 of a second or less. When shooting with strobes, both the big studio and small portable types, remember that adjusting the shutter speed controls how much ambient light is allowed in your image and the aperture controls how much of your flash is allowed to light up the model.

Continuous lights

Continuous lights are lights that stay on all the time, giving out continuous illumination. Where strobes put out a very intense flash of light in a very brief moment of time, continuous lights have less intensity but are much easier to use. They are like having a really big flashlight. These lights need a power source, which usually means plugging them into a wall outlet. When you use these lights on location, make sure you have a power source close. Another solution for shooting with your studio lights on location is to purchase an external battery pack, but make sure you get one designed to power your lights.

The biggest advantage to using continuous lights is that you can set the exposure in the camera using the built-in light meter and a metering mode. The light is on and constant, so the exposure doesn't change because the light doesn't change. Composing your portraits is easier when using continuous lights because you can see exactly where the light strikes your subject.

Continuous lighting comes in many flavors, from cheap systems for the beginner to big, powerful units for the working professional. Lighting systems such as the Westcott Spiderlite and Photoflex Starlite use cool color-balanced lights that are easy to set up and use. Continuous lights used to be called "hot" lights because they created lots of heat when turned on. Any model posing under these lights felt like a burger under a heat lamp at a fast food place. The cool lights now available don't get nearly as hot, and they allow for a more comfortable modeling experience. These bulbs are also color balanced so color shift is no longer a problem when the lights stay on.

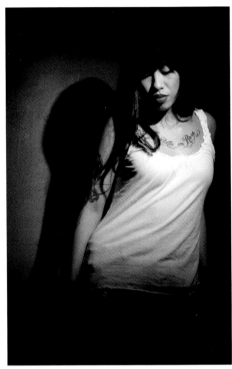

7.14 Taken using a single continuous light with a snoot (a tube used to direct the light) to get a hard spotlight effect. I could see where the light was going to be before taking the photo; using the camera's built-in light meter, I took a spot meter reading from the model's face and set the camera to Aperture priority mode. I took a series of images, checking the composition and exposure on the LCD until I had what I wanted. Taken at 1/500 second, f/8, ISO 200.

Continuous lights cannot compare to strobes when it comes to freezing subjects. Because the lights are on all the time, the highest shutter speed you can use is determined by the intensity of the light, the aperture used, and the ISO. To freeze something moving fast, you have to increase the light's output as much as possible, and then either open the aperture and risk a shallow depth of field, or raise the ISO and risk introducing digital noise.

Portable flashes

These flashes attach to the hot shoe of your camera. No matter what brand of camera you have, your system has a dedicated external flash or two. In recent years, the use of these types of lights has increased, especially for shooting portraits on location.

You should know that these small portable lights can't fully replace the power and ability of studio lights, but they can do so much. Because of their small size and extreme portability, you can keep them with you. And these flashes have another feature that makes them great: their ability to be triggered from the camera wirelessly.

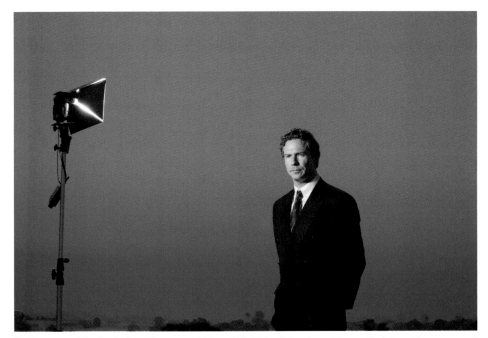

7.15 A portable flash, in this case a Nikon SB-900 with a LumiQuest Softbox III, was used to illuminate the subject. The white balance on the camera was set to Tungsten, which turned the sunset sky a deeper shade of blue. To make Tim look natural, a correcting gel was placed over the flash. Taken at 1/250 second, f/5.6, ISO 200.

Other accessories

You can use many accessories when shooting portraits, from posing tables to props and many other light controlling tools. The accessories covered here help with your portrait shooting both in the studio and on location.

Reflectors

Reflectors do exactly what they sound like they do: They reflect light from the main light source onto the subject. One of the most common uses for reflectors is to add more light to the face, especially to help remove or reduce the shadows that can form under the eyes when the model is lit by overhead lighting. Reflectors come in a variety of sizes, shapes, and colors. The following factors contribute to what effect the reflector has on your subject:

▶ **Size.** As the size of the reflector increases, so does the amount of light reflected from the light source onto your model. Reflectors can range from small to really large.

▶ **Shape.** Reflectors come in a variety of shapes, but the most common is round. They create a circle of light reflected back on the subject and can look more natural than a square reflector. Some of the newer reflectors are wedge shaped and have a grip handle on one end, making them easier to use.

▶ **Color.** The color of the reflector's surface changes the color and quality of light. These are common colors:

 ● **Silver.** A silver surface reflects the most light and doesn't change the light much, But it can cause the light to be slightly cooler. Because it doesn't change the color of your studio lights, you can avoid any mixed lighting situations.

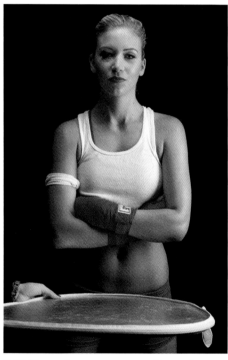

7.16 My assistant moves a reflector into place to bounce the light up and into the face of the model. This helps to eliminate the shadows from the overhead lighting. Taken at 1/250 second, f/9, ISO 100.

- **Gold.** A gold surface reflects lots of light, but not as much as silver. The gold surface adds a warmer tone to the light, more like the light at sunset. The gold surface also causes light to look very yellow when used in a studio and is best used outdoors with natural sunlight.

- **White.** A white surface reflects less light than the silver and gold surfaces and produces a soft, even light that is less intense than the silver or gold. White can work well in both the studio and with natural light, and the white surface doesn't add any color to the light.

- **Mixed surfaces.** Often, you'll come across gold and white or gold and silver surfaces. These basically are just toned-down versions of the full color versions.

Many reflectors are collapsible and can be folded and stored away in much smaller spaces. This makes the reflectors good for location work. The reflector material is sewn around a sprung steel hoop, which keeps the material tight but allows the reflector to be folded into a size roughly one-third to one-quarter its size. Most reflectors come with different covers that can be zipped on and off, making one reflector useful in many situations.

Using a reflector to add light to a scene lets you use faster shutter speeds and smaller apertures. To add more light into the shadow portions of your scene, position the reflector opposite the main light source and aimed toward the subject. The challenge is to position the reflector and be in position to take the photograph at the same time. This is when you want to have an assistant to hold the reflector so you can be behind the camera to meter the scene correctly and take the photograph. If you are alone, you can place the reflector against something. Some reflectors come with handgrips, so you can position them more easily. When shooting a headshot, you can have the model hold the reflector, but make sure that it doesn't move between the metering of the image and the actual taking of the image.

Diffusers

A diffuser is a light modifier that goes between the light source and the subject to soften the light. When it comes to portraits, softer light is better because it creates softer shadows.

Diffusers are very useful for making small, bright light sources into bigger, softer light sources. When you're shooting in direct sunlight, the light source is actually very small and harsh. The diffuser must be placed between the sun and your subject, which can be difficult to do and remain in position to photograph. An assistant or good light stand can really help in these situations.

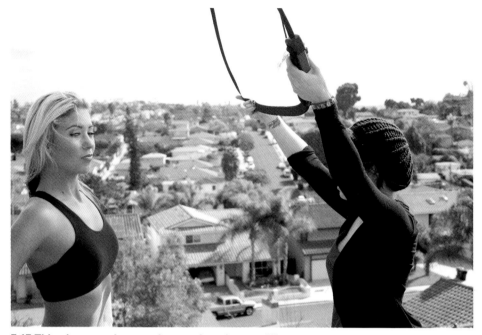

7.17 This photograph was taken to show how a diffuser was placed between the sun and the model. The diffuser used here is a Lastolite tri-grip diffuser. Taken at 1/250 second, f/8, ISO 200.

When using diffusers outdoors to change the intensity of sunlight, you also need to adjust your exposure. The reduction in light from using a diffuser means that you must use a slower shutter speed or open the aperture to achieve proper exposure, compared to shooting the same scene without a diffuser. You can simply increase the ISO, but be careful of introducing too much digital noise.

When shooting indoors and using sunlight streaming through an open window or door to light the scene, any white piece of semi-opaque material can be used as a diffuser. A white bed sheet makes a great diffuser in this situation; simply tape it over the window or door to soften and reduce the light from a bright, hard light to a softer, diffused light. The downside is that the reduction in the intensity of the light means you need to adjust the exposure accordingly.

You can modify studio light and flash units using specialized diffusers called softboxes and umbrellas.

▶ **Softbox.** A softbox is a specialized light diffuser that connects to the front of a studio light or flash and diffuses the light. The bigger the softbox, the more the light is diffused. Softboxes come in a variety of sizes and shapes from small squares to very large octagons.

▶ **Umbrellas.** The umbrellas used in photography to diffuse light are very similar to umbrellas used to keep the rain off your head. One way to use an umbrella is to position it so the light is aimed directly at the umbrella and then the umbrella is aimed 180 degrees away from the subject; this bounces the softer, diffused light back at the subject. Another way to use an umbrella to diffuse light is to shoot the light through the umbrella at the subject.

Backdrops

What's behind your subject can be an important element in your image or can be used to make your subject stand out. When working on location, you have a choice between using the environment where you are shooting or bringing a backdrop with you.

Many backdrop systems and materials are available, but no system is perfect for everyone. Two of the more common types of backdrops are paper and fabric.

▶ **Paper.** Paper backdrops are great for photographers who want a solid color background without painting a wall or spending lots of money. Paper backdrops come in rolls, usually referred to as seamless. These rolls come in various widths, lengths, and colors, and you can use them in the studio or on location. You can use a couple of light stands and a cross bar to hold the paper, or you can just tape the paper to a wall. The seamless paper is then unrolled to the required length, and you are ready to shoot.

▶ **Fabric.** Many different types of fabrics are used to make photographic back-drops, including satin, cotton, and muslin. These backdrops are used in the same way as paper backdrops, but they are reusable and come in solid colors or designs. These backdrops can add texture to your images without distracting from your model, but they can wrinkle and crease, and they don't reflect the light the way paper backdrops do.

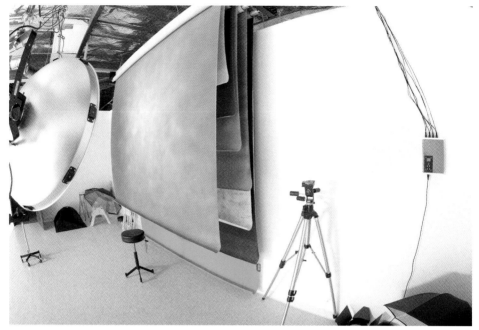

7.18 These backdrops can be raised and lowered as needed. This backdrop system lets me change the backdrop with a touch of a button, saving time and allowing a variety of different looks all in the same studio.

When it comes to dealing with your exposure, backdrops can play a key role in the metering process. A solid black or solid white backdrop can cause your meter to misread the light. I recommend either using a separate light meter or spot metering to make sure the backdrop doesn't affect the camera's meter reading.

Light meter

Getting an accurate light reading with your camera can be tricky when using strobe lights in a studio. Because strobes fire only when you press the Shutter Release button at the same time the shutter is opened, you can't get a reading before taking the photo. One advantage of digital photography is that you can look at the LCD after taking the first shot and see how close you are, and then you can try again until you get it right. However, if you want to know for sure without all the trial and error, you need to use a light meter.

Many light meters now can trigger the strobes, allowing you to take a reading as the light meter triggers the flashes. This allows for an accurate reading before even taking the first shot. The readings are then set in the camera using Manual mode, and although the settings should be very close, you should double-check the exposure on

the LCD. When using a light meter, be sure to take the reading from the area that is most important in the image, usually the model's face, and remember that the light meter tries to make the metered area 18 percent gray. If the area needs to be lighter than that, the scene needs to be overexposed; if the area needs to be darker, the scene needs to be underexposed.

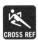

For more on the 18 percent gray card, see Appendix B.

Shooting Portraits

When it comes right down to it, portrait photography is all about bringing out the best in your subject. It doesn't matter if you are shooting a senior portrait or a wedding entourage; the goal is to make the people look good. Part of looking good has to do with what your models are wearing and part has to do with making sure they are posed correctly.

It is said that clothes make the man (and woman) and when it comes to portraits, clothes can make or break a shoot. The style of the portrait can be determined by what the models are wearing. If the portraits are taken for an important event or formal occasion, the attire tends to be more formal. Following are some basic helpful tips when dealing with all types of attire:

▶ **The collar.** Make sure the collar is straight, not twisted or uneven. If the collar is not straight, you may get weird shadows on the neck that distract from the rest of the image.

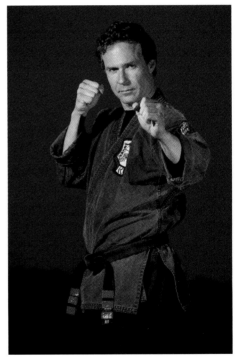

7.19 Although not a suit and tie, this martial arts uniform was very important for this portrait. Tim, a third-degree black belt, needed that to be clear in the shot. The belt was positioned so both ends hung properly and was lit with a small grid light to make sure that the red stripes were properly lit. The focal point is still the eyes. Taken at 1/125 second, f/4, ISO 200.

▶ **The tie.** For a man wearing a tie, make sure the knot looks good and is placed nice and tight at the collar. The rest of the tie should hang straight and not show out the bottom of the jacket.

▶ **The cuffs.** For men and women wearing suit jackets, the cuffs of the shirt should be seen to help break up the line between the sleeve and the hand.

▶ **The line of the jacket.** Make sure the jacket is hanging correctly; be sure that a woman's jacket bust line is not gaping.

▶ **The color.** Most formal clothes tend to be dark. This is great for shooting low-key portraits and can have a slimming effect on your subjects. When it comes to the exposure for these outfits, using the spot meter avoids getting too much of the clothing into the exposure equation.

When you're shooting a group of people, they should be wearing the same type of clothing. It doesn't have to match, but when half the folks are wearing formal suits and the other half are dressed in casual clothes, the photograph looks sloppy and unplanned. Try to stick with solid colors and very subtle patterns and avoid bright, bold patterns because they can clash.

The next part of the portrait equation is how to pose your subjects so they look natural and good at the same time. I talked earlier about setting up a group of people so they can all be seen, but also consider these things:

▶ **Angle the shoulders.** Everyone looks better when one shoulder is turned toward the camera. This keeps your subjects from looking really wide and flat. Even if their shoulders are turned, their heads should still face the camera, or not — it's your choice.

▶ **Direct your subject.** Nothing's worse than a quiet portrait shoot. As the photographer, you need to talk to the subjects and direct them. Assume they don't know how to stand or sit, and you need to help them so they look great in the frame. Give directions that are clear and easy to follow. Trust me; they will appreciate it.

▶ **Have them sit down.** Using a chair is a great way to get a natural look in a photo, but most people tend to slouch even if they don't realize it. Have your subjects sit near the end of the chair so they can't lean against the back. This keeps their posture straighter and helps fix any slouching problems.

▶ **Keep a folder of poses you like.** When you open a magazine or are looking at any photograph and you see a pose that you think works really well, save that image in a folder and use it for reference later. I'm not saying you should copy other people's work, but use what you see to help refine your style. My idea folder holds images torn from magazines. Sometimes, I try to mimic a pose, and other times I use something as an element of the overall photo. Every couple of months, I go through the folder and throw away images that didn't work for me and add new ones I'd like to try.

The best portrait photographers know how to get their subjects to relax in front of the camera, which results in a more natural-looking photograph. You can do some simple things to make your portraits turn out better.

A great way to keep your model comfortable is to talk to her, establish a rapport, and let her know what you are doing. When you explain what you are doing, you remove the mystique associated with portrait photography. These general tips can help with some of the more common posing problems:

▶ **Baldness.** Baldness can cause unwanted reflections from lights that are overhead or are aimed at the head. Try to diffuse the light that's hitting the trouble spots. In the studio, you can use a bigger softbox or even move the softbox closer to the model. Outdoors, you can use a diffuser to soften the light. You also can adjust the angle of the lights in the studio so they are not striking the problem spot. Another solution is to use a professional makeup artist to help with reducing shiny skin.

▶ **Glasses.** Eyeglasses can cause unwanted glare and reflections in your images. The trick is to move the glasses so the light isn't reflected back at the camera. Moving the arms of the glasses up slightly above where they normally sit causes the glasses to be aimed slightly down and not at the camera. You also can try to move the light up or down a little to change the angle of the light.

▶ **Slimming the subject.** Have the model turn slightly toward the camera, because having one side close to the camera makes your model look a little slimmer. You can reduce the appearance of double chins by having the subject look upward and placing the main light higher than the camera and aimed down at the subject; this causes more shadow to fall under the chin. Don't shoot profile poses if your subject is a little heavy, because these tend to exaggerate the body size.

▶ **Hands and feet.** The hands of your model are important as they can add character and interest to your image, but they can ruin a great portrait if not placed correctly. The most common mistake is letting the hands appear too large in the image, especially if they are placed close to the face. Make sure the hands are turned so the side of the hand is facing the camera. Try to have the hand curved because a flat hand doesn't look very pleasing.

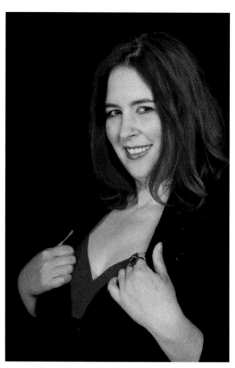

7.20 I turned the model slightly toward the camera, and because the black jacket blended into the black background, the viewer's eye is drawn up the arms to the face. Taken at 1/250, f/7.1, ISO 100.

The last part of the portrait photograph — after the location, lighting, the clothes, and pose — is the composition of the portrait. Keep portraits simple. The same rules apply when shooting portraits that apply when shooting landscapes and just about everything else. The basic Rule of Thirds is a great way to compose portraits, and that's where I usually start with my compositions. Imagine lines dividing the scene into thirds, both horizontally and vertically, like a tic-tac-toe board. The goal is to place the important elements on one of the four points where the lines intersect. If you look back through the images in this chapter, they all follow this rule. In figure 7.21, I took the original photo at the start of this chapter and overlaid a Rule of Thirds grid; you can see that the lines go down though the eyes and lips, and two lines intersect at the eye and the hand. The angle of the hand also leads the viewer to Nicole's face.

You don't have to follow the rules every time; part of being a photographer is finding your own vision. Think of the Rule of Thirds as a starting place, a jumping-off point to help you get a good start. After you have taken the portrait, try one last thing: Change the orientation. If the shot you just took was in portrait orientation, switch to landscape and see how it differs. Sometimes, just looking at the scene in a different way can open it up to new possibilities.

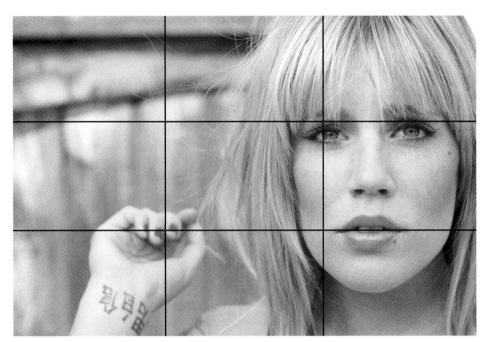

7.21 Nicole's portrait has the Rule of Thirds grid overlaid to show the intersecting lines. Taken at 1/250 second, f/5.6, ISO 200.

Shooting Tips

The process of shooting portraits can be a little overwhelming when you first start, but keep these things in mind and you will do great:

▶ **It's all in the eyes.** Focus on the eyes. If the eyes are out of focus, the rest of the portrait won't matter. If one eye is closer to the camera, focus on that eye.

▶ **Look to change your angle.** When shooting children, get down to their level. Taking all the photos looking down doesn't show the child in the best way. Being at your subject's eye level adds a look of intimacy. When shooting large groups, though, try a shot from a higher angle and have everyone look up to you. A ladder comes in handy for this.

▶ **Wait until your subjects are used to you.** When photographing children, having them comfortable around you makes for better images. When photographing adults, try to build rapport quickly so they relax in front of the camera. Most people are tense when having their portraits taken.

▶ **Talk to your subjects.** Talking to your subjects keeps them at ease and makes for a more relaxed atmosphere, but it also lets you direct the poses without sounding like you are ordering them around.

▶ **Keep them busy.** When shooting children in a studio setup, have plenty of toys and games around to distract them from what you are doing. This helps in getting a natural look in an unnatural situation.

▶ **If they can't see you, you can't see them.** When shooting groups, especially large groups, ask the folks if they can see you before you take the photo. If they are having a problem seeing you, then chances are good that their faces will not be in the image.

▶ **Have a posing plan.** Look in magazines, books, and online to see what poses appeal to you. Keep these in mind for the next time you need to pose a person or a group.

▶ **Be patient.** This is especially important when shooting children. You may need to shoot lots of photos to get the one you want. Just stay calm and be patient.

▶ **Meet beforehand if possible.** Although it isn't always possible, meeting with the subjects before a portrait session lets you know what they expect to get from you and, just as importantly, what you will receive from them. This meeting also goes a long way in getting them comfortable with you and results in a more relaxed shoot.

▶ **Follow simple clothing rules.** Vertical stripes add length, giving the subject the illusion of being taller and slimmer. Horizontal stripes have the opposite effect and should be avoided. Logos on clothing should be avoided unless they are needed as part of the portrait. Remember that dark clothes can cause your camera's metering system to underexpose the skin tones, and light clothing can cause the metering system to overexpose the skin tones.

▶ **Makeup is key.** Do not underestimate the usefulness of a professional makeup artist. The portrait photograph is capturing a moment in time, and looking good is important. A good makeup artist can do wonders, and proper use of makeup can accentuate the positive and hide the negative.

▶ **Shoot multiple shots.** Take as many shots as possible in as short a period of time as possible. People seem to relax right after the first shot is taken, so the next two or three photos are better. This is especially true when photographing children.

▶ **Get in close.** Unless the background is an important part of the photograph, fill the frame with your subjects.

Landscape and Nature Photography

A great many photographic subjects are available in nature, from mountains to des-erts, forests to beaches and lakes, and just about any place in between. When planned correctly, photographing landscapes and nature is not the same frantic shoot-ing that happens when photographing sports or events. To become great at landscape and nature photography, you have to slow down and really study your surroundings. Getting the best landscape images requires learning the best times to shoot and what modes to use, as well as what accessories will be most helpful. Also covered is spe-cial information on macro and panoramic photography.

Early morning light illuminates the fall colors. Taken at 1/20 second, f/11, ISO 200.

Exposure Considerations

When shooting landscapes and nature, the main exposure consideration is making sure that the whole scene is in acceptable focus. It is possible to shoot landscapes where areas are purposely left out of focus, but for this chapter, I am talking about the classic landscape, which is in focus throughout the entire image. Using the best possible light and choosing appropriate shooting modes can help you capture the depth of field that you need.

When to shoot

The best time to shoot landscapes is when you get the warmest light and the softest shadows. Photographers call these times the golden hours. In reality, you get two golden hours; the first one starts about 30 minutes before the sun rises and lasts for about an hour, and the second is from about 30 minutes before the sun sets until about an hour after sundown. This is when the light is at its best for most photography, but especially for landscapes. There are other times when the light can be as dramatic as this like right before or after a storm, but be careful when shooting in bad weather to keep yourself and your gear protected and dry.

8.1 The dry grass catches the light in the morning making it stand out against the hills in the background. Taken at 1/20 second, f/9, ISO 100.

The full midday sunlight is considered the worst for photography in general and landscape photography in particular, because the direct overhead light creates a scene with washed-out color and little texture. Using a circular polarizing filter (discussed later) in this light can help save your images and add some contrast to the sky and clouds.

Shoot in Aperture priority mode

When you shoot in Aperture priority mode, you can pick the aperture that gives you a very deep depth of field. This results in the foreground, middle ground, and background being in focus. Using the smallest aperture on your camera and lens will ensure this. This is key to getting the whole image in focus, but the problem is that by using a small aperture, you have to leave the shutter open for a long time and/or raise the ISO. Many landscape images have vast areas of the sky in them, which is one of the places where digital noise can be very noticeable. Keep the ISO as low as possible when shooting these images to create as little noise as possible. The optimal solution is to keep the shutter open as long as necessary to get a proper exposure.

8.2 This Irish countryside landscape was photographed mid morning in Aperture priority mode so the whole scene was in focus. Taken at 1/400 second, f/16, ISO 125.

Using a slower shutter speed has some great advantages when shooting landscape and nature images. As mentioned, this allows you to use a low ISO to avoid digital noise and a small aperture (big f-number) like f/22 to get the whole image in acceptable focus.

Metering modes

The hardest decision for me is always which metering mode to use when shooting landscapes and nature. The answer depends on what the scene looks like and how it is lit. One of the advantages of shooting at daybreak and right around sunset is that the tonal range of the scene is more easily captured because it isn't as extreme as during other times of day. Using a scene metering mode works great in these circumstances.

If you are shooting a scene that has vast areas of brightly lit sky, the best solution is to use Spot metering on the part of the scene that is the most important.

Shooting snow

The majestic snow-capped mountain range has been a landscape photographer's dream for many years. The problem is the snow; it looks white to you and me, but to the camera it looks like a bright area that needs to be dimmed to 18 percent gray. If you let your camera set the exposure, you get great shots of gray, dull-looking mountain ranges. The difference between pure white and dull gray is two full stops of light. The secret is to overexpose the image slightly, but not by the full two stops. Check the histogram and the highlight clipping on the camera's LCD. You want to make sure that the histogram shows bars nearly all the way to the right, and if the snow is blinding white, those bars need to be all the way over to the right. The quickest way to deal with the snow being underexposed is to dial in some exposure compensation. You need to use +1/3 as a starting point and work from there. If the snow is still too dark, go to +2/3 and try again. In the areas of pure white snow, you should see a highlight clipping warning blinking on the LCD.

 For more on exposure compensation, see Chapter 1.

When shooting an entire scene that is snow covered, chances are good that the snow is not pure white. If the snow is pure white, then all you see is a bright white area, and it's likely you wouldn't have stopped to photograph it. The tiny shadows and textures in snow-covered areas need to still exist in photographs, so the image needs to be overexposed between one and one and three-quarters of a stop. When shooting snow-covered areas, you need the low angle of light that can be present only early in

the morning and late in the afternoon. That's another great reason to shoot during those two times of the day.

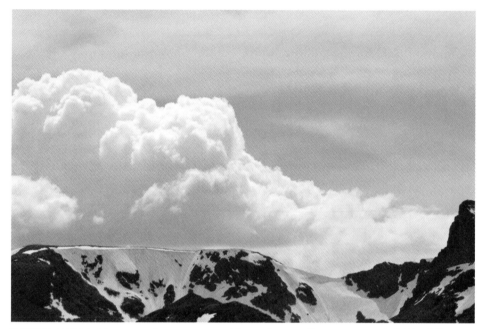

8.3 This scene was purposely overexposed to make sure the snow was bright white. Taken at 1/250 second, f/9, ISO 200.

Checking the exposure

When you are shooting using sunlight, the light can change from moment to moment, so making sure you have a good exposure quickly and accurately when shooting is important to getting the best images. Although the histogram is a great tool to use when shooting landscapes, I like to use the highlight clipping warning on the camera's LCD.

For more on the histogram, see Chapter 1.

Use the highlight clipping mode to check to make sure that you are not losing all detail in the brightest parts of your image, which are usually the brightest parts of the sky or clouds and might or might not be what you want in your images. If the areas in your photos that are blinking are areas in which you want to have detail, then you need to adjust the exposure. One of the easiest ways to do this is to use exposure compensation.

Exposure compensation is covered in detail in Chapter 1.

Change the exposure compensation to –1/3, which underexposes the image by one-third of a stop. Take another photo, and check the exposure again. If the image still shows blinking areas in the lightest areas, change the exposure compensation to –2/3 and shoot again.

If you are shooting toward the sun and any part of the sun is in your scene, you will have areas of pure white; you can't get around it. You either need to recompose the image without the sun in it or change to Spot metering and take a reading from an area that does not have the sun present.

The Right Equipment for the Job

Any camera can be used to take landscape photos, because it is the person behind the camera that takes the photo. But the right lens and accessory choices can help you get the best images — and make your life easier too.

Lenses

One of the most unexpected things I experienced when first shooting landscapes was the disappointment I felt after seeing my images. They never seemed to match the great views I saw when taking the photo. One of the ways that I have since rectified this problem is by using a super-wide-angle lens. This is a lens with a focal length at least as wide as 12mm on a cropped sensor and 8mm on a full-frame sensor. Using these lenses, I have been able to really encompass the views I see into my images.

For more on cropped sensors, see Chapter 7.

Because landscapes are all about the wide-open spaces, getting a lens that captures as wide a space as possible makes sense. Fisheye lenses can capture incredibly large areas, but the fish-eye distortion makes these useful only for a small niche market when it comes to landscape photography. If you like this look, you want a fisheye in the 10.5mm or so focal length for cropped sensors and the 16mm or so focal length for full-frame sensors.

Even though landscape photography can be shot in low light, and it *really should be* shot in low light, you don't need a lens with a wide aperture like f/2.8 because a shallow depth of field is not needed and really not wanted.

When you use wide-angle lenses, the elements in the rear of the scene seem even farther away than they appear at the scene. Wide-angle lenses also make those elements in the forefront seem closer. The inverse also is true. When using a telephoto lens, the entire scene seems to be compressed and flatter than in reality.

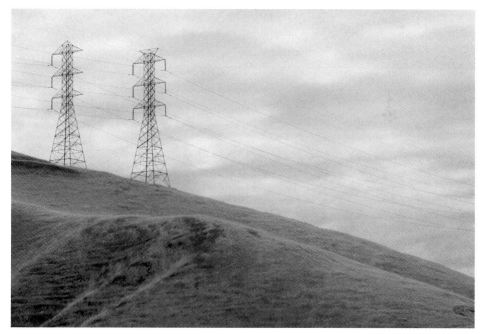

8.4 These hills and power lines were photographed in the late afternoon in central California. Taken at 1/350 second, f/11, ISO 100.

Accessories

Shooting landscapes doesn't take much more than a camera and lens. But if any one accessory can help your landscape photography, it's a good tripod. There are also a couple of filters that can really help and improve your landscape shots. And keeping track of where you have shot is now possible using GPS technology to embed the location right into the photo file.

Tripods

The job of a tripod is to hold the camera rock steady while the shutter is open. Any camera movement, no matter how slight, causes blurring of the image when the shutter is open for any extended period of time. The most stable tripod has the fewest leg segments; every joint is a weak spot and causes the tripod to have slight vibrations. Another common cause of vibration is when the center column of the tripod is fully extended. The center column adds shooting height, but when fully extended, the tripod is slightly less stable.

Because the job of a tripod is to hold your camera steady, you want to make sure the tripod you use is big and strong enough to hold your camera and lenses. I often see people out photographing with tripods that are just too small and lightweight to properly support their cameras. I know that a big, heavy tripod is a big commitment, but it is worth the extra weight and size to make sure your camera is supported and you get the sharpest photographs.

It also matters what you are shooting with and the subject you are shooting. If you are going to be photographing lots of macros, you need a tripod that can get very low to the subject. You may even want it to have a removable center post so the camera can be set parallel to the ground and your subjects. If you want to shoot panoramas, then you may want to get a tripod head that's made for shooting panoramas, like the equipment available from Really Right Stuff, which has special gear designed to shoot panoramas.

 For more on tripods, see Chapter 9.

Filters

You should always have a selection of photographic filters in your camera bag, but for landscape photography, the two filters that are most useful are a circular polarizing filter and a neutral density gradient filter.

Circular Polarizing filter

A circular polarizing filter cuts down on reflections in your images and can darken the sky, leaving the clouds white, which increases the contrast and the blues, which in turn produces more saturated colors throughout your photograph. The following tricks can help you produce the best results with a circular polarizing filter.

The first trick is to position yourself where the circular polarizing filter does the most good. This is at a 90-degree angle from the sun, which means that to get the best

results from your polarizing filter your subject needs to be at right angles to the sun. When shooting at sunrise or sunset, this means you should be facing north or south. If the sun is directly behind you, the effects of a circular polarizing filter are nearly completely negated. The second trick is to use the rotating ring on the circular polarizer to "dial in" the best setting for the scene. You can decide what area in your photo needs the most help.

You should keep three things in mind:

▶ The circular polarizing filter blocks some light, as much as two stops worth, from reaching the sensor, meaning that a slightly longer shutter speed is necessary.

▶ Don't use a circular polarizing filter when shooting panoramas, which can cause big problems because each frame will have a slightly different color.

▶ Polarizing filters have two thick rings and can cause vignetting problems when used with super-wide-angle lenses. Special thin polarizing filters are available, but they do cost more.

Polarizing filters are not cheap, but they're worth the price. Other than a tripod, a circular polarizing filter is the best accessory you can use when shooting landscapes.

Neutral density gradient filter

No digital sensor available at this time can record the contrast range that the human eye can. The second filter that you should carry in your camera bag when shooting landscapes is a neutral density gradient filter. This filter lets you darken an area of the image (like the sky) but leave the rest (the ground) alone. This means you get a proper exposure for the entire scene, which would have been impossible to do any other way. When confronted with a landscape that has a very dark ground and a much brighter sky, you simply cannot get both exposed properly at the same time. You must either expose for the sky, which leaves the ground underexposed, or you must expose for the ground, which leaves the sky overexposed. If you use a neutral density gradient filter, the darker area on the top of the filter can be used to darken the sky so that when you expose for the ground, the sky won't be overexposed.

GPS receiver

This is one of the newer accessories available for photographers. Although it may not improve your landscape photography, it is a great tool for tracking and geo-tagging your images. You can now get a GPS unit that embeds the latitude and longitude directly into the image file. This information is great for keeping track of your image locations and can be embedded into maps directly inside most software packages now.

Macro Nature Photography

Macro photography is a great way to shoot nature images. Instead of focusing on the whole wide scene, this lets you focus in on a single element. Instead of photographing an entire forest, capture the detail in a single leaf. A macro lens lets you get really close to your subject, allowing you to see the world in a different way. To get really close to your subject without using a specialized and expensive macro lens, you can use a special close-up filter that turns any zoom lens into a macro lens, which is a great way to see the possibilities without spending the money before you know this is something you want to pursue.

Shooting macros takes patience; you have to carefully set up each shot and be very exact. Even a small amount of vibration when taking the image can cause severe blurring. A tripod is a necessity, and I recommend that you use a cable release or a remote so that you can trigger the Shutter Release button without actually touching the camera.

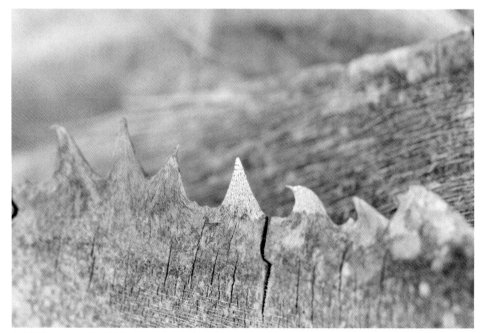

8.5 This might look like the teeth of a wild animal, but it is really the edge of a palm frond. Taken at 1/320 second, f/9, ISO 1600.

For more on cable releases, see Chapter 9.

When shooting so close to your subjects — sometimes less than an inch away — the depth of field becomes critical. Small movements can blur an object out of focus. To get a good depth of field and the sharpest image possible, you need to use a large f-number — an aperture of f/11 or higher — and keep your camera parallel to the subject. Because the focus can change drastically if you move just millimeters, having the camera parallel to the subject increases the chances of the whole subject being in focus. I also do 99 percent of my macro photographs using manual focus to make sure that the areas I want to have as the focal point are the focal point.

The best exposure modes to use when shooting macro photographs are Aperture priority mode or Manual mode. This is because getting the depth of field right is so critical. Slower shutter speeds are used so that the very small apertures can be used, giving the image sufficient depth of field. If your camera has a depth of field preview function or button, now is a great time to use it. This lets you see how much light is available, and you can set the shutter speed accordingly.

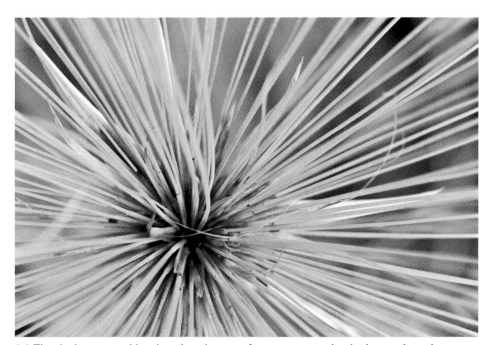

8.6 The design created by shooting the top of papyrus grass leads the eye into the frame. Taken at 1/320 second, f/9, ISO 800.

Some subjects in nature may not stay still for slower shutter speeds, and this is when you need to increase the ISO so you can increase the shutter speed but not change the aperture. The balance becomes using an ISO low enough to avoid digital noise, but a shutter speed high enough to keep the subject from blurring. When shooting nature macros, the wind is your enemy. A little breeze can create lots of movement when shooting that close. Your best bet is to try to block the wind as much as possible and time your shots during a break in the wind. I find that a piece of foam board propped against my tripod legs acts as a great wind break and can be used to reflect more light onto the scene.

I have found that the best metering mode when shooting macros is a scene metering mode. Usually the subject of your image is filling the frame, and a scene metering mode takes everything into account. If either a very bright or very dark area is in your composition, then you need to switch to Spot metering and have the camera meter the light that is being reflected off your main subject. Do this using Aperture priority mode with the aperture set to f/11 or higher, and make note of the camera's choice for shutter speed. Then switch to Manual mode, enter the same aperture (f/11 or higher), and then enter the shutter speed that the camera came up with when in Aperture priority mode.

After you have taken the photograph, use the LCD to check the exposure and focus. The first step is to make sure no areas are too bright or too dark. The next step is to zoom in on the image using the camera's preview controls; although it is never 100 percent accurate, you can check the critical areas of your image to make sure the focus is correct.

Panoramic Photography

Panoramic photographs are those with an exceptionally wide field of view and are well suited to landscapes because of the way they can convey great wide-open spaces. Panoramic photography used to take specialized equipment but can now be done with any dSLR.

You can create panoramic images using two different methods: You can crop an image using software in post-processing, or you can stitch together a series of images to create one wide photograph.

When creating panoramic images by combining multiple images, you must get the same exposure for all the images involved. This creates a final image with the same look and feel throughout. The key to shooting good panoramic photographs is to set

up the shot correctly before making the first exposure. Although you can shoot a panoramic without using a tripod, stitching the images together later is much easier if they were all taken from the same level.

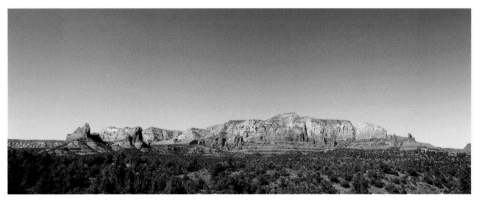

8.7 This panorama was shot in Sedona, Arizona, and was created using eight images, all shot at 1/640 second, f/9.0, ISO 200.

To shoot images that you plan to stitch together later using an image-editing program, follow these basic steps:

1. **Set your camera in the tripod in portrait orientation (rather than landscape) orientation.** Although you need more images to cover the same area, the results are worth the extra images.

2. **Set the white balance on your camera to Cloudy or Shade.** Use anything that's not Auto so the camera doesn't change the color temperature between shots.

3. **Determine the focal point of the scene you want to photograph.** Set the metering mode to Spot metering, and the exposure mode to Program auto, and then aim the camera at the focal point.

4. **Press the shutter button halfway down so the camera's built-in light meter gets a good reading from the area.** Make a note of the exposure settings.

5. **Set the exposure mode to Manual, and enter the shutter speed and aperture from the preceding step.**

6. **Set the camera to manual focus, and focus on the focal point.**

7. **Take a series of images starting on the left, and make sure you overlap as you take a series of images moving to the right.**

 I like to overlap the images by at least 25 percent, which gives the software a better chance of stitching the images together correctly.

Once you have the series of images, you can stitch them together to create a panorama. There are many options when it comes to software that can stitch your images together. Adobe Photoshop and Photoshop Elements can both do it. The software that came with your camera might even do it, just check your manuals.

Shooting Landscapes and Nature Photographs

Sweeping vistas and high mountain ranges make for breathtaking images. As the sun rises and crosses the sky, the landscapes below are ever-changing. You can photograph a landscape one day, and the next day it is different because the light is never exactly the same twice. I have my favorite spots to photograph, and I visit them often, and the results are always different.

Good landscape photography is all about making good decisions when looking through the viewfinder because the camera just records everything in front of it. So it is important to explore your surroundings before setting up your tripod. Walk around and look at the different views, and make sure you look around at different heights as well. Shoot from a low perspective, and the landscape could seem to tower over you; shoot at a downward angle, and the landscape could seem to stretch out even farther. Look through the camera's viewfinder, and adjust the focal length of the lens to get the image set before setting up the tripod. You may find that the best image is not the one closest to the car or at the easiest height. By previewing the scene through the camera, your chances of getting a great image are seriously increased.

The placement of the horizon in your image is key to getting professional-looking photos. The goal is to put the horizon line either one-third of the way from the top of the scene or one-third from the bottom. This placement depends on whether the sky is interesting enough to warrant two-thirds of the image or whether the ground warrants the extra space. Look to the sky and decide whether including more or less of it will enhance or detract from your image. A clear sky usually detracts from an image; if nothing is in the sky; the viewer has nothing to look at. Clouds, on the other hand, can add much-needed texture and color.

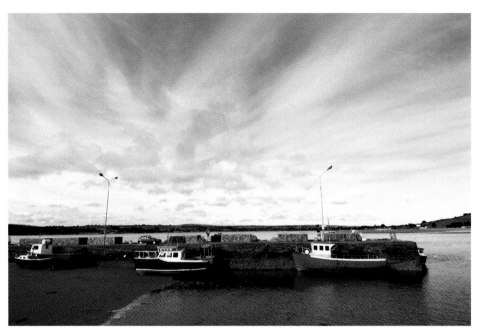

8.8 This was shot in Ireland in the early morning. I placed the horizon line lower in the image because I wanted to make sure I got the great cloud formations. Taken at 1/320 second, f/9, ISO 125.

Most amateurs just put the horizon line smack in the center of the image, neatly bisecting the photo. Although this could work, the next time you see a travel magazine or a book of landscape images, look to see how many times the horizon is right in the middle of the image. It won't be many.

This placement of the horizon is a part of the Rule of Thirds, a composition guide that photographers have been using for a long time to help improve their images. This rule works for all types of photography and can do wonders for your composition. You need to imagine lines that divide the image into thirds both horizontally and vertically — similar to a tic-tac-toe board. You place the important elements of your photograph at one of the four points where these lines intersect, or in the case of landscapes, you place the horizon a third of the way in from the bottom or the top. Using a fisheye lens for landscapes is the one time that you want to put the horizon line in the center of your image. Although this placement breaks the Rule of Thirds, it does create an image with less of the fisheye distortion.

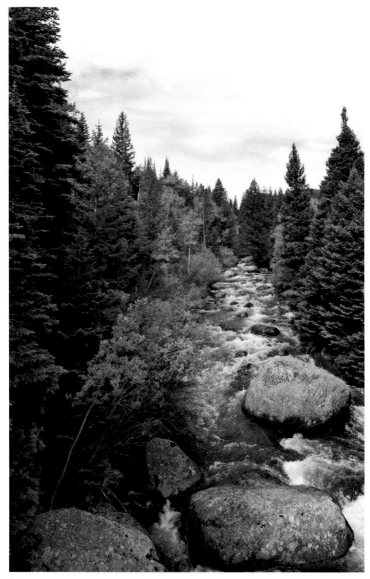

8.9 This stream was photographed using a beanbag rest on top of a rock outside Boulder, Colorado. Taken at 1/320 second, f/9, ISO 100.

Adding a person or other readily identifiable element is a great way to show the size and perspective of your scene. Sometimes the vista has no sense of size because the viewer can't relate to anything in the scene. Including any element that the viewer can

relate size to helps with this, even if it is simply a flower, rock, or branch in the fore-ground. Placing this element at one of the four points of intersection on the Rule of Thirds grid also creates a stronger composition.

When you shoot a landscape in the horizontal or landscape orientation, the images have an expansive feeling, conveying the feeling of wide-open spaces. But no rule states that this is the only way you should shoot landscapes. Shooting your land-scapes with a vertical or portrait orientation emphasizes the height of your subjects. Just because the orientation is called landscape doesn't mean that you have to shoot every landscape in landscape orientation.

No matter which way you decide to frame the image, keep the horizon parallel to the top and bottom of the frame. I had this problem all the time when I first began photo-graphing landscapes, and it sometimes still crops up in my images. When this hap-pens, I usually have to straighten my images using software, which ends up cropping the edges of my photo. The easiest solution is to get a little bubble level that attaches to the hot shoe of your camera so you can make sure the images are perfectly level. Some tripod heads even have this built in to let you know when the tripod head is level, meaning the camera is level. Recently Nikon has started to include a virtual hori-zon function in some of its cameras to help with this very problem.

Shooting Tips

Shooting landscapes and nature takes patience. You have lots to think about, mostly before the Shutter Release button is ever pressed.

- ▶ **Look around before shooting.** The best image may not be the first one you see. Take a moment to look around before setting up your photograph.

- ▶ **Look for patterns.** There are great patterns in nature, from the structure of the leaves and petals to the way the flowers all follow the sun. These patterns make for interesting elements in your images.

- ▶ **Identify your subject.** Find the most interesting feature in the landscape and make sure it doesn't have to compete for the viewer's attention.

- ▶ **Try different focal lengths.** Telephoto focal lengths cause elements in the background to appear closer than elements in the foreground, while wide-angle focal lengths cause elements in the background to be much farther away than elements in the foreground.

▶ **Check for distractions.** When shooting landscapes, check not only the background but the foreground as well. Any feature that draws the viewer's eye away from what you want to be the focal point needs to be removed from the composition.

▶ **Add a person.** Including a person in the image adds a sense of scale and perspective. Sometimes determining the true size of a landscape can be difficult without an easily recognizable object to give a scale of reference.

▶ **Protect yourself and your gear in bad weather.** When shooting outdoors, be careful about protecting yourself and your gear from the elements.

▶ **Adjust your exposure when shooting snow.** Huge areas of bright white can cause the metering system in the camera to underexpose the rest of the scene, so adjust accordingly.

▶ **Watch the light.** As the sun moves across the sky, the light changes constantly. Watch where the shadows fall and how different areas are lit over time. The same landscape photo taken at dawn will look very different even one hour later.

▶ **Use a tripod.** This is the most important thing you can do for your landscape and nature photography. Nothing in this chapter is as important as using a tripod. It is the only way to get the slow shutter releases needed with very deep depth of field and a tack-sharp image.

▶ **Use a tripod.** When shooting macro images, you must get the camera as steady as possible so you can use the smaller apertures to make sure the whole image is in focus.

▶ **Use a tripod.** Keep the camera on the same plane when taking images that will be stitched together in a panorama. The image-editing software will be better able to create a good merge of your images.

Night and Low-Light Photography

If photography is all about capturing the light, what happens when very little light is available? Digital photography at night is not only possible, it can be lots of fun. You may encounter some difficulties photographing in the dark, but the ability to get instant feedback using the camera's built-in LCD screen make it much easier than ever before. Just before the sun goes down (or comes up) is one of the best times to photograph. After the sun goes down there is still a great deal of light remaining, especially in cities. Buildings are lit up at night, streetlights cast their glow, and glowing neon signs are all great light sources for night and low-light photography. Other great subjects to photograph at night are light trails and fireworks, both which are covered in this chapter.

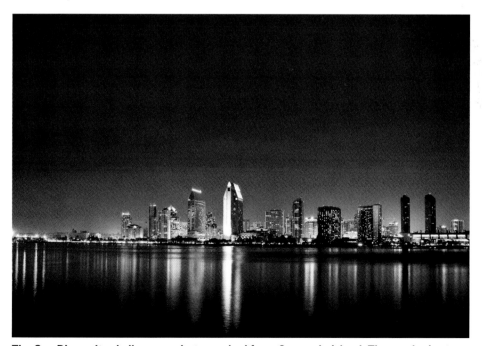

The San Diego city skyline was photographed from Coronado Island. The sun had set more than 30 minutes earlier, but I had enough light from the city to light the scene. Taken at 20 seconds, f/9, ISO 100.

Exposure Considerations

Photographing at night and in low light is a huge exposure problem. If you are shooting at night, you must learn how to estimate proper exposures because the built-in light meter won't be as reliable.

One way to help get the best exposure at night is to start photographing before the sun goes all the way down. While the sun is still present, you can use a scene-metering mode to get a good starting point.

Here is a general outline of how to proceed:

▶ Set the camera to Program auto mode (P), and press the shutter button halfway down to get an exposure reading. Look at what the camera believes are the best exposure settings.

▶ Change the camera to Manual mode, and input the shutter speed and aperture settings from your exposure reading.

▶ As the light changes, you need to raise the ISO or use a wider aperture or a slower shutter speed. Sometimes, you need to adjust all three.

You have three options when shooting in low light: Leave the shutter open for longer, use a wider aperture, or raise the ISO — or a combination of these options.

Long shutter speeds

The obvious solution when shooting in low light is to leave the shutter open for a long time so the sensor can see as much of the available light as possible. The big downside to this is that anything moving in the image will be blurry, and if you don't keep the camera steady the whole image will be blurry. Keeping the camera steady is easy when using a tripod, which is covered later in this chapter.

Your camera can record light you can barely see. When you use slow shutter speeds, the exposure settings are best set in Manual mode because most cameras' built-in light meters cannot handle very long exposures. The one real downside is that using slow shutter speeds can increase the amount of digital noise in your image even when using low ISOs.

Using slow shutter speeds also means that anything in motion when the shutter is opened is blurry in the image. Even people standing still move enough that they aren't in sharp focus.

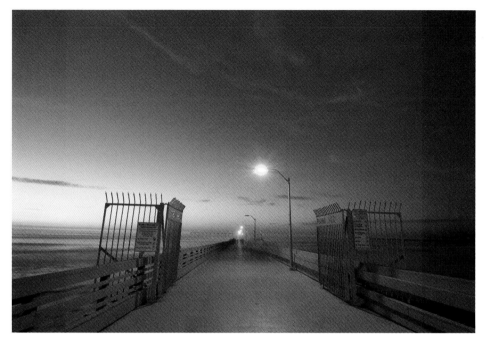

9.1 Look closely at the pier. Can you see the people? This photograph was taken at 6 seconds, f/11, ISO 100. With the shutter open that long, the people just become blurs.

Wide open aperture

One method that lets as much light reach the sensor as possible is to use the widest available aperture available. This is lens-dependent, and on a variable aperture lens, this can change depending on the focal length. The downside when using a very wide aperture like f/1.4, f/1.8, or f/2.8 is that you have a very shallow depth of field.

When shooting using the maximum aperture, it is very important to make sure that you are focusing on the most critical part of the photo because when you have a shallow aperture it means that items in front of and behind the focus plane can be out of focus. If you need to use a deep depth of field, then you will either need to use a longer shutter speed, increase the ISO, or do both.

High ISO

Using very high ISOs lets you use higher shutter speeds in low light to help you freeze the action. I usually shoot these types of photographs in Manual mode, using Spot metering to get an exposure value (EV) reading.

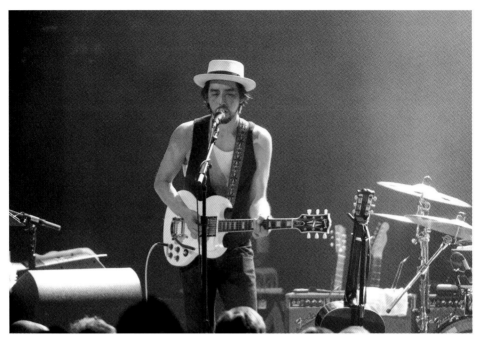

9.2 Musician Jackie Greene was photographed at 1/60 second, f/2.8, ISO 3200. The high ISO was necessary due to the really low lights in the club.

The trick is to determine the slowest shutter speed you can use and still freeze the action. For people standing pretty still, this is usually about 1/60 second, but it can be slower. Then open the lens as wide as possible by setting the aperture to the smallest f/number. Check the EV through the viewfinder, and raise the ISO until the image is properly exposed according to the EV readout.

As camera manufacturers improve the high ISO capabilities of their cameras, this will be less and less of a problem. With the newer cameras I now use, I use ISO values on a regular basis that I never would have tried with my older cameras.

The Right Equipment for the Job

You really don't need any special equipment when shooting in low light and at night but there are some items that will make your life easier and your photos better. One of the most important accessories for low light and night photography is a good tripod. Another key accessory is a way to take a photo without pressing the Shutter Release button by using a cable release or remote control. While all cameras and lenses can be

used to take night and low-light photographs, there are some things to look for both on your camera and in your lens selection.

Cameras and lenses

Most cameras and lenses can be used for night and low light photography, especially the types of images when the shutter is kept open for long periods of time. Be sure to look for the following things if you are getting a new camera and you want to keep taking photos in low light.

▶ **Bulb setting.** Check to see if the camera has a Bulb (B) setting. This is when the shutter stays open as long as you are holding down the Shutter Release button. This is a great setting for shooting fireworks and other light-trail photography.

▶ **Bracketing.** Shooting bracketed exposures can really help your low light and night photography. A camera that has adjustable bracketing is very useful.

▶ **Low noise at high ISO.** If your low-light shooting needs to use faster shutter speeds, you need to use higher ISOs. Look at the visible noise in the high ISO range — 1600 and above.

Although it is true that any lens can be used for night and low-light photography, you can more easily get images using higher shutter speeds when using a maximum aperture of f/2.8 or wider. My favorite lens for shooting in low-light situations is a 50mm f/1.4 prime lens.

Accessories

You need two important accessories for low-light photography: a tripod and a cable release or remote control. The tripod holds the camera steady, and the cable release lets you trigger the shutter release without actually touching the camera. Combine these two items with the ability of the camera to lock the mirror up before the image is taken, and you get the sharpest possible image in any light.

Tripods

A good tripod is an absolute necessity for taking photographs when using slow shutter speeds. Many photographers use a tripod all the time, which is fine, because this usually results in the sharpest image possible. The best tripod is the tripod you will take with you and use. This means you need to pick one that is light enough for you to carry and that is still strong and stable enough to hold your camera and lens combination stable.

9.3 A camera locked onto a tripod with a cable release attached is used when the shutter is open for long shutter releases.

Not all tripods are created equally, and this is usually a case of you get what you pay for. If you are serious about taking long-exposure photographs, where the shutter is open for seconds or minutes at a time, you want a very steady tripod. Tripod materials can differ greatly and can affect weight, price, and stability.

▶ **Wood.** Wood is an excellent material for tripod legs because wood has a natural ability to reduce vibrations and keep the camera very steady. Although wooden legs can still be bought, they are not very common anymore and can be very heavy and expensive.

▶ **Aluminum legs.** Aluminum is an inexpensive alternative to wood. It creates a lightweight, stable tripod.

▶ **Carbon-fiber legs.** Made from layers of carbon fibers, these tripod legs are lighter than wood and aluminum and can be as stable as or even more stable than wooden legs. These tripod legs can be very expensive.

▶ **Other materials.** Newer and more exotic materials such as Basalt and titanium are being used in the creation of tripod legs. These tripods range in price from the very affordable to the very expensive.

Tripod legs are made to extend and collapse so their height can be adjusted and so they can be carried easily to the location where they are needed. The working height of a tripod is important. You want to be able to shoot from as high and as low as your style of photography requires.

The tripod head sits on the tripod legs and is the part that attaches to your camera. Having a tripod that can accept different tripod heads means you can change the tripod head when needed. These types of tripod heads are available:

▶ **Ball head.** A ball head can swivel in all directions, letting the photographer adjust the exact angle of the camera with one locking knob. A good ball head supports a heavy camera and lens combination and allows the photographer to securely lock the camera position with one knob.

▶ **Three-way pan head.** This is the more traditional type of tripod head, with separate controls for left, right, tilt up, and tilt down: and you can change the orientation from portrait to landscape. The advantage of this type of tripod head is that after one of the axis settings is locked into place, the others can still be changed. For example, if the orientation is locked into portrait position, the camera can still move left or right. Many of these heads also have a quick release plate that allows the camera to be removed from the tripod and reattached quickly. These plates mount on the camera and then are easily attached to the tripod head.

Cable release and remote control

A cable release or camera remote control is a device that allows you to trigger the shutter release without actually pressing the button. When trying to keep a camera totally steady, even pushing the shutter button on the camera can cause the camera to move enough to cause camera blur.

Check to see if your camera manufacturer has a cable release or remote for your camera. Some manufacturers supply a remote control that works as a cable release to trigger the shutter button.

If you don't have a cable release or a remote control, another method is to use the self-timer. Set the timer for the shortest time, and then press the shutter button. The theory is that any vibration caused by pressing the shutter button has dissipated by the time the image is actually taken.

Some cameras also allow you to lock the mirror out of the way before the shutter is opened. This mirror lock-up function moves the mirror up and out of the way, reducing any internal vibration of your camera, and only then is the shutter moved out of the way and the photo is taken. Check your camera's manual to know whether your camera has this function.

Photographing Light Trails and Fireworks

One of the great subjects for night photography is light trails, including the light trails from fireworks displays. This is a situation where the built-in light meter on your camera has very little use and you have to shoot in Manual mode to achieve proper exposure.

The secret to taking good light-trail photos is using a slow enough shutter speed that the individual lights become trails through your image. Think about the light trails created when photographing moving cars; the trail is created by the red taillights and the white headlights as they move through the scene. When you use a fast shutter speed, the car doesn't get to move very far and the light trails are very short. When the shutter is left open for an extended period of time, cars can travel through the whole frame creating, long solid light trails.

When light is the main subject of your photograph, the rest of the scene needs to be rather dark, making the best time to look for light-trail subjects after the sun has set. Look for viewpoints where you can see the movement of light — for example, the headlights and taillights on a busy road at night. Because light-trail photography creates a sense of movement in a static image, you can use the light trails to guide the viewer's eye into the image.

To create a light-trail photo, follow these general steps:

1. **Make sure your camera is set securely on a tripod.**

2. **Compose the image through your viewfinder.**

3. **Set the ISO to the lowest native setting on your camera, usually ISO 100 or 200.**

4. **Set the exposure mode to manual (M) and the aperture to f/9.**

5. **Set the shutter speed to 5 seconds, and take a photo.**

6. **Check the image on the back of the camera using the LCD.** If the image is too bright, make the aperture smaller by using a larger f-number (f/11) and shoot again. If the image is too dark, increase the shutter speed to 6 seconds, and shoot again.

Keep adjusting the shutter speed and aperture until the image looks right on your camera's display. The camera's built-in light meter will be no help during this type of photography.

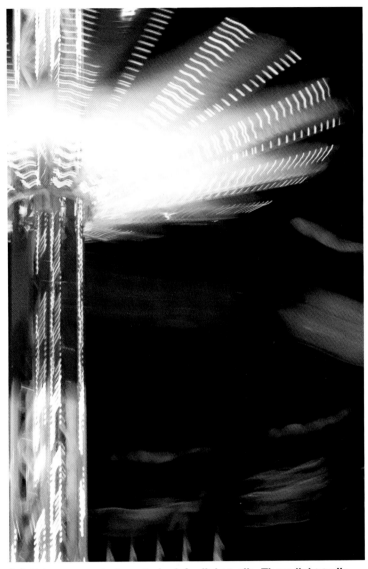

9.4 Fairs are great places to look for light trails. These light trails were formed by the lights of the swing ride. Taken at 1/6 second, f/7.1, ISO 200.

When it comes to photographing fireworks, the basics are the same, but fireworks are actually very bright so the initial settings are a little different. Again, you must set your camera on a tripod. This keeps your camera steady during the long exposure needed for this type of photography. I have found that these steps are a good starting point when shooting fireworks:

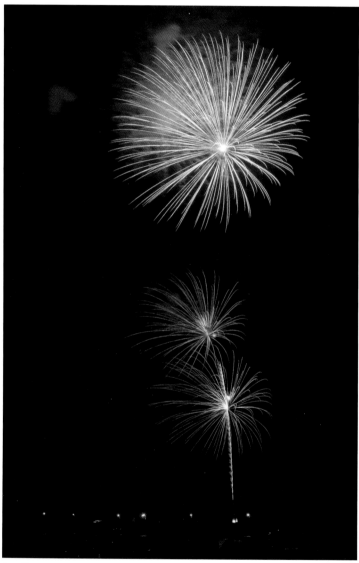

9.5 Fireworks explode over Ocean Beach on the 4th of July. These were photographed using a tripod and a long focal length to fill the frame with the fireworks. Taken at 5.7 seconds, f/11, ISO 100.

1. **Set the focus to manual, and focus on infinity.**

2. **Set the ISO to the lowest native setting on your camera, usually ISO 100 or 200.**

3. **Set the exposure mode to Manual and the aperture to f/11.** The only change now is the length of time the shutter is kept open.

4. **Trigger the shutter button while watching the fireworks.** Start with a 2-second shutter speed and increase or decrease the speed depending on the fireworks being used.

5. **Check the LCD on the back of the camera to make sure you capture the display the way you want to.**

Remember that the finale will be much brighter than the fireworks leading up to it, so you need to increase the shutter speed to allow less light to reach the sensor.

With cameras that have a Bulb setting, one that keeps the shutter open as long as the Shutter Release button is pressed, you can watch the fireworks and just open the shutter when the rocket enters the frame and close the shutter when the explosion has faded. The metering mode used doesn't matter, because the camera's built-in meter can't meter the exposure correctly.

Photographing Silhouettes

The silhouette is a style of photography that purposely underexposes your subject so it is nearly black or is full black against a brightly lit background. The basic idea is to place a recognizable shape against a bright background and expose the image for the background, which turns the subject black.

To create a silhouette, keep these tips in mind:

▶ **Pick a subject.** Silhouettes work best when you have an easily identifiable subject. The silhouette doesn't have any colors or tone, so the shape of the subject must be compelling.

▶ **Position your subject.** Place your subject directly in front of your light source; in other words, make sure the image is completely backlit. This ensures that the background is brighter than the subject.

▶ **Meter the light.** When photographing silhouettes, you need to get a meter reading for the background, not the subject itself. Use the spot meter to take a reading from the background. The camera sets the exposure settings for the bright light and underexposes the subject.

▶ **Underexpose the image.** As when shooting sunrise and sunset photographs, underexposing the image slightly creates a more striking image. You can either shoot in Manual mode and purposely increase the shutter speed or use the Exposure Compensation to purposely underexpose.

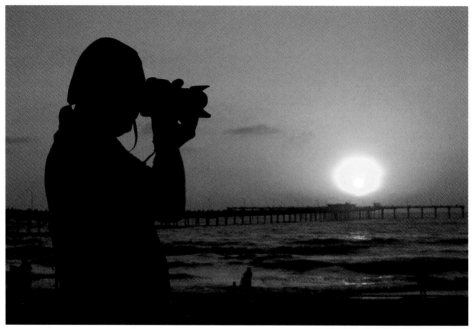

9.6 A silhouette of a photographer shooting right before sunset. Taken at 1/320 second, f/16, ISO 200.

Sunrise and Sunset Photography

The best part about shooting sunrises and sunsets is that a new one appears every day. The worst part about shooting sunrises and sunsets is that the light changes very rapidly, so you don't have much time to get your images.

Everyone loves a good sunrise or sunset photo, and one of the reasons is that the light during those times of day is just plain awesome. The deep reds, oranges, and yellows during this small window of time make for great images. The problem is that when you rely on the automatic modes of your camera, you often can be disappointed with the results. Exposure has a direct effect on colors; overexposing the image makes the color weaker, while underexposing the image intensifies the colors, but only up to a point; then the whole image is too muddy and dark.

9.7 This sunrise was photographed with San Diego in the foreground. Because the image was purposely underexposed, the dark areas start to turn completely black. Taken at 1/90 second, f/5.6, ISO 200.

The easiest way to underexpose the image to get the brightest colors is to set the camera to Spot Metering mode and Program auto mode, and aim the camera at a section of the sky that does not include the sun in it. Look at the reading that the camera came up with, change the mode to Manual, and enter the shutter speed and aperture that the camera calculated. Then underexpose the image by one stop. The easiest way to do this is to decrease the amount of time the shutter is open by one full stop. If, for example, the camera suggests f/5.6, 1/30 second, and ISO 100, you should set the camera for f/5.6, 1/60 second, and ISO 100.

Now is a good time to check the exposure by using the LCD on the camera to see how the colors look. If everything still looks a little too light, then adjust the shutter speed again. As the sun sets, the scene will continue to darken and you will have to adjust the exposure accordingly.

Shooting at Night and in Low Light

When shooting low-light or night photography, the first thing to realize is that the scene probably contains more light than you think. Use the camera's spot meter on

the most important part of the image, so that any large dark areas are not taken into consideration when determining the exposure settings. Shooting in low light or at night is a great time to bracket your images — taking a series of exposures that range from being purposely underexposed to purposely overexposed. This works really well when your camera is held steady by a tripod, and you can take multiple photographs without the composition changing.

See Chapter 1 for more detail on bracketing.

When shooting at night, chances are good that all the light in the scene is artificial light and has different colors. The color of these lights can cause your image to have an unnatural color cast. You may be able to correct this using software later in post-processing, especially if you photograph using RAW. But at times, these colors add to the overall feel of the image.

Colors of light are detailed in Chapter 2.

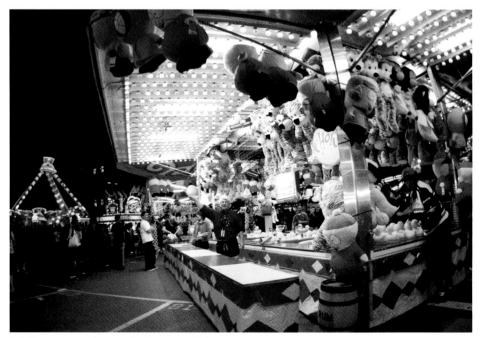

9.8 These incandescent bulbs were lighting up the whole booth and yielded no unnatural colors. Taken at 1/40 second, f/2.8, ISO 200.

One of the best times to shoot is right after the sun has set, before the sky turns completely dark. The sky starts to turn a pleasing deep blue, but because this doesn't last for long, you need to be ready to photograph the scene before the sun actually sets.

Bodies of water reflect light and increase the amount of light in the scene. Static subjects make good subjects for night and low-light photography. Buildings and other structures usually have their own light source. When shooting at night, take all the various light sources into consideration.

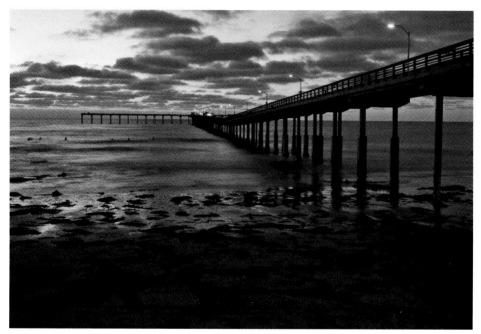

9.9 The Ocean Beach Pier stretches out into the Pacific Ocean. Even though the sun had dropped below the horizon, using a 5-second shutter was enough. The lights reflected in the ocean helped with the exposure. Taken at 5 seconds, f/16, ISO 100.

Shooting Tips

You should keep all these things in mind when shooting in low light or at night.

- ▶ **Use a tripod.** Light-trail exposures need slow shutter speeds, and the best way to keep the camera steady is by using a tripod.

- ▶ **Use the 2-second self-timer or remote.** Pressing the Shutter Release button can cause the camera to shake, which can cause the image to be slightly blurry.

169

Using the self-timer or a cable release or wireless remote will help you avoid this.

▶ **Use the screen on the camera to assess the exposure.** One of the biggest advantages of digital photography is the ability to review the photograph you just took to make adjustments before the next photograph.

▶ **Use the full moon.** To make the most of shooting at night without having to use any extra lights, try to use the light of the full moon. On a clear night, moonlight can be very bright and useful in getting a good image.

▶ **Use the Internet to find out sunrise and sunset times.** You can use Internet search engines such as www.google.com or sites like www.sunrisesunset.com and www.timeanddate.com to find sunrise and sunset times for most areas around the world.

▶ **Arrive early.** To shoot a sunrise, arrive before the sun has started to rise and get set up. After the sun has started to light the sky, you don't have much time to get the shot.

▶ **Bracket your exposures.** The light at sunrise and sunset changes very quickly. Bracketing your exposures helps you get the exposure you want.

Sports and Action Photography

Sports and action photography is all about capturing a very short moment in time. That tiny sliver when the bat hits the ball, the receiver snatches the football out of the air, or the surfer rides the crest of a wave. The basics of sports and action photography also can be used when shooting kids playing in the yard or a subject whose motion you want to freeze. Picking the best settings to shoot sports, whether indoors or outdoors, day or night is covered here along with picking the right camera and lenses for the job and some useful accessories that will help you get the shots you want.

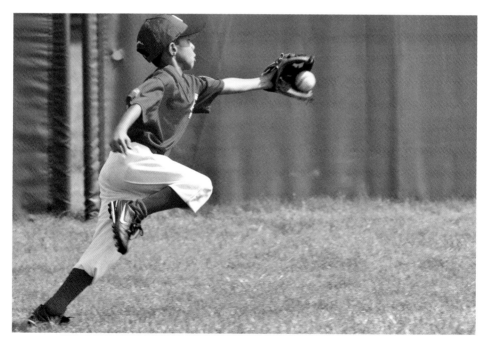

I captured the baseball as the outfielder caught it during a little league game using a 200mm lens with a 2X extender and a fast shutter speed. Taken at 1/1000 second, f/5.6, ISO 200.

Exposure Considerations

This chapter deals with fast-moving subjects, but the real exposure challenge is making sure you get enough light reaching the sensor. The biggest exposure worry is whether you can freeze the action without the resulting image being too dark (underexposed). Fast shutter speed combined with wide open apertures and (if needed) an increased ISO can help you get the best images possible when shooting sports and action. But what shutter speeds and apertures do you need, and when do you need to boost the ISO?

There are three different locations where sports and action photography usually take place, each with its own set of problems, but some of the basics apply to all three locations. There is shooting outdoors during the day, shooting indoors, and shooting outdoors at night. The most important decision is to pick the shutter speed necessary to freeze the action you are shooting. For most sports, even kids running after a soccer ball, a shutter speed of 1/250 second is the absolute minimum that should be used, and I recommend a shutter speed of 1/500 second or even 1/1000 if possible. What this means in practical terms, is that either you need a whole lot of light or you need to use a lens with a maximum aperture of f/2.8 or bigger.

 A list of shutter speed ranges is covered in Chapter 3.

When shooting action coming toward you or moving away from you, you can get by with 1/250 second, but for action moving across the frame, you need much higher shutter speeds. These are the times you need to use shutter speeds of 1/1000 or higher.

Shooting outside during the day

What a great time to shoot sports and action shots: The sun is high in the sky, giving you plenty of light when using shutter speeds over 1/1000 second. You can use lenses that have maximum apertures of f/5.6 without much worry, and you can use the lowest ISO settings on your camera and not be concerned about digital noise. This is the best time to shoot action, and lucky for you, this is when most Little League, kids' soccer, and Pee Wee football games are played.

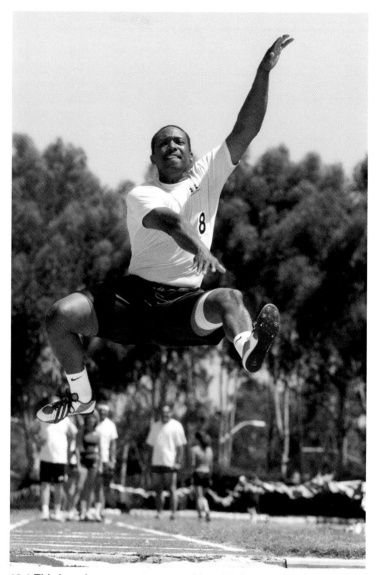

10.1 This long jumper was captured in mid-air using a shutter speed of 1/1250 second, aperture f/5, and ISO 200. The bright light made it possible to use a really high shutter speed without having to raise the ISO or use the widest aperture possible.

Set the camera to Shutter speed priority mode, dial in the shutter speed, and shoot away. This probably will work out great, but you need to take one very important setting into consideration. You need to make sure you're not underexposing your subjects because of the brightness of the sky. I know this sounds counterintuitive, but

when the sky is very bright, the whole scene you're shooting becomes very bright and the camera still wants to use a setting that will result in an overall scene with an 18 percent gray value. If the area surrounding your subject is very bright, your subject could end up underexposed.

The easiest way to fix this problem is to make sure you set the camera's metering mode to Spot metering. The bright sunlight can cause a big difference in meter readings between your subjects and the very bright sky and between the subject and the brightly lit surroundings. Using Spot metering helps make sure the exposure is accurate for the subject, not the brightly lit ground behind the subject.

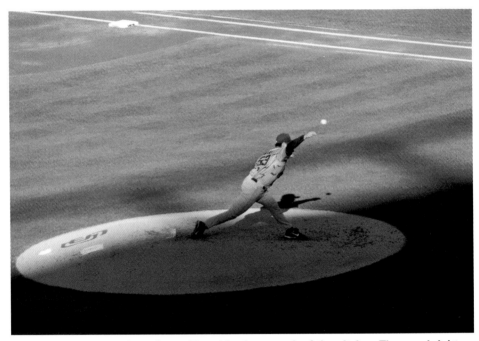

10.2 I used Spot metering when taking this photograph of the pitcher. The very bright green grass on one side and the dark shadows on the other would have not given me the exposure I wanted. I used a shutter speed of 1/1250 so the ball would be frozen in the air, and even at that speed the ball is blurry. The variable aperture lens was zoomed out to 200mm, which made the widest aperture f/6.3. To help with getting the fast shutter speed, I used ISO 320.

Another thing to remember is that you should keep the sun behind you or at least 90 degrees to the side of the action. If the sun is behind your subject, you're likely to capture only a silhouette and lots of lens flare. Cloudy days, while maybe not that

great for the participants playing the sports, are great for photographing the action. With no hard shadows and more even overall lighting, you can get good exposures and not too bright highlights and too dark shadows. The problem is that with clouds and lower light, higher shutter speeds become more difficult to obtain, and faster lenses and/or higher ISOs are needed. The difference between a bright, sunny afternoon and one with heavy cloud cover can be as much as four stops of light, meaning that to use the same shutter speed and aperture, you would have to change the ISO from 100 to 1600. The noise levels at ISO 1600 may not be acceptable, which means you either have to use a slower shutter speed or a wider aperture.

Shooting inside

The goal when shooting indoor sports is the same as when shooting outdoors: freeze the action. Shooting inside is much tougher than shooting outside because you are depending on the lights in the room, and they usually are not very bright. The solutions are to use a lens with a wide maximum aperture and raise the ISO as much as possible without producing too much noise.

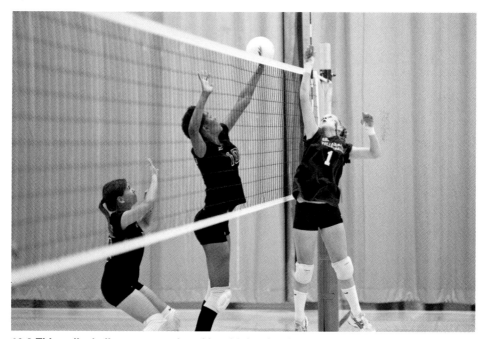

10.3 This volleyball game was played in a high school gym with very poor lighting. I used a shutter speed of 1/400 second to keep the girls and ball in focus. Taken at 1/400 second, f/1.4, ISO 1600, to freeze the action.

The good part about shooting inside is that you are more likely to be closer to the action, which means you don't need a long telephoto lens.

When shooting inside, I use Spot metering mode so that only the brightness of the light being reflected off my subject is used to calculate the exposure. I then set the camera to Shutter speed priority mode and set the shutter speed to freeze the action. The camera uses the widest aperture available, and chances are good the scene is still underexposed. Now I increase the ISO until I get a proper exposure reading in the viewfinder with the selected shutter speed. In an indoor gym, that means using ISO 800 to 1600.

Shooting outside at night

Shooting outside at night is much like shooting inside; you are depending on the external lights to illuminate the scene. Using Spot metering mode can ensure you expose only for the subject and that any very dark areas in the frame are ignored.

The first time I shot a nighttime sporting event, I was amazed that even though the lights looked very bright, they really weren't. When I looked through the camera viewfinder, I saw that I was going to have to really increase the ISO to use a shutter speed that would freeze the action. I used a lens that had a maximum aperture of f/2.8, and I still needed to use ISO 2500 to capture the football player in figure 10.4.

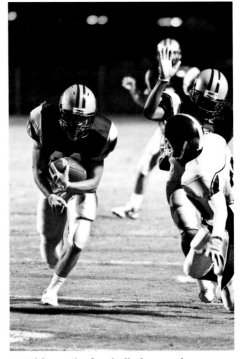

10.4 I froze the football player using a shutter speed of 1/250 second because he was running toward me. I used the widest aperture available on the lens, f/2.8, and still had to drastically increase the ISO to 2500 to get the shot.

The Right Equipment for the Job

Check out the sidelines of any professional sporting event and you will see the sports shooters with their cameras and long lenses supported on monopods. While the top professional sports photographers use the fastest professional camera bodies and lenses, you can get great results using your camera and lenses to the best of their ability.

Cameras

Professional sports photographers carry two or more camera bodies when shooting a sporting event: one with a very long lens to capture the far away action and one with a shorter focal length lens to capture the action up close. The truth is that any camera can be used to shoot sports and action photography if used correctly

Your first step should be to turn on continuous shooting mode. Most dSLRs available today have a continuous shooting mode where the camera keeps taking photos as long as you hold the Shutter Release button down. Using this mode helps capture the action and reduces your chance of missing the crucial moment.

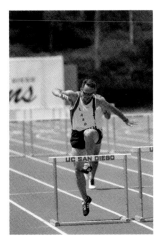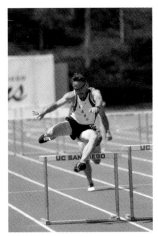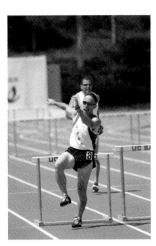

10.5 This sequence was taken using continuous mode. Had I just tried to capture the runner going over the hurdles, I might have missed it, but being able to start photographing at the beginning of the jump and keep taking shots during the jump allowed me to capture the moment he cleared the hurdles. All three images were shot at 1/800 second, f/5.6, ISO 200.

The second thing you want to do is shoot using JPEG instead of RAW. Because JPEG files are smaller than your camera's RAW files, shooting in JPEG allows your camera's buffer to empty faster and allows the images to be written to the memory card faster. This allows you to take more photos in less time. Just to be open and honest, I do all my shooting in RAW mode. To me, the ability to edit the settings later using software outweighs the advantages of capturing images faster, but try it and see if it makes a difference in your shooting.

One of biggest differences between professional and consumer digital cameras is the amount of images that can be taken before the camera buffer fills. Many consumer cameras can shoot at approximately 3 frames per second using RAW files where the pro cameras can shoot at roughly 10 frames per second using RAW files.

 For more on file types, see Chapter 1.

Lenses

Have you ever seen the guys on the sidelines of a professional football game? They have really big lenses because they need to get really close to the action. When shooting sports, getting close to the action is important, meaning you need to use a lens with a long focal length.

On a camera with a cropped sensor, a 70-300mm zoom lens gets you pretty close to the action, anywhere from 45 to 150 feet away, which is really great for outdoor sports. Of course, if you are farther away from the action, you need a longer lens to get really close. Lenses that can zoom out to 300mm, can fill the frame with action happening across a field. The downside to all the lenses is the variable maximum aperture.

As I wrote in Chapter 4, variable aperture lenses are produced by lens manufacturers to help keep the costs down, making the lenses available to a wider customer base. That means the maximum aperture changes depending on the focal length used. As you zoom in, the maximum aperture is reduced. Both these lenses have a maximum aperture of f/4 at the 70mm focal length and f/5.6 at the 300mm focal length, but other lenses have different maximum aperture settings.

These lenses work great when used outdoors in bright light. A shutter speed of 1/500 second with an aperture f/5.6 is possible; the problem is when the light starts to fade or you are shooting inside or outside at night. When the light is low, you have a harder time using high shutter speeds with apertures of f/5.6 without raising the ISO. If most of your shooting is done in lower light, then look at lenses with wide apertures.

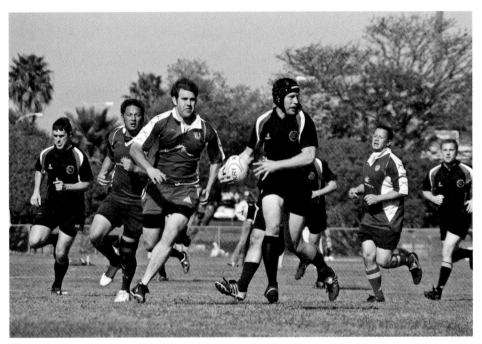

10.6 I photographed these rugby players using an 18-200mm f/3.5-f/6.3 lens at the 200mm focal length, which meant the aperture was f/6.3. Because I had plenty of light, I shot this at 1/1000 second and ISO 200.

Telephoto zoom lenses with constant wide apertures are very expensive. For example, a Nikkor 200-400mm f/4G IF-ED lens retails for more that $5,000, which is more expensive than nearly all the dSLR camera bodies on the market today. The advantage of these lenses is that they can get you really close to the action and can be used in low light. If you don't need to reach quite that far, or don't want to spend that much money, a great lens for shooting in lower light is the 70-200mm f/2.8 lens. Every camera manufacturer has a lens in this focal length range, and even though it is still an expensive lens, it is not as expensive as the longer lenses.

A third option is a fixed focal length lens, also known as a prime lens, which can have an even wider maximum aperture than any of the zoom lenses mentioned previously. These lenses can be very expensive, but if you want to make a living at shooting sports, then they are a necessity. The usual focal lengths of these lenses range from 200mm to 600mm and can cost over $10,000. These lenses let you get in very close to the action and can be used in low light.

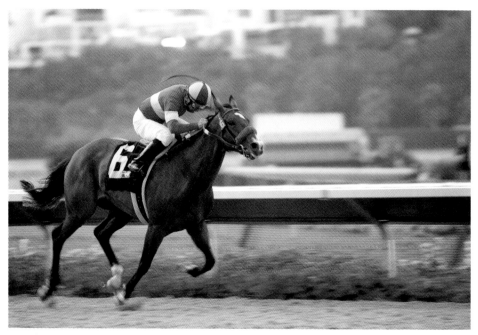

10.7 Getting in close took a 70-200mm lens. I purposely used a slightly slower shutter speed to capture some motion in the image. I shot this at 1/160 second, f/2.8, ISO 640. I needed to increase the ISO because the sun was setting and the light was fading fast.

When shooting inside, you can use a prime lens that isn't as long as those needed outside. Lenses with focal lengths of 50mm can be used inside easily, and these lenses typically have a maximum aperture of f/1.4 and even f/1.2. I use an 85mm f/1.4 lens when shooting indoors, which lets me get close and use a lower ISO.

Accessories

There are a few very useful accessories when it comes to shooting sports and action. These are the monopod, which will help with stability when using long lenses, and lens hoods, which will help when shooting in the sun.

▶ **Monopods.** When shooting sports outside, hand-holding a long lens can quickly become very tiring. That's when a monopod comes in handy. A monopod is like a tripod, except it only has one leg, and is used to stabilize a camera and lens. Using a monopod allows a photographer to hold the camera steadier and is really helpful when using long lenses. I use a monopod when shooting sports and action, especially sports such as surfing where I follow the action through the viewfinder. However, monopod, unlike a tripod, cannot hold a camera steady all by itself. The monopod needs you as the photographer to supply the other two legs of the tripod. The biggest advantage of using a monopod is to hold the camera up and relieve the strain on the photographer.

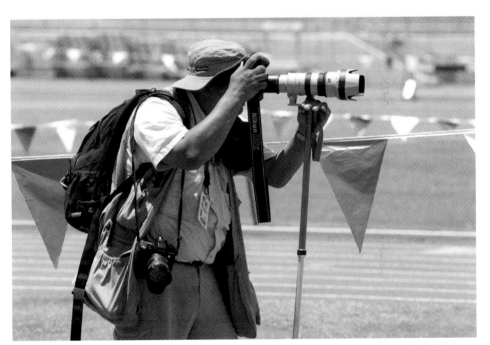

10.8 This photographer covering a track and field event is using a monopod to hold his lens steady. Also note that the lens has a hood in place. Taken at 1/800 second, f/6, ISO 200.

▶ **Lens hoods.** When I shoot sports, I like to make sure that all my lenses have lens hoods in place. The lens hood is that piece of plastic, metal, or other light-weight material on the front of the lens that keeps the sun from creating a glare or lens flare. Lens hoods are different sizes, and those on wide angle lenses tend to be smaller so that they don't cause vignetting at the edges of the image.

Shooting Sports and Action Photographs

You've probably heard that saying that a little knowledge can go a long way, and that is very true when it comes to shooting sports and action. Knowing the sport you are shooting increases your odds of getting the good shots. If you know when and where the action is likely to happen, you can plan ahead to capture it.

Get into position

Knowing how the action plays out helps you pick the best place to capture the action. Think of how the action works during a kids' soccer match. To see the whole game, you need to be positioned at the midfield point, but is that really the best place to photograph the action? The answer is no; the best spot to shoot the action is from the corners of the end zone, which give you a better view of the kids coming toward you. If you station yourself at the corner of the opposing team's end zone, you can capture your team as they come to score a goal, making for a better sports photograph.

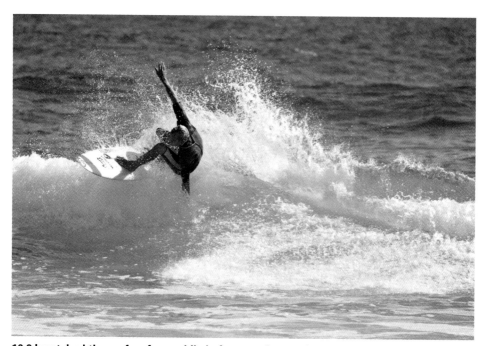

10.9 I watched the surfers for a while before starting to shoot, and when this surfer took off on a wave, I was able to track him and capture the cut. I shot this at 1/1600 second because the surfer was moving across my view, and higher shutter speeds are needed to freeze this action. I used ISO 100 and aperture f/3.2. I shot in Shutter speed priority mode using Spot metering with the spot on the surfer, not on the bright white water.

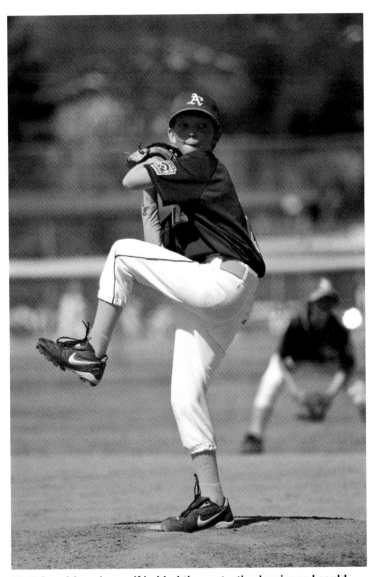

10.10 I positioned myself behind the protective barrier so I could photograph my nephew as he pitched in a Little League game. Because I was behind the batter, I could zoom in and capture the look on the pitcher's face. I got as close to the barrier as possible and used a 300mm focal length lens and the widest aperture possible on the lens, and the barrier just disappeared. I shot this at 1/2500 second, f/4, ISO 100.

When shooting indoors in lower light, if you know the times when the action slows, you can use a slower shutter speed and still capture the action. For example, when the action in a basketball game is going fast and furious, it's very difficult to freeze a player as he shoots for the basket, but when someone is shooting a free throw, the action slows down considerably and you can use a much slower shutter speed to still capture a player in the middle of a shot.

Figure out which mode to use

Freezing action is the most important part of shooting sports and action, and the best way to do that is to use Shutter speed priority mode because you can make sure to use a high enough shutter speed. Another method uses the highest possible shutter speed and the biggest aperture. This combination really makes the subject of your photo stand out against the background. In this method, you use Aperture priority mode and set the aperture at the biggest opening possible on your lens. Because aperture and shutter speed work together, the wider the opening in the lens, the shorter the amount of time the shutter has to be open.

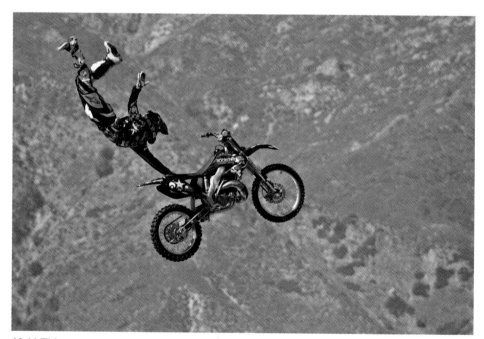

10.11 This motocross biker flying through the air was captured at 1/1600 second. I set my lens to Aperture priority mode and kept the aperture wide open at f/2.8. I fired away in Continuous shooting mode. I shot this using ISO 200.

When you use Aperture priority mode to shoot sports and action, the camera is always using the fastest shutter speed possible for the light available and the lens attached. Be aware that with variable aperture lenses, the widest opening can change as you zoom, meaning that your shutter speed can change as you zoom.

Suppose you are using a 70-300mm f/4-5.6 lens at 70mm in Aperture priority mode and you set the aperture to f/4, which allows you to use a shutter speed of 1/500, and you zoom in on the action so the focal length goes from 70mm to 300mm. The aperture gets smaller by a full stop and is now f/5.6. To keep the exposure correct, you need to reduce the shutter speed by a full stop to 1/250, which might be fast enough or it might not. One solution is to raise the ISO by a full stop, and then you can still use the 1/500 second shutter speed.

Get good non-action action shots

When the action slows down is a great time to take photos, and because the action isn't as fast, you can use a slower shutter speed when shooting inside or outside in low light. You also can use a lower ISO.

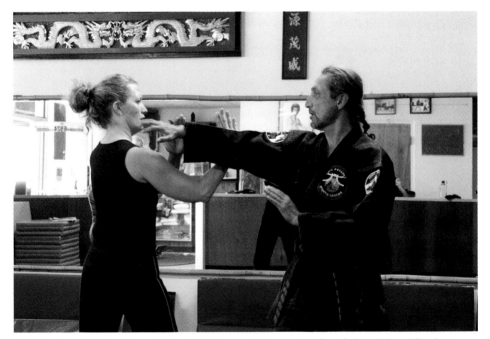

10.12 Instead of shooting during the full-speed demonstration, I shot this while they were going slowly through the moves. I was able to freeze the action using a shutter speed of 1/40 second, aperture f/3.2, and ISO 400.

Photographs of a home-run celebration or the look as the losing team walks off the field can both be very powerful images. Getting these shots is not that difficult if you keep your eye to the viewfinder and look for these opportunities after the action has ended.

Shooting Tips

Shooting sports and action is, by nature, fast-paced and can be quite stressful. These tips can help with your shooting experience.

- ▶ **Know your sport.** Knowing the sport lets you know where the action is likely to take place. In surfing, for example, you can watch the surf and start to see patterns in the way the waves break, and this lets you anticipate where the surfer will appear, so you're ready to capture the action.

- ▶ **Watch the sport for a few minutes before shooting.** If possible, watch the game for a few minutes before bringing the camera to your eye. It helps to see where the action is taking place and where to focus to get the best shots.

- ▶ **Anticipate the action.** Sporting events move quickly, and you need to be ready to press that shutter button. The best way to do this is to make sure that both you and your camera are focused on the action. Watching the action through the viewfinder lets you be ready to press at the optimal time.

- ▶ **Watch your shutter speed.** If you drop too low, the action is blurred, and unless that is what you are going for, you need to keep the shutter speed up around 1/250 second at a minimum.

- ▶ **Shoot using the widest aperture possible.** Shooting with the widest possible aperture lets you use the highest possible shutter speed, which helps freeze the action. It also blurs the background, which helps keep the focus on the main subject.

- ▶ **Look to use different angles.** Sometimes you want to kneel down and shoot from a lower angle, especially when shooting a field game like kids' soccer. Other times, going a little higher in the bleachers and shooting down results in the best shots. Watch how the light changes when your angle does. When shooting down, the background is the darker ground, and when shooting at an upward angle, the background could be the bright sky.

▶ **Shoot through the fence.** Kids' sports like baseball take place behind a protective fence. Get as close as possible to the barrier, and using a 100mm focal length or longer, focus on the action. Use the shallowest depth of field possible on the lens (largest aperture/smallest number), and the fence will seem to disappear.

▶ **Know the rules.** When going to a professional sporting event, call ahead and check the camera policy. Each sport/venue has different rules regarding photography. This also applies to kids' sporting events, especially when the league or team has hired a professional to shoot the games. Check to make sure you are following the rules so you don't cause the team any problems.

▶ **Ask permission when shooting kids.** I know this has nothing to do with exposure, but this is good to keep in mind for any event. Parents are highly protective of their children, and asking them before aiming your long lens at their children helps avoid any misunderstandings. If the parents are not present, talk to a coach or game official.

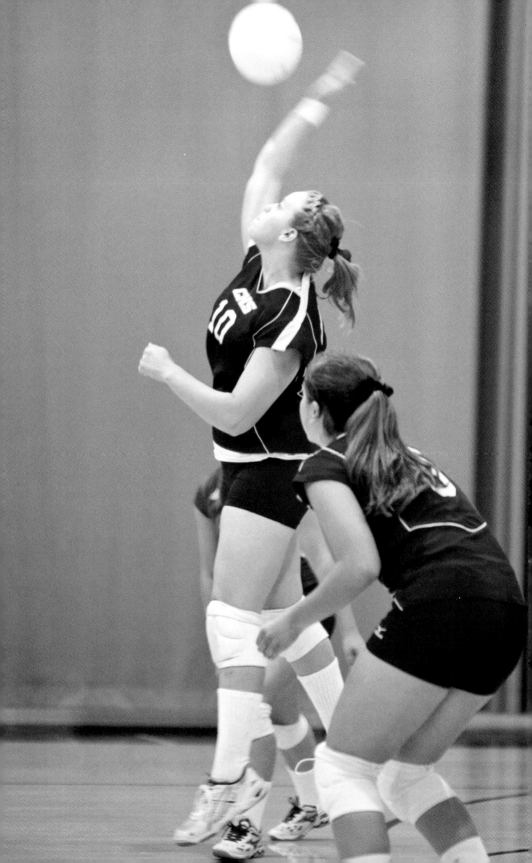

Wedding Photography

Weddings are happy times, and couples want to preserve their wedding memories forever, which is why wedding photography is such a huge business. This chapter helps you get started because chances are good that when your friends and family find out you are even slightly serious about your photography, they will want you to photograph their wedding. This can range from you being the only photographer or just being asked to take a few photos because you are going to be there already. You think to yourself, no problem, I take good photographs and I'll be there anyway; how hard can it be? This chapter can help you get ready for one of the most stressful photography jobs around — from shooting the bride and groom to picking the best gear and checking the exposure on the fly.

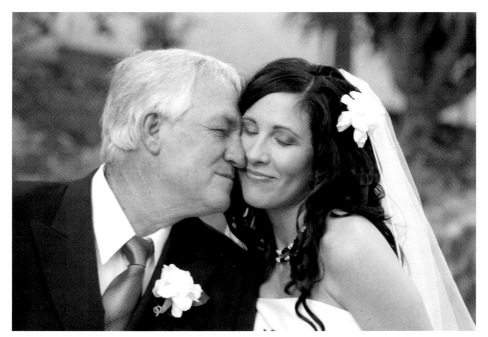

The bride shares an intimate moment with her father before walking down the aisle. Because the light was fading, I used a shutter speed of 1/30 second, f/2.8, and ISO 320.

Exposure Considerations

Shooting a wedding may seem straightforward, but some real exposure challenges exist. The bride, dressed in white, can cause lots of problems when it comes to getting the best exposure. And just when you think you have the exposure handled for the bride, the groom dressed in a dark tuxedo needs a whole different approach to getting the right exposure. Low lighting inside buildings where they don't allow flashes and then a series of portraits outside in whatever light is available all make for difficult shooting.

The bride and groom

The bride and groom are the center of attention, and making sure you capture them in the best way is the most important part of photographing a wedding. Getting the right exposure when photographing the bride can be challenging if she is wearing a white dress because when a majority of the frame is a bright white, the camera's built-in light meter tries to balance the exposure and can underexpose the whole image by up to two stops.

Photographing the groom has its own challenges if he is wearing a dark tuxedo because the large dark areas can cause the camera's built-in light meter to misread the scene and set the camera to overexpose the image by as much as two stops.

These four methods can help you deal with situations like the underexposure of the bride in her wedding dress or the overexposure of the groom in his tuxedo.

▶ **Change the metering mode.** Use Spot or Center-weighted metering, and meter off the bride's or groom's face to avoid the large areas of a bright white dress or a dark tuxedo.

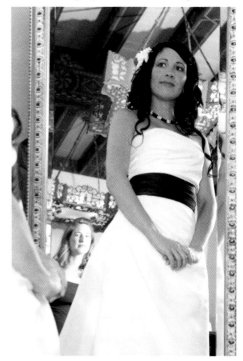

11.1 I used Center-weighted metering taken off this lovely bride's face to make sure the large areas of white stayed white and the image didn't end up underexposed. Taken at 1/60 second, f/4.8, ISO 200 with a flash bounced off the ceiling.

▶ **Utilize Exposure Compensation.** Use Exposure Compensation to purposely overexpose the bride's image to keep the white dress bright or underexpose the groom's image to keep the tux dark.

▶ **Shoot in Manual mode.** Use Manual mode to set the shutter speed and aperture yourself, allowing you to purposely underexpose or overexpose the image depending on what it needs. I use the built-in light meter as a guide and adjust the exposure based on the camera's readings.

▶ **Shoot in RAW and then adjust the exposure in post-processing.** You can use software such as Adobe Camera Raw to achieve the best results. All software programs available for digital photographers have exposure adjustments that allow the photographer to "fix" the exposure.

Shooting inside

Many weddings take place in a house of worship where the lighting is low and the use of a flash is prohibited. This can be a significant problem for a wedding photographer and one that requires a hardware solution. You need to use as fast a lens as possible. A fast lens has a maximum aperture of f/2.8 or wider. You also need a lens with a longer focal length, which allows you to get closer to the action without being a distraction.

Getting the best exposure in this situation is a matter of balancing the shutter speed, ISO, and aperture. Follow these steps when shooting inside during a wedding.

1. **Set the camera to Manual mode.** Start by setting the exposure mode to Manual so you have total control of the shutter speed and aperture.

2. **Set the metering mode to Spot metering.** Use Spot metering to make sure you're getting close to the best exposure by metering on the face of the bride or groom.

3. **Set the aperture.** Start by setting the f-stop to f/2.8 (or wider if possible) depending on the lens you're using.

4. **Set the shutter speed.** Select the slowest shutter speed that will freeze the action, usually 1/60 second. Using a shutter speed of 1/60 second can cause camera shake when using longer lenses, but the small amount of softness caused by camera shake is a fine trade-off for a correctly exposed image.

5. **Set the ISO.** The last thing to do is to adjust the ISO to the lowest possible setting while still getting a good exposure. This is usually in the ISO 800 range but can be higher or lower depending on the amount of light.

Now watch the EV (exposure value) in the viewfinder and adjust either the aperture or shutter speed (or both) depending on the readings from the built-in light meter. When shooting to get the whole room in good exposure, use the scene metering modes, which now do a better job of metering the light than cameras of previous years and generally give the best results.

Exposing for movement

At some point during the wedding, especially during the reception, you'll want to use slower shutter speeds to give the images a sense of movement. The problem is that when you are taking photos of people dancing and use a slow shutter speed combined with a flash, the dancers are frozen in place; so instead of looking like they're dancing, they look like they're standing still.

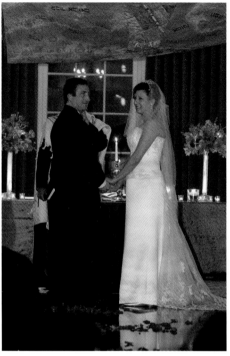

11.2 I took this shot of the couple during the ceremony using the available light, which meant a shutter speed of 1/30 second, f/2.8, and ISO 1000.

You can use the panning technique to follow one of the dancers, preferably the bride or groom, using a shutter speed of 1/15 second or slower. This keeps the subject of your photo in focus while blurring the rest of the dancers. A really nice effect can be created if you set your camera on a tripod and have the bride and groom stand still while the rest of the party goes on behind them. Using a longer shutter speed will make the other guests blur but keep the couple in sharp focus.

For more on using shutter speeds for capturing motion, see Chapter 3.

Evaluating exposure

The advances in multi-segment metering in today's digital cameras have improved the built-in meter readings. This has improved the exposures of images taken when using the camera's choices for shutter speed and/or aperture. It is still very important to

understand when there could be exposure problems so that you can evaluate the exposures and correct anything that is not right.

This is where the LCD monitor on your camera comes into play. You can use it in two ways to help determine whether you have achieved the correct exposure:

▶ **Evaluating the image.** The LCD preview quickly lets you know whether the image is close to what you want in exposure, but it's better at determining the composition and focus. Some cameras allow you to turn on highlight clipping, which causes the sections of the image that are pure white to flash in the preview.

▶ **Evaluating the histogram.** Using the histogram is a quick and easy way to check the exposure of any image. Because the histogram works by graphing the tones in the image, you can easily see whether the image is light or dark. A histogram with more information to the left is darker and any information on the far left is pure black, while a histogram with more information on the right is lighter and information on the far right is pure white.

For more on histograms and using histograms for evaluating exposures, see Chapter 2.

A great photography tool is the Hoodman HoodLoupe. The loupe allows glare-free viewing of your images using the LCD on the back of the camera. Using the loupe helps you evaluate the image and the histogram, especially when shooting outside in bright light.

The Right Equipment for the Job

Professional wedding photographers usually carry lots of camera gear because shooting a wedding is really a combination of different types of photography. The portrait photography part occurs when shooting the bride and groom in a posed setting, and the event photography takes place when shooting the wedding ceremony itself, which can involve shooting indoors in low light. The candid portraits of the newlywed couple and the guests are captured during the reception. And don't forget the action shots as the brides tosses the bouquet or the guests twirl around the dance floor.

Camera bodies

Professional photographers usually carry at least two camera bodies, each with a different lens so they can switch cameras instead of lenses. It takes less time to switch

cameras than to switch lenses, which minimizes the chance of missing any of the important moments. In addition, a camera is more vulnerable when it is open to the elements as you are switching from one lens to another.

Many camera bodies are on the market right now, and chances are good that you already have one. If you plan on shooting lots of weddings, at some point, you will want to add a second camera body to your system. If you are just starting out, having two camera bodies may not be feasible, but a good alternative is to make sure you have the lenses you need easily accessible and you have practiced changing the lenses quickly. If you already have a camera and lenses, getting a second camera the same brand as the first is a good investment. That way, you can use the same lenses and accessories on either body. Keep these things in mind when looking at cameras:

▶ **High ISO capabilities.** Camera manufacturers have really improved the high ISO capabilities of their cameras. Being able to use ISO 800 to 3200 with low noise makes it possible to shoot indoors in low light with better results than ever before. This means you can use faster shutter speeds and narrower apertures because you can use higher ISOs.

▶ **Battery pack/vertical grip.** Other than the very top-of-the-line cameras, which come with built-in vertical grips and more battery power, most consumer and prosumer digital cameras have an optional battery pack/vertical grip that can be purchased separately. These external battery packs/vertical grips allow you to shoot longer without having to change batteries and make the camera easier to hold if you have big hands or want to shoot in portrait orientation.

▶ **Sensor size.** Today's digital cameras have two basic sensor sizes: the full-frame sensor and the cropped sensor. The full-frame sensor has the same dimensions as a 35mm film frame, while the cropped sensor is smaller than a 35mm film frame. The cropped sensor records a narrower depth of field than the full-frame sensor, meaning that your wide-angle lenses aren't as wide, but the telephoto lenses have more reach.

For more on cropped sensors, see Chapter 7.

The most important thing to know about your camera body is how to change the settings. Practice changing the shutter speed, adjusting the aperture, and picking the right ISO without having to study the camera. You also want to know the usable ISO range of your camera, and whether it can be used at ISO 1600 without too much noise or whether ISO 800 is the highest you want to shoot. Knowing this is key when deciding what settings to use.

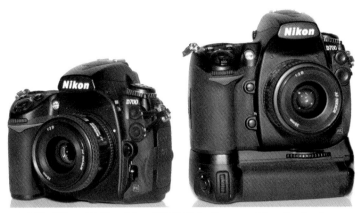

11.3 This Nikon D700 with a MB-D10 battery pack/vertical grip attached allows for longer shooting without changing batteries; the vertical grip helps when shooting in portrait orientation.

Lenses

Because a wedding can take place in a variety of locations, a wedding photographer needs to be prepared. The ceremony may take place in a dark church where a flash is not an option or even allowed, so a lens that has a maximum aperture of f/2.8 or wider is a necessity. These lenses are not very expensive and can really give you many options in all kinds of photography. Another reason to use lenses with extremely wide apertures is that you can then use a shallow depth of field to make the bride and groom stand out from the background.

You also need to have a lens for portrait shots, including the individual shots of the bride and groom and the group photographs of the wedding party, family, and friends. As the photographer, you can either have an assortment of prime lenses or a zoom lens that covers a variety of focal lengths.

For more on portraits, see Chapter 7.

A super wide-angle or fisheye lens can open creative doors. Using one sparingly can add some great photographs to your work, but be aware that the distortion inherent in fisheye lenses can cause people to look warped and distorted.

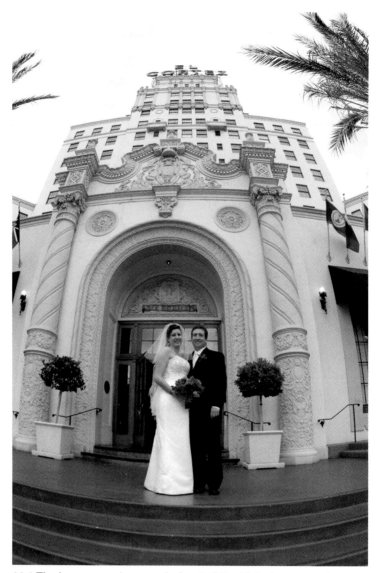

11.4 The happy couple poses in front of the historic venue where the wedding was held. The fisheye adds a distorted effect on the building. Taken at 1/60 second, f/5.6, ISO 100 with a 10.5mm DX lens.

A long lens with a focal length of 200mm or more is very useful when shooting the ceremony and candid shots of the wedding party and guests. A 200mm lens with a maximum aperture of f/2.8 is even better because you can use it in low light. You can get 70-200mm f/2.8 lenses for all cameras, but they are expensive.

Many of the zoom lenses available are variable aperture lenses, that is, they are lenses where the maximum aperture changes as the zoom changes. This allows lens manufacturers to create lenses cheaper than the fixed focal length counterparts. Great variable aperture lenses are available, and using one is fine, but pay attention to the aperture when you are changing the zoom.

For example, if the 24-120mm lens is marked f/3.5–f/5.6, then the maximum aperture at 24 is f/3.5 and the maximum aperture at 120mm is f/5.6. When shooting in Aperture priority mode, the aperture changes as you zoom out and the shutter speed gets slower.

Dedicated flash

A very important piece of equipment for any wedding photographer is a dedicated flash. A dedicated flash can help you especially when shooting portraits indoors and outside. The advantage over the built-in flash is twofold; the angle at which it can be used and the ability to use it off the camera.

A dedicated flash can have its flash head angled so you aren't firing directly at the subjects, but rather bouncing the light off a ceiling or nearby wall, resulting in a softer, more even, light. This is also possible when shooting outdoors. Using fill flash outdoors helps to eliminate harsh shadows especially when shooting in strong sunlight. Tilt the flash head up at about a 45-degree angle, and rotate the flash to one side or the other so the light doesn't strike the subject directly, and then change the flash compensation to –1 or –2 depending on how much you want the flash to light up. Check the results in the camera's LCD, and adjust if needed.

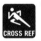 For more on flash compensation, see Chapter 1.

A dedicated flash can be removed from the camera and fired remotely either using the built-in capabilities of the camera (certain Nikon and Sony cameras) or with a remote trigger or off-camera flash lead. This lets you move the flash to where it will provide the best light for the scene.

Accessories

Lots of different accessories are available for all types of photography, and what you might take along for a wedding shoot varies depending on your shooting style and the time allotted for the photographs. I like to have these things with me at a wedding:

▶ **A tripod.** Tripods let you set up a camera and keep it steady while shooting. This may not seem like a great wedding photography accessory, but it can be very useful when shooting in low light. Getting some shots inside the venue under natural light can be difficult if you're handholding a camera, but with a tripod you can use much slower shutter speeds without resorting to a shallow depth of field or high ISO.

▶ **Reflectors and diffusers.** These help to modify light and can be used to get better exposures. Reflectors help by reflecting or bouncing the light onto the subjects, while diffusers help to soften the light when placed between the light and the subject. You can use these tools by yourself, but having an assistant really helps.

▶ **An assistant.** Technically, an assistant isn't a photography accessory, but having one is very useful at weddings. Getting all the folks in place for group photographs is difficult enough, but you also have to make sure you have the right lens on the camera and hold a reflector so that the light is even across the whole group. This is where an assistant comes in very handy, and if that assistant can also take a few photographs, then that's a bonus.

Shooting a Wedding

Weddings don't stop, and if you miss the shot, you don't get a second chance. The first kiss, the exchange of rings, the first dance — all these are moments that can't be repeated. As the photographer, it's your responsibility to be ready to capture them. Meeting the expectations of the bride and groom can be difficult if you don't make sure you are on the same page from the start. Long before the actual wedding day, you should sit down with the bride and groom and discuss what they expect from you and what you can expect to see. This meeting also gives you a chance to discuss the "look and feel" the couple wants in their photos. Some couples want the images to be light and bright, while others want their images to be darker and moodier.

You also should make sure you get to see the venue prior to the wedding day, so you can plan where to do the formal portraits and figure out how much light will be available for the ceremony and during the reception. All these parts let you make up a wedding day plan. The first step is to create a list of the photographs that the couple must have. You can have a generic list already made up of images you think they will want, which can help to make sure they don't forget anybody, or ask the couple to provide a list that you can add to.

I like to divide a wedding into five shooting sections and keep the different exposure needs in mind when planning what I need for each section.

Getting ready for the bride

The wedding day starts and ends with the bride. I usually start by shooting the bride getting ready. Chances are good that she spent long hours picking out that perfect wedding dress and the perfect shoes; make sure you spend time photographing them.

When capturing these types of shots, I usually set my camera to multi-segment metering mode and Shutter Priority mode with the shutter speed to 1/30 second and a dedicated flash unit aimed at the ceiling, or rear curtain sync. This allows a little of the ambient light to be in the photo, and because the flash freezes any movement, this usually lets me achieve the best exposures.

Use the camera's LCD to check on the exposure; if the scenes seem to be underexposed, switch the metering mode to Spot metering and make sure you are metering on their faces.

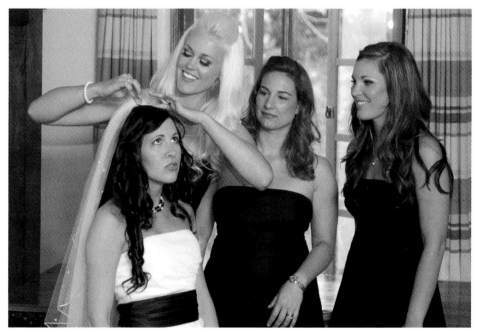

11.5 The bridesmaids are helping the bride adjust her veil. This was shot inside using a combination of the light coming through the side window and an external flash bounced off the ceiling. Taken at 1/30 second, f/3.2, ISO 200.

When shooting the wedding dress alone, watch the exposure carefully because the camera will have a tendency to underexpose the image. And with no bride to meter on, you need to set the exposure compensation between +1 and +2 to keep the dress white. Carefully check your exposure after each shot so as not to overexpose the dress. It is also possible to adjust the exposure in post-processing, which is made easier if you use the RAW file type.

This is also a good time to shoot some of the formal portraits of the bride with her family and bridesmaids. Make sure you have a lens that is wide enough to photograph the whole group. I start by setting the metering mode to multi-segment metering, setting the camera to Aperture Priority mode, and making sure I have a depth of field deep enough to get everybody in sharp focus. If I don't have enough light to use a shutter speed that will keep everyone in sharp focus, I use the external flash to make sure everyone is properly exposed. Remember to adjust your exposure if needed when shooting the bride in her bright white dress.

Getting ready for the groom

The groom is nearly as important as the bride; it's a special day for him as well. Although it's not as important to show the groom getting dressed, a photo of the best man helping the groom with his boutonniere or helping him get his collar straight is a must. If the groom has a special pair of cufflinks or something that holds a special place in his heart, make sure you get a photo of that as well. As with the bride, this is the time to get some formal portraits of the groom, his family, and the wedding party.

It has been my experience that the groom gets ready faster than the bride, and although you'll have some good photographic opportunities here, the most important thing is to make sure the images don't end up overexposed. Keep in mind that if the groom is wearing something lighter, just set the camera on multi-segment metering and you are good to go.

The ceremony

The ceremony can take place anywhere from a sandy beach to the inside of a grand old church. The one thing that never changes is that the photographer needs to work without being a distraction to the guests or the couple. This means using a longer lens and staying in the background, and when shooting indoors, it also means limiting or eliminating flash usage. Some venues don't even allow the use of flashes, so be ready to shoot in very low light. It pays to ask beforehand what the rules and regulations are so you will be prepared. When shooting inside a church or other building, chances are good that you just won't have enough light to get a good exposure without raising the ISO.

If the ceremony is held outside, you still may not have enough light to use low ISOs and fast shutter speeds along with deep depths of field. Practice shooting in low light so when you have to capture the special moment, you will be ready.

When shooting in low-light situations, I set the camera to Spot metering when shooting the people involved in the ceremony and multi-segment metering when shooting the overall scene. These settings determine which part of the scene is the main focus of the exposure settings. If the bride and groom or any member of the wedding party is the focus of the image, then the background exposure just doesn't much matter. If you are shooting a wedding outdoors at the beach or in the mountains or even in a very old and beautiful church, then the exposure of the whole scene is important.

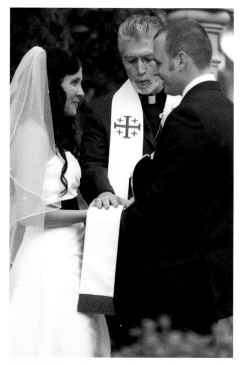

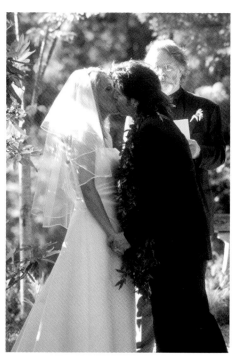

11.6 The blessing over the couple was photographed with a long lens and shot at ISO 400, 1/100 second, and f/2.8, fast enough to freeze the subjects and using a shallow depth of field to blur the trees in the background.

11.7 Getting in place for the first kiss was easy; making sure my exposure setting was correct took a little more work. With the bright light coming from the left, I used Spot metering on the bride's and groom's faces. Taken at 1/80 second, f/5.6, ISO 100 with an 80-200mm f/2.8 lens at the 200mm focal length.

When shooting a wedding ceremony, I try to position myself on the sides and back so I'm not a distraction. Having a second photographer or assistant helps ensure that all the angles are covered. I also meet with the officiator before the wedding so I know the sequence of events. Knowing when the ring exchange, blessing, and first kiss are going to take place allows me to be in position to capture those special events from the best angle.

I make sure to have lots of space on my memory card before the ceremony starts so I don't have to replace the card in the middle of the ceremony and chance missing something. This also is a great time to have two camera bodies, one with a long lens to get close to the action and another with a wide angle to get an overview of the ceremony.

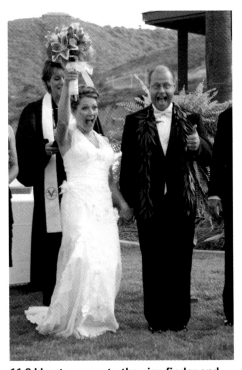

11.8 I kept my eye to the viewfinder and focused on the happy couple as they turned to their guests after the ceremony had ended. Taken at 1/250 second, f/3.5, ISO 100.

The formal portraits

Immediately after the ceremony is a great time to get the formal portrait shots of the wedding couple, their wedding party, and family. I used to handhold the camera when shooting these portraits, but I recently started using a tripod, which has really helped to create better-looking portraits. By setting the tripod at the correct height, I can avoid tilting the camera up or down when shooting.

When you're shooting head and shoulder shots, the camera should be at the bride's eye level. For the full-length portrait shots, the camera should be aimed at the waist of the bride and should be shot straight on. This may seem a little low, but try it at home and see how it looks. For portraits that are not quite full length, the camera should be at the height of the bride's chest.

When it comes to the formal portraits, I usually set my camera to multi-segment metering and Aperture Priority mode with the aperture set to f/5.6 as a starting point. When shooting a large group, like the entire wedding party, multi-segment metering works really well. The biggest problem when shooting outdoors is when the light

starts to drop and the shutter speeds get slower and slower. It becomes more and more difficult to get shots in sharp focus. Increasing the ISO and using a wider aperture are good options, as is adding a dedicated flash.

If you don't have an assistant, ask the best man and maid of honor to help you corral all the people needed for the photograph. While the people are gathering, take that time to get some shots of the bride and groom, and then move onto the group portraits.

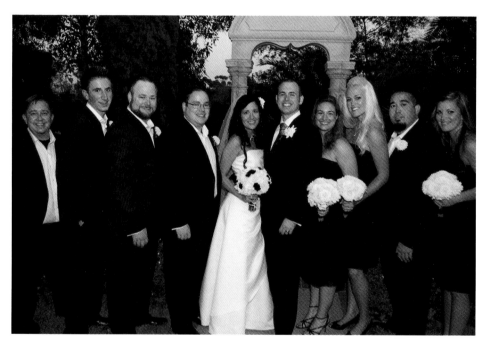

11.9 The group portrait was shot using a wide-angle lens to get the whole group in the shot. The multi-segment metering on the Nikon D2X worked fantastically well, and no adjustments were needed. Taken 1/60 second, f/2.8, ISO 200 with a dedicated flash used for fill.

I like to start with the biggest group of people and slowly work my way back down to the bride and groom. When shooting the formal portraits, you want to eliminate distracting backgrounds. When setting up the group portraits, set the bride and groom in the middle and position the rest of the people around them. This helps cut down on the time needed to take all the photos.

The reception

The ceremony is over, and it's time for the reception. This is generally a party for the guests, but the wedding photographer still has lots of work to do. A great many special moments happen during the reception.

You can photograph everything from the couple's first dance to toasts and speeches, the cutting of the cake, the garter and bouquet tosses, and most importantly, the guests having fun. The key to getting the shots is knowing when they are going to occur and having the right camera/lens combination. I like to use a wide-angle lens for things like the garter and bouquet toss and a longer lens for things like the cake cutting and toasts. Shooting the first dance is a great opportunity to be a little creative. After shooting a couple of standard shots with the action frozen, try using a slower shutter speed to show some motion.

During the reception, a great way to make sure you have photographed all the guests is to photograph the tables. This takes a little help from the bride and groom, but in the end it's worth it. After the couple has had a bite to eat, have them visit each table to greet each group of guests and get a group shot with each table. Using a slightly slower shutter speed, 1/15 to 1/30 second with a rear curtain sync flash allows some of the light from the room to illuminate the groups with the flash, making sure they are not underexposed. Using a dedicated flash aimed 45 degrees over the group causes the light to bounce off the ceiling and light the group evenly.

Shooting Tips

Shooting weddings can be a stressful time with lots going on every moment of the event. These tips can make your life a little easier.

▶ **Shoot RAW.** With the sheer number of photos taken in different lighting situations, shooting in RAW is easier than having to set the white balance for each JPEG shot. The ability to set the white balance and tweak the exposure settings during post-processing leaves you with more time to shoot.

▶ **Use the LCD to evaluate the exposure.** The LCD on the back of the camera is a great tool to check the exposure, but remember that the display is not completely accurate, so also check the histogram for a more accurate distribution of the tones in your image.

▶ **Adjust the metering mode.** Picking the right mode for the right situation helps in getting the best exposure. Using multi-segment metering takes the whole scene into consideration, while Spot metering and Center-weighted metering modes take only a small part of the scene into consideration when metering the light.

▶ **Soften the light.** Using a flash indoors creates flat, unflattering light with harsh shadows. The last thing you want at a wedding is unflattering light, so this is a great time to use a diffuser either on the built-in flash or on an external flash unit.

Wildlife and Animal Photography

Everybody loves animals, and photographing them can be a real pleasure. It also can be much more difficult than it looks, as animals tend to only come out in the morning and evening and will stay away from human contact. So learning to pick the right gear and use the best exposure modes and settings can help. I really enjoy photographing both domestic and wild animals and often head to the zoo for a morning of photography. You can find many opportunities to photograph animals, from the local zoo to a nearby park, or even a photographic safari in Africa. Your own backyard is also a great location. And if you have pets, they can be fantastic subjects. And although the animals and locations may change, the images, if done right, will capture the viewer's attention like very little else.

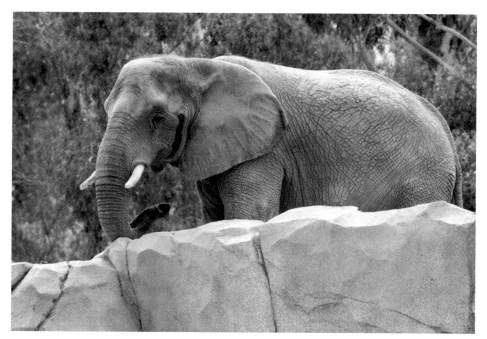

I arrived at the zoo early and photographed the elephants before the crowds arrived. I used Spot metering on the elephant, which is very close to 18-percent gray, giving me great exposure using Aperture priority. Taken at 1/500 second, f/4, ISO 200.

Exposure Consideration

Photographing wildlife and animals can really put your exposure skills to the test. Most of the action in wildlife photography takes place in low light due to the time of day or in deep shadows because that's the natural habitat of the animals you are trying to photograph. You'll have the same problems shooting at zoos because of the man-made structures present. Even the best-designed zoos must have walls to keep the animals in and the humans out. Other structures that present problems include glass enclosures and fences. And then the actual color of the animals can present exposure challenges.

Animals have evolved to blend into the background of their natural environments. This is a natural defense mechanism that has served wild animals well. The challenge becomes how to make the subjects stand out against a background that they blend into naturally. Many of the exposure problems can be solved by picking the right aperture and the right metering mode.

Using Aperture priority mode

Aperture priority mode gives you control of the depth of field in your image. This is particularly helpful when getting a subject to stand out against a background. Keeping your subject in sharp focus and the background blurry naturally keeps the viewer's attention on the subject, even if the coloring and tone are the same. When you use Aperture priority mode, you select the aperture and the camera picks the shutter speed based on the metering mode and the meter reading.

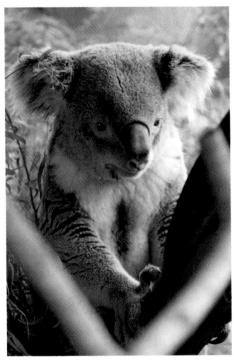

12.1 The koala was shot using Aperture priority to keep both the foreground and background out of focus and keep the attention on the subject. Taken at 1/100 second, f/2.8, ISO 200.

A great deal of wildlife photography takes place in low light. This can range from shooting on safari to shooting at a zoo or even in your backyard. Most animal activity takes place in the early morning and late afternoon. Setting the aperture to its widest setting does two things, both of which are great for wildlife photography:

▶ **Shallow depth of field.** Using the widest aperture (smallest aperture number) possible results in the shallowest depth of field, which makes your subject stand out against its background.

▶ **Fastest shutter speed.** When you use the widest aperture (smallest aperture number), your camera uses the fastest shutter speed available, freezing your subject.

You still need to make sure that the shutter speed the camera has selected is fast enough for your purposes.

 Setting the widest aperture always allows the camera to pick the fastest shutter speed.

Picking the right metering mode

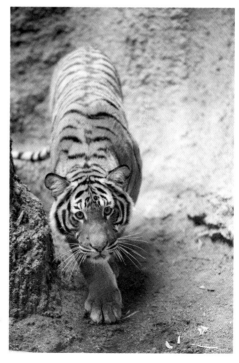

Picking the best metering mode for the situation increases your chances of getting the best shot. The two choices that work best are Spot metering mode and a Scene metering mode. The trick is determining which one is the right one to use.

Spot metering mode

Camera manufacturers spend lots of time touting the advances of their Scene metering mode, but most of the digital cameras still have a Spot meter-

12.2 I used Spot metering mode on the tiger and kept the focus pointed right on the eyes. Taken at 1/100 second, f/2.8, ISO 800.

ing mode. This mode allows you to use a small section of the scene instead of the whole scene for metering purposes. This is the mode I use for most of my wildlife photography. I make sure the camera meters off the face of the animal I am shooting. I always make sure the animal's eyes are in focus and correctly exposed.

Spot metering mode is the only mode to use when shooting birds because they are usually photographed against the sky. If the sky is brighter than the birds, the birds will be underexposed; if the sky is darker than the birds, the birds will be overexposed.

Scene metering mode

Sometimes, Scene metering mode works best. When you manage to get close enough to fill the frame with your subject, switch to Scene metering mode. Some animals throw off the metering just by their coloring, such as the white of a polar bear or the stark white and black of a panda.

 Each camera manufacturer calls Scene metering mode something different. Nikon calls it Matrix metering, Canon calls it Evaluative metering, and Sony calls it Multi-segment metering.

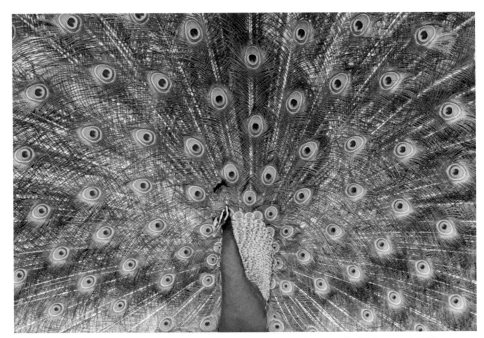

12.3 The peacock was photographed using Scene metering mode. Taken at 1/100 second, f/5, ISO 200.

The Right Equipment for the Job

You can use any camera and lens combination for animal photography, especially when shooting pets or at the local zoo, but some equipment can make getting successful animal photos easier.

Cameras

To increase your odds of getting great wildlife shots, shoot in continuous advance mode if your camera has one. If it doesn't then you will have to practice pressing the shutter button as rapidly as you can to get the same results. When shooting in the continuous mode, you are no longer limited in the same way film photographers were, by the length of the film in their camera.

You are no longer limited to 36 photos on a roll of film; the new 16 GB Compact flash cards can store 600 or more images on a single card. You can shoot all day and never have to change the card. The only limiting factors as to how many shots you can take are the file type you are using and the buffer size in your camera. Even though you can get more JPEG images than RAW images on a card, I recommend that you shoot in RAW, because making corrections during post-processing is easier with RAW images.

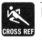 For more on RAW, JPEG and other file types, see Chapter 1.

Different focus modes can greatly help you in capturing moving subjects. Learn about the different auto-focus modes on your camera so you pick the right mode for the right situation. Some cameras offer predictive auto focus, which aids in tracking the action across the frame. This information will be in your camera manual. The downside of using auto-focus is that it needs a fair amount of light and contrast in the scene to lock on. Make sure you know how to switch to manual focus so you can take over from the camera if needed.

Lenses

Wild animals are difficult to get close to, and even those in a zoo or animal park can be quite far away. You need a good telephoto lens with a focal length of at least 200mm. This lets you fill the frame with your subject. One of the ways you can extend the reach of your lens is by using teleconverters. Also, using fast lenses will allow you to shoot using higher shutter speeds in lower light.

Telephoto lenses

You need a telephoto lens when you want to fill the frame with something that is far away. Such lenses let you get close to the action without actually being close to the action. When photographing wildlife in the wild, this is important for two reasons: Wild animals don't like humans very much and usually don't allow us to get close, and wild animals are wild and can be very dangerous. I know that those reasons seem very simple, yet every year people are hurt by animals when they try to get too close. I love photographing the tiger at my local zoo, but I am not going to try to get any closer than allowed.

Many professional wildlife photographers use very long, very fast telephoto lenses. A standard long lens for wildlife shooting is the 600mm f/4 lens, which gets you in really, really close, and when combined with a teleconverter is even more amazing. The problem is that this lens is incredibly expensive and rather

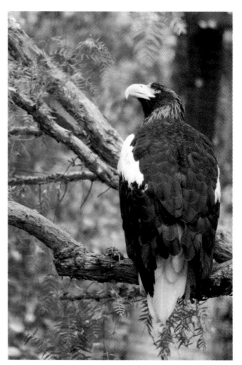

12.4 I used an 80-400mm lens to get in close on this eagle. I waited until the eagle turned to the side before shooting. Taken at 1/500 second, f/5.6, ISO 400.

large. The rest of us have some alternatives. A great many 70-300mm lenses and even some 80-400mm are available for a fraction of the cost of a 600mm lens. Most dSLRs available today have cropped sensors, and unless you are shooting the top models from Nikon, Canon, and Sony, chances are good that you have a cropped sensor. These sensors effectively increase the focal length of a lens by 1.5X, meaning that a 300mm lens on a cropped sensor has the angle of view of a 450mm lens.

Some cameras even let you double the focal length of the lens by cropping the image even more, giving you a 600mm effective focal length from a 300mm lens. The downside to these lenses is that the maximum aperture at the longest focal lengths is usually f/5.6 or smaller. This limits their usage in low light, but with the advances in the higher ISO noise reduction, you can use these lenses and get great wildlife images.

Teleconverters

Teleconverters are specialized devices that are placed between your camera and lens that increase the focal length of the lens. The price for this increase in focal length is a decrease in the maximum aperture. The more the teleconverter increases the focal length, the greater the reduction in the maximum aperture. This affects both the exposure of your images and the ability of your camera to successfully auto-focus. When less light is let through the lens into the camera, the ability of the camera's autofocus system can be reduced. To get the best results, switch to Manual focus if the camera is having trouble locking on with autofocus. When it comes to exposure problems, be aware that you likely will lose at least a full stop of light and also need to increase the shutter speed. That means shooting in bright light or raising the ISO.

Teleconverters were very popular before lens manufacturers started to produce affordable telephoto zoom lenses that matched the quality of prime lenses. Teleconverters usually come in two different sizes: a 2X teleconverter that doubles the focal length of the lens and a 1.4X teleconverter that increase the focal length by 1.4X. These are the two most common converters on the market, but I have seen converters in other sizes between the 1.4X and the 2X. The same rules apply for those. Here's an example of what these teleconverters do:

▶ **2X Teleconverter.** This teleconverter doubles the focal length of the lens it is attached to and reduces the maximum aperture by two full stops. For example, when the 2X converter is attached to a 300mm f/2.8 lens, the lens becomes a 600mm lens with a maximum aperture of f/5.6, and a 70-200mm f/2.8 lens becomes a 140-400mm f/5.6 lens.

▶ **1.4X Teleconverter.** This teleconverter extends the range of the lens its attached to by 1.4X and reduces the maximum aperture by 1.4X. For example, when a 1.4X is attached to the 300mm f/2.8 lens, the lens becomes a 430mm f/4 lens, and when attached to the 70-200mm f/2.8 lens, it becomes a 100-320mm f/4 lens.

Most camera manufacturers produce their own teleconverters, and many third-party teleconverters are available. You can check whether your lenses and camera will work with teleconverters on the lens manufacturer's or camera manufacturer's Web site.

So to get close to the wildlife, if you attach that 2X teleconverter to your 70-200mm lens, you can now zoom in all the way to 400mm. To shoot at this focal length without any camera shake, you need to use a shutter speed of 1/400 second or faster, and because the maximum aperture is now f/5.6, you either need lots of bright light or you need to raise the ISO. You can use slower shutter speeds, but then you need a tripod,

monopod, or other support for your camera. Be aware that your image may not be as sharp with a teleconverter as it would be without.

I really like the ability to double my focal length whenever I want to with a relatively inexpensive piece of equipment that takes up very little space in my camera bag. It all depends on the subject matter and how close I want to get or can get.

Fast lenses

A fast lens, one with a maximum aperture of f/2.8 or faster, is great for wildlife photography. This lets you use the shallow depth of field to really make your subject stand out, but it also allows you to shoot through barriers and make them disappear. This is really useful when shooting at zoos and other areas where fences are between you and the wildlife.

To make a fence vanish, just try the following:

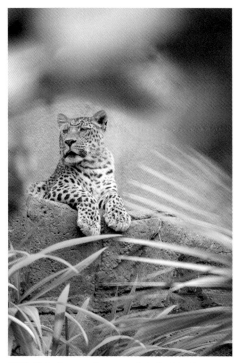

1. **Set the camera to Scene metering mode.**

2. **Get as close to the fence as possible.**

3. **Focus on the animal with at least a 100mm focal length.**

4. **Use Aperture priority mode, and set the aperture for the widest available setting, which also gives you the faster available shutter speed.**

5. **Take the photo.**

6. **Check the LCD on the back of the camera.** If the image is underexposed, raise the ISO. If the subject is blurry, the shutter speed is too slow and you need to raise the ISO.

This technique uses the shallow depth of field to have only the wildlife in focus while the lens blurs the objects that are

12.5 This leopard was safely behind a fence, the same type of fence shown in figure 12.6. Because the leopard was toward the back of the enclosure, I was able to use a shallow depth of field to make the fence disappear. Taken at 1/320 second, f/2.8, ISO 200.

close so they seem to disappear. When the subject is too close to the fence, however, you can't use the shallow depth of field to create any separation between the fence and the animal.

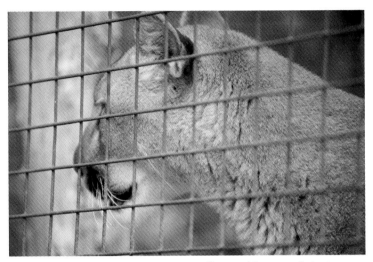

12.6 When shooting at zoos, you usually get this type of shot because of the fenced enclosures. Taken at 1/160 second, f/2.8, ISO 200.

 When the subject is too close to the fence there is no way to use the shallow depth of field to create any separation between the fence and the animal.

Another reason for using fast lenses is that animals tend to be more active during the early morning and late afternoon hours when light is faint. This lower light requires a slower shutter speed or wider aperture, and when you use slower shutter speeds, chances are good that the animal will be blurry in the final image.

Accessories

You may need lots of different accessories when shooting wildlife, from something to hold your camera steady to a way to remotely trigger your camera.

Tripods

I have covered tripods in more detail in earlier chapters, but when it comes to shooting wildlife, especially with a long lens and when using a teleconverter, you really need the support of a tripod. A special type of tripod head, called a Gimbal tripod head, is used in wildlife and nature photography.

These tripod heads allow the camera to be rotated around its center of gravity quickly and easily, which allows the photographer to track the wildlife in the viewfinder while still giving the maximum support. These tripod heads are designed for the larger lens, and they attach to the lens instead of the camera.

 For more on tripods, see Chapter 9.

Monopods

Monopods are single-leg tripods. They trade stability for convenience and work great for stabilizing a long lens. They also are allowed in many places where a full tripod is not and can be moved easily if needed. The monopod usually is screwed straight into the bottom of the camera or into the lens tripod collar. Many tripod manufacturers also make monopods, which can cost less than $50 or more than $300, depending on the construction materials, height, leg sections, weight, and most importantly load capacity. Make sure you choose one that supports your camera.

Think of a monopod this way: It's one leg of a tripod and your legs are the other two. The weight of the camera is held by the monopod, which lets you work on keeping the camera steady and making sure your image is framed the way you want it. The other advantage is that handholding a long lens can get very tiring, and when your arms get fatigued, chances are good that you'll miss the shot. With the monopod holding the camera, you can patiently wait for the right moment to shoot.

Beanbags

Beanbags are great for holding your camera steady when it is on the ground or any other stable surface. You can set a beanbag under the lens to keep it at the right angle and support it during the shoot. Beanbags have a lot going for them; they are inexpensive, and you can make one at home from a pair of old jeans or a shirt. I like to fill my beanbags with rice, because it seems to be the most solid and at the same time most pliable material. Make sure you don't fill the beanbag all the way up because you get the maximum stability when the rice has a little room to move so it can mold itself around a lens. This keeps the lens from moving and results in sharper images.

Remote triggers

Remote triggers are great for getting close-ups of animals without using a long lens or putting yourself in harm's way. For a successful remote trigger setup, you need to be able to set up the camera where you know the wildlife is and be able to trigger the shutter release at the right time.

One of the most dependable remote triggers is called a Pocket Wizard. Most people think of Pocket Wizards as the devices used to remotely trigger flashes, but they also can be used to trigger cameras. Because they work on radio waves, they don't need to have line of sight like infrared triggers do. Keep these things in mind when using a remote trigger:

▶ Set the camera to manual focus, and pre-focus where you believe the wildlife will be.

▶ Make sure the batteries in the camera and the remote are fully charged before setting the camera out, and turn on the camera and the remote.

▶ Make sure the camera is secure and use the appropriate-sized tripod.

▶ Set the camera for Aperture priority, and set the aperture for a wide-open value like f/4 or f/5.6, which should keep the subject in acceptable focus and blur the background.

▶ Set the metering mode to Scene metering because you don't really know in what part of the frame the subject will be.

▶ Use the continuous drive function to shoot a series of images, which increases your odds of getting a keeper.

Pocket Wizards are not cheap, and you need two of them, one for the camera and one to trigger it. To make sure your camera has this capability, check with your camera manufacturer or with Pocket Wizard at www.pocketwizard.com. On the plus side, the same set of remote triggers can also be used to fire a flash off-camera, which can really help with portraits.

 For more about off-camera flash and Pocket Wizards, see Chapter 7 on CROSS REF portraits.

Pet Photography

Household pets are usually not wild animals, although I have come across more than one dog or cat that was a little on the wild side. Pet photography is a booming business. People love their pets, and many times they are considered part of the family. They are included in the family portrait, and will even have their photo taken in studio and on location.

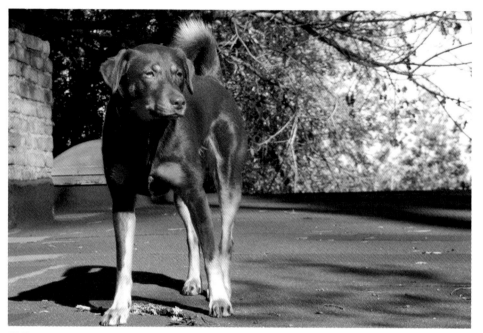

12.7 I shot Jester while she was standing on the roof of the house, lit by the afternoon sun. Taken at 1/80 second, f/10, ISO 200.

Photographing pets uses some of the same techniques as when shooting portraits, with a touch of the wild thrown in. Remember that they are still animals, and if they feel threatened, they will react to defend themselves. The following tips can make it easier to get good pet photographs.

▶ **Consider the personality.** Every pet has his or her own unique personality. A pet's personality is reflected in his actions and expressions. If the pet being photographed is yours, you already know the behaviors to watch for; but if you are photographing someone else's pet, ask her what separates her pet from all others. Most pet owners I have met love to talk about what makes their pet special.

▶ **Use a long lens.** Pets, just like their wild counterparts, do not like to have their space intruded upon by strangers. They can react in negative ways or just turn and run away. The best approach when shooting animals, pets or wild, is to use a longer lens. I really like the 70-200mm f/2.8 lens for getting in close without physically being too close.

▶ **Try a wide angle.** After you have gained the animal's trust, try shooting close with a wide-angle lens. Even the distortion that can be present when shooting people very wide can be used when shooting pets. For some really unique images, try to photograph using a fisheye lens. The effect can be charming when used on a puppy, not so charming when used on people.

▶ **Location, location, location.** Most times, shooting a pet at its home is your best bet. Pets are more likely to act in a natural way if in familiar surroundings. You are much more likely to get a good photo if the pet is relaxed and comfortable.

▶ **Change your point of view.** Try to shoot from the pet's eye level and see the world the way he does. If every shot you take is from above, the images will all look stale and boring.

▶ **Capture the action.** You need to use a shutter speed that will freeze the action of the pet. You need a minimum of 1/250 second, and if you have a very active animal, you may need a minimum of 1/640. If you are having problems getting a shutter speed that fast and still getting good exposure, raise the ISO.

▶ **Shoot one shot with the owners.** Pets are considered part of the family. Make sure you get a shot of the owners along with Fido or Fifi.

When it comes to shooting pets, the action can be fast and you'll have little time to check and adjust the exposure. Added into the mix is the fact that some animals are close to pure black or pure white, and some are a mix of both. This makes getting the right exposure the first time difficult.

I like to set the exposure mode to shutter speed priority to make sure I'm using a shutter speed fast enough to freeze the action. I also switch the metering mode to Spot metering to make sure I'm taking a meter reading only from the part of the image that is most important. When it comes to shooting pets that are very dark or very light, I use the exposure compensation feature. When the pet is very light, the camera underexposes the image to make everything a nice even 18 percent gray. I dial in the exposure compensation so the image is overexposed by 2/3 of a stop.

For animals that are very dark, the camera wants to overexpose them, so the black coat ends up being 18 percent gray coat. For these shots, I underexpose the image by 2/3 of a stop. I then quickly check the LCD on the back of the camera, and with the histogram view, I make sure the pet looks right and the histogram matches the animal's color.

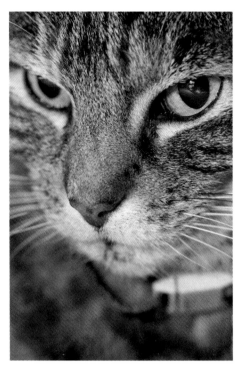

12.8 I photographed our cat using a telephoto lens that allowed me to fill the frame with its face. There is a very shallow depth of field with the eyes and nose in focus but the mouth and collar starting to lose focus. Taken at 1/30 second, f/7.1, ISO 400.

Shooting Wildlife and Animal Photographs

Most people start to shoot wildlife and animals at their local zoo or animal park. This is a great place to start to learn about wildlife photography. Often, the first wildlife photos you take are really animal portraits, and these are easier to take at the zoo.

Very few places can beat the diversity and access to wildlife that a zoo can. If you follow a couple of simple rules, the images that you take at a zoo will look like you were out in the wild:

▶ **Watch the background.** Try to compose your images so the animal fills the frame and any man-made structures are out of the frame.

▶ **Go early.** The earlier you go the better when it comes to the zoo. Doing this helps you beat the crowds, and the animals are more likely to be active early in the day. Look to see if your zoo has early admission, and take advantage before the crowds arrive. Some zoos have special photography programs, check with your local zoo to see if they do.

▶ **Shoot wide open.** Shooting wide open is probably the best single piece of advice for shooting wildlife and animals. It keeps the depth of field narrow so the animals stand out from the background and allows the fastest possible shutter speed so the animals are frozen in place.

▶ **Focus on the eyes.** If the eyes are in focus, the rest of the image will be in acceptable focus; if the eyes are out of focus, the rest of the image doesn't matter.

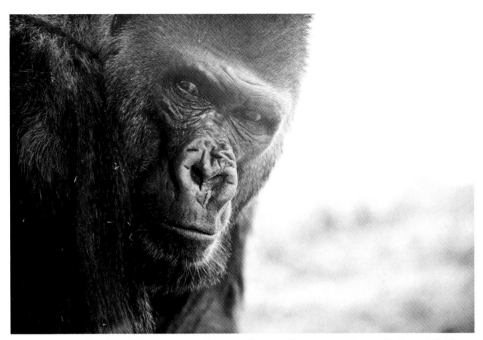

12.9 This silverback gorilla was very close to the viewing area and was sitting with his back to me. I waited patiently until finally he got up and started to walk away when he suddenly turned and looked at me. Taken at 1/50 second, f/2.8, ISO 200. I used Spot metering and set the exposure compensation to underexpose by 2/3 of a stop.

The angle you choose for taking the photo helps determine how the viewer feels about the image. Picking the right angle can change the whole feel of the photograph. If you photograph looking down on your subject, you can create a feeling that's overbearing toward the subject of your image. If you photograph looking up at a subject, you can create a feeling that the subject is dominating the viewer. The best idea is to try to photograph the animal at eye level. I know this is not always possible, but if you can get down or in some cases up to the animal's eye level, the results will be worth it.

Shoot close to home. Most of us live in areas that are not teaming with exotic wildlife, but you can still find many photo opportunities to shoot wildlife, especially birds. You can simply put up a bird feeder in the garden and wait, but waiting is the hardest part.

One of the reasons people love animal photography is that on some level they recognize themselves in their behaviors and expressions. These behaviors are more noticeable when you can see the interaction between the animals. For example, look for the

12.10 This young giraffe thought the peacock was pretty good to snack on. The peacock had other ideas, and soon left the scene. Taken at 1/125 second, f/5.6, ISO 200.

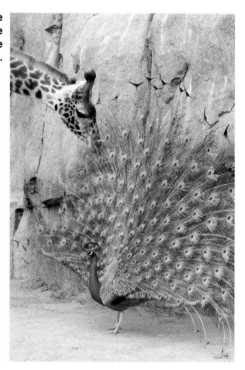

interaction between a mother and her young or between a young giraffe and a peacock, as in figure 12.10. Work on capturing the wildlife in action. Some action is predictable — for instance, if you see an animal running or a bird in flight, you can judge its speed and direction, which allows you to be ready with your camera. The best way to shoot this is to have the camera set to Shutter speed priority and dial in a fast enough shutter speed to freeze the action. Shoot using continuous mode as you track the animal with your camera. You can also use panning to capture an animal running through your

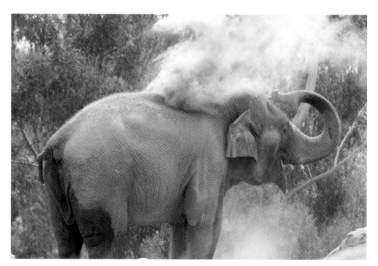

12.11 This elephant was giving itself a dust bath, not that enjoyable to us but a great frozen moment of an animal doing what it wants to do. When shooting at zoos, look for any action to give your images something different. Taken at 1/500 second, f/4, ISO 200.

frame. When framing your shot, leave some space in front of the animal. This makes it look like the animal has some place to go and is not trapped by the edge of the photo.

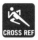

Panning is covered in detail in Chapter 3.

When shooting animals, information is key. Do a little research beforehand, especially if you are going out on a photo safari. Get some books on the animals you expect to see and shoot. Talk to other photographers, and do some Internet research. You can take a great many photo safari trips. Some go to Africa, and others take photographers to locations around the United States for shooting a variety of wildlife. If you go on a photo safari, consider renting a long lens from a local camera shop. These trips can be a once-in-a-lifetime experience, and having the right gear can make all the difference.

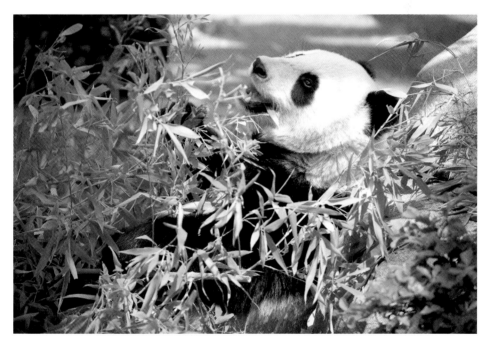

12.12 I kept checking back at the panda exhibit, waiting for the giant animal to be fed. Waiting for a certain behavior can lead to better photos. This has much more interest than a photo of the same panda sleeping. Taken at 1/1000 second, f/2.8, ISO 400.

Shooting Tips

The most important thing to keep in mind when shooting animals in captivity and in the wild is to be safe and to treat any animal with the utmost respect. These additional tips will help you get the best shots:

► **Use a large aperture to make your subject pop.** The subject of your photograph needs to stand out from the background, and using a shallow depth of field helps with this.

► **Use a wide aperture to make fences disappear.** When shooting at zoos, a shallow depth of field can make the fence seem to vanish.

► **Get close to the glass.** If a glass barrier is between you and the animal, get the end of your lens as close to the glass as possible to cut down on unwanted reflections.

► **Go early or late to the zoo.** Animals are more active in the early morning or late afternoon, and the crowds are usually smaller than during the middle of the day. The light at this time of day can cause more shadows and feature lower light, so keep an eye on the shutter speed. You don't want to get unintentional blur.

► **Check for special events or feeding times.** Check the schedule at the zoo for any special events and feeding times, which make great photo opportunities.

► **Use the best exposure mode for the situation.** Check the LCD on the camera, and if necessary change the metering mode. This can be a quick fix in situations where your subject is either very brightly backlit or in deep shadows.

► **Don't harass, tease, or torment the animals.** This holds true for pets, animals in the zoo, or any other animal at any other time.

► **Check the Internet for information on the zoo before leaving home.** Modern zoos take advantage of the Web by posting their hours and exhibit details. Use this information to help plan a successful trip to the zoo.

Creative Exposure

U ntil now, this entire book has been about getting the proper exposure — one that produces an image with good shadows without being too dark or has good highlights but is not too bright. But what about the creative side to it all? This is the time to use the exposure settings, shutter speed, aperture, and ISO to create images that have your feel in them, that are statements of your creative side. Here you learn to use settings that purposely overexpose or underexpose the image in relation to what the camera's built-in light meter believes is the correct exposure. Also covered are creating moods with exposure and using ISO noise creatively.

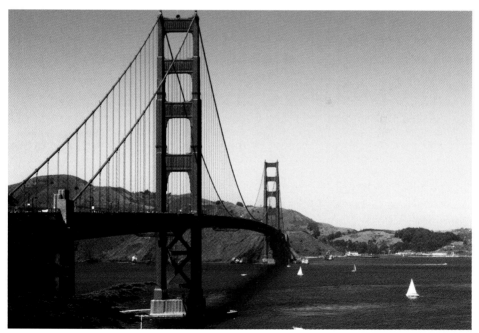

When I photographed the Golden Gate Bridge from the San Francisco side, I purposely underexposed the image so the bridge would stand out against the sky. Notice how the shadows have no detail visible. Taken at 1/500 second, f/9.5, ISO 100.

Exposure Considerations

When I am taking photographs, my creative process can be divided into three elements: the subject matter, the composition, and the exposure.

When it comes to subject matter, you need to shoot things you love. You may notice quite a few shots of concerts and music-related events in this and all my books. I shoot for lots of musicians and cover concerts extensively. The simplest reason for this is that I love live music and wanted it to be a part of my photography. I also photograph lots of other subjects and even shoot a wedding once in a while, but the concert photography is my love and the part that lets me be creative.

When it comes to discussions of composition, plenty of great books are available. Composition covers everything from the classical rule of thirds and the golden mean to leading lines and other tried-and-true composition rules. The exposure considerations usually come

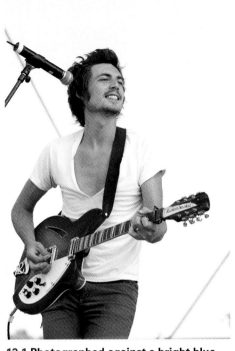

13.1 Photographed against a bright blue sky, this whole photo needed to be overexposed which made the sky too light but brought out the detail in the guitar player. The image was overexposed by a full stop and a half over what the camera thought was the correct exposure. There is no detail in the sky at all. Taken at 1/800 second, f/5, ISO 200.

after the subject and composition are already in mind. So how do you make the photographs you took look like you took them? That's where the creative use of exposure comes in.

Earlier I discussed different ways to get the same amount of light to reach the sensor. If the opening in the lens is very small, then the shutter needs to be left open longer, and if the shutter is open only for a short amount of time, then the opening in the lens needs to be bigger. When you start increasing and decreasing the perceived sensitivity of the sensor by adjusting the ISO, you end up with a variety of settings that will give you the same exposures but not the same image.

High exposure

When you overexpose an image, you are letting too much light into the scene, so everything looks too bright. You can overexpose an image in three ways: You can leave the shutter open too long, use a wider than needed aperture, or use an ISO higher than needed. Each of these methods can overexpose the image, but because they do it in different ways, they create different effects. When you decrease the shutter speed, items in motion in your image that were frozen in place now can be blurred. When you use a wider aperture, you decrease the depth of field, and backgrounds that were in acceptable focus now can be blurred. When the ISO is increased, the amount of digital noise is increased, but because the goal here is to overexpose the image, the noise is less noticeable in the lightest parts of the image.

One of the most common uses for overexposing an image is when taking high-key portraits where part of the image, usually the background, is overexposed all the way to pure white and the whole image can be on the light side.

You can sacrifice one part of the image to make sure other parts are correctly exposed. This can be very useful when shooting a scene with a range of tones and areas that are too bright and too dark for the camera's sensor. Exposing for the darker areas overexposes the lighter areas.

13.2 When photographing guitarist Mark Karan in a studio, someone opened the door and suddenly I had much more light. I decided against increasing the shutter speed because I liked the slight blur, and I didn't use a smaller aperture because I liked the shallow depth of field. I purposely overexposed the image to get the pure white background and bright light on his face. Taken at 1/25 second, f/1.4, ISO 800.

At times, the proper exposure does not accurately represent the scene as you see it. Even though the lightest parts are bright and the darkest parts are dark, the scene just seems flat. This can happen when your light source is in your image. At these times, overexposing the image makes the scene more representative to the feel of the original scene.

For more on high-key portraits, see Chapter 7.

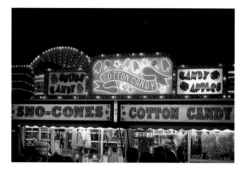 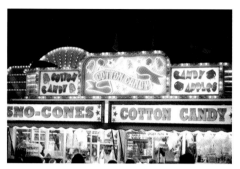

13.3 These two images taken at the fair show the difference between the camera's exposure and a creative overexposure. The first photograph was taken at 1/500 second, f/1.4, ISO 320; the second image was taken at 1/250 second, f/1.4, ISO 320.

The images in figure 13.3 were taken at the fair just moments apart. The first image was taken using the camera's Program auto mode, and because the lights of the sign were really bright, the camera's settings tried to get an average 18 percent gray, making the image look dull and muddy. The photo has detail in the darkest and lightest part, but the whole scene lacks the punch of the bright lights. I purposely slowed the shutter speed by a full stop to overexpose the scene.

13.4 For this belly dance photo, I purposely overexposed the image to begin with and then increased the exposure in Photoshop to get the end result. Taken at 1/200 second, f/2.5, ISO 100.

Digital photography offers another way to purposely overexpose your images; you can increase the exposure to all or part of your image in post-production. You can take an image and selectively overexpose certain parts while leaving other areas alone; although this is certainly easier using digital formats, this method was used in film photography as well. In the darkroom, it was a process of selectively overexposing certain areas when making a print. This process was called dodging and still exists in Adobe Photoshop as the Dodge tool, which allows you to selectively overexpose some areas.

Underexposure

When you underexpose an image, you are letting in too little light, which makes the image too dark and mutes colors. As with overexposing an image, you can underexpose an image in three ways: Use a shutter speed that doesn't leave the shutter open long enough, use an aperture that is too small, or use an ISO that is too low.

When you use a faster shutter speed, items in your image in motion and blurred are less blurred, but depending on how fast they are moving and the shutter speed chosen, they still may not be frozen in place. Using a smaller aperture not only lets in less light but also increases the depth of field, meaning that any out of focus backgrounds start to come into focus as the aperture decreases. The final way to underexpose your image is to decrease the ISO, which decreases the digital noise and makes the sensor less sensitive to light. Decreasing the ISO is the easiest way to underexpose your image and changes your image less than the other methods of underexposure.

13.5 This image of Danielle was purposely underexposed to add some drama to the image. Her dark hair and the background are both nearly completely black with no detail visible. Taken at 1/250 second, f/6.3, ISO 100.

One of the most common uses of creative underexposure is when shooting low-key portraits, where all or part of the image is purposely underexposed.

For more on low-key portraits, see Chapter 7.

Sometimes purposely underexposing an image can bring back the details that would otherwise be lost in very bright light. This is particularly true when shooting in the bright daylight where the shadows are very light and the details are washed out. When I photographed at Fort Rosecrans National Cemetery, I was limited by the hours the cemetery was open; I had no control over the light and really wanted to give the cemetery a darker look. I adjusted the exposure to be a full stop darker than what the camera light meter believed was the correct exposure.

13.6 This shot of the Fort Rosecrans National Cemetery was taken in the afternoon right before closing time. Taken at 1/250 second, f/11, ISO 100.

When I am shooting concerts, especially indoors or at night, I never trust the camera's sensor. The large areas of dark space almost always want the camera to overexpose

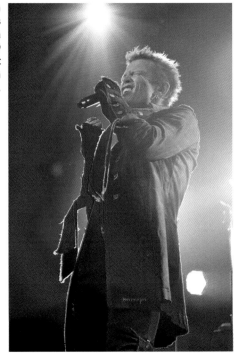

13.7 I got this shot of Billy Idol in concert with the lights behind him. I ignored the camera's suggestions and adjusted the exposure by a full stop. Taken at 1/160 second, f/3.2, ISO 800. With the shutter speed and aperture set to the way I wanted, I dropped the ISO from 1600 to 800.

the scene, and I nearly always have to underexpose the image so the background stays dark and the performer is correctly exposed. This is especially true if a light source is in the image.

Using Exposure to Create a Mood

Many elements go into photography that create the mood of the image. For example, the colors used can evoke different responses, as can the white balance. Images with a blue color seem to be cool while those in red and orange color tones seem hot or warm. When photographing people, they appear to be healthier with a warm tone rather than with a cool tone.

When it comes to using the exposure settings to set a tone, it is about personal choices. Consider how dark tones are used in movie posters and magazine covers. And how lighter images can portray a feeling of lightness and openness.

One of the best ways to add a feeling of lightness or darkness is to use the auto-bracketing feature available on most cameras. The key to doing this successfully is to be careful and fast. If you will have only one chance at the shot, I suggest adjusting the exposure later using software. If it is a scene that's pretty stationary, using the bracketing mode is perfect. Not only does it give you the camera's suggestion for the correct exposure according to the built-in light meter, but it lets you both overexpose and underexpose the image.

For more on bracketing your exposures, see Chapter 1.

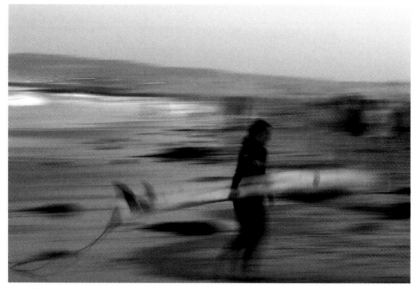

13.8 This image was shot by slowly panning as the surfer carried her surfboard out of the water. I used a small aperture and a low ISO so I could use a slow shutter speed to get the motion blur. Taken at 1/4 second, f/10, ISO 100.

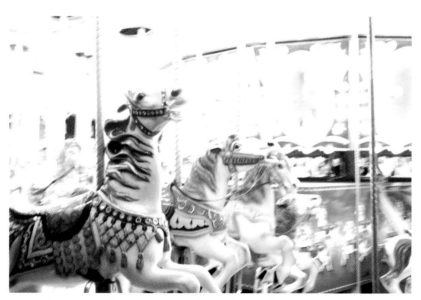

13.9 These calliope horses were photographed as the carousel was in motion. I used a relatively slow shutter speed and a wide aperture to purposely let more light into the scene. Taken at 1/10 second, f/4.0, ISO 320.

Using ISO Noise Creatively

The range of ISO values available on today's digital cameras is amazing. When I was shooting film, I would use three or maybe four different film speeds depending on the situation. I used ISO 100 for landscapes and nature, ISO 400 for lower light or when I needed to use faster shutter speeds to capture some faster moving action, and ISO 800 and ISO 1600 for those very-low-light situations. But when it comes to shooting digital, I use a huge range of ISOs and sometimes I change the ISO between every shot.

When using the higher ISOs, you can shoot in much lower light, but the higher the ISO, the more digital noise is produced. Even though newer cameras allow you to shoot at much higher ISOs with much lower noise than ever before, much noise still is present at the highest ISOs and you can use it creatively.

When I shoot at the very high ISOs to get some noise into the image, I am usually thinking about emulating the older high-speed black and white films. Because digital noise can appear as random multi-colored pixels in the image, especially in the dark parts, I often shoot these in color but turn them into black and white in the computer. This creates a look more like older photographs and adds a timeless feel to your images.

When digital photography became more popular than film photography, many photographers wanted to actually have the look and feel of the film they used to use. Software solutions are available for this, including Adobe Photoshop plug-ins from Alien Skin and Power Retouche; they add a real grain-like appearance to digital images. You also can use a high ISO in the camera and get a grain-like effect.

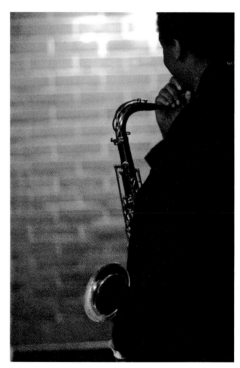

13.10 This lone saxophone player was waiting nervously in a hallway backstage. A single light in the hallway illuminated him and I chose not to use a flash, so I needed to really increase the ISO. After seeing the image, I really thought the noise added to the feel and didn't use noise reduction software. Taken at 1/15 second, f/1.4, ISO 1600.

High Dynamic Range Images

A High Dynamic Range or HDR photograph is a single image created by combining a series of images with bracketed exposures — at least one that is exposed for the middle tones, then at least one exposed for the lightest parts of the scene correctly and one exposed for the darkest parts of the scene correctly.

When it comes to shooting a sequence of images, I suggest that you use a minimum of three images, one properly exposed, one underexposed, and one overexposed. However, I like to use a minimum of five images, which gives the software more to work with. After you have a sequence of images, you need to combine them using software and create the HDR file.

Make sure to adjust your exposure by changing the shutter speed only — not the ISO or aperture. If you adjust the aperture between images, when the images are combined, the change in the depth of field creates an image that is not in sharp focus. Use a tripod to get the sharpest images possible and maintain consistent composition.

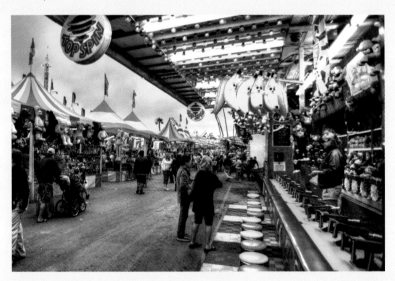

The leading software for HDR images is Photomatix Pro from HDRsoft (www.hdrsoft.com); the good news is that you can try before you buy with a free trial. The software creates a tone-mapped HDR file using your bracketed images that you then adjust further to create the look you want. You then convert the image to a useable format, such as JPEG or TIFF.

Software

Gone are the days of darkrooms, developing chemicals, and enlargers. They have been replaced with card readers, computers, and printers, and you now have the ability to share your images with thousands of people at the same time using the Internet.

Software programs created for photographers can apply watermarks to images, prepare images for e-mail, and even create entire Web galleries. In this Appendix, I cover a few software programs that can adjust the exposure of your images. All the software listed here can do more than that, and some — such as Adobe Photoshop — can do so much that a book three times this size would barely cover all the features and capabilities. This is by no means a comprehensive guide of all the software available to edit your images.

Each camera manufacturer has its own software, each with its own pluses and minuses. I don't cover those software packages here because this is not a camera-specific book. All the software here works with cameras produced by any of today's camera manufacturers. Two of the programs, Aperture and iPhoto, are available only on Apple computers but are included here because of their widespread use by photographers. Also, all the software discussed here works with the RAW file types produced by today's cameras.

The goal is to get the exposure right in the camera when shooting and not have to use any software to fix the image later. People now seem to think that Photoshop (or any photo-editing software) is the answer to all the questions, but it isn't. It is just a tool that can help you fix an image that didn't quite get captured the way you wanted it to.

Adobe Photoshop

Adobe Photoshop, or just Photoshop as it is usually called, is the industry standard for photo-editing software and has been for many years. Adobe Photoshop is currently in version 11.0.1 or called CS4 and comes in two flavors: Adobe Photoshop CS4 and Adobe Photoshop CS4 Extended. (CS stands for Creative Suite.) Photoshop has grown and improved with every version, and the software has new tools that make it popular not only with photographers but with print designers, Web designers, artists, and hobbyists. Numerous books, DVDs, Web sites, blogs, magazines, and user groups are dedicated to Photoshop. If you want to explore the details of Photoshop, check out your local bookstore. One of the biggest resources for Photoshop is the National Association of Photoshop Professionals, which can be found at www. photoshopuser.com.

Photoshop actually is three separate programs that all work together: Adobe Bridge, Adobe Camera Raw, and Adobe Photoshop. Bridge is an asset-management program that allows you to sort and rate your images. It also conveniently lets you launch Adobe Camera Raw just by double-clicking the selected image.

When it comes to dealing with exposures, the most useful, and arguably the most important, is the Adobe Camera Raw module.

Adobe Camera Raw

Adobe Camera Raw, or ACR, is the part of Photoshop that reads the RAW files produced by many digital cameras and lets you develop these digital negative files before opening them in Photoshop. ACR gives you an amazing amount of control over the RAW files produced by your camera, and because the program is updated independently of Photoshop, support for newer cameras is added regularly.

ACR has a very simple layout, as you can see in image AA.1, with a big preview window and the main editing control on the right. The histogram display in the upper right gives real-time feedback when you're making adjustments. Nine different editing menus offer you many choices: Basic, Tone Curve, Detail, HSL/Grayscale, Split Toning, Lens Corrections, Camera Calibration, Presets, and Snapshots. The most important one for dealing with exposure is the Basic editing menu.

The Basic editing menu is where the White Balance, Exposure, and Saturation are set and adjusted. When I discussed using RAW file types and setting the white balance after the photo had been taken, this is where that can be done. You can pick one of

the seven presets of Auto, Daylight, Cloudy, Shade, Tungsten, Fluorescent, or Flash, or you can use the value that the camera set by leaving the White Balance set to As Shot. You also can adjust the white balance by using the Temperature and Tint sliders or by using the White Balance Tool, an eyedropper that lets you select an area of your image that you believe is neutral, and the white balance adjusts accordingly.

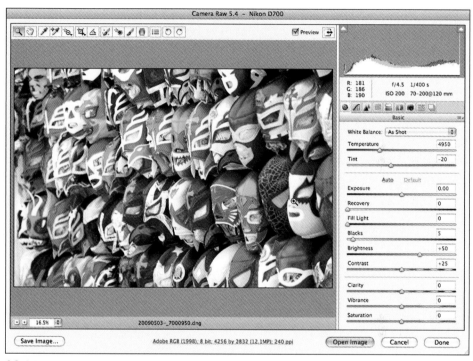

AA.1 The Adobe Camera Raw interface

For adjusting your exposure directly, the next sliders are the most important tools. The first tool is the Exposure slider that lets you either increase (lighten) or decrease (darken) the image. The range is from –4 to +4 stops. This is very useful for slightly adjusting an image that is either a little underexposed or overexposed. The second slider controls the Recovery setting, which helps recover any areas that are too bright. The third controller, the Fill Light slider, adds a little light to the image — a little fill light if you will. It also brings out some of the details in the shadows without making the highlights too bright. The next slider is probably the second most important tool behind the actual Exposure slider, and it is the Blacks slider. This can increase the amount of

black in your image, and a little goes a long way. Sometimes the whole image just needs a little more black, and this does it without removing any of the light. Pushing this slider from the default of 5 to 9, 10, or higher can deepen the shadows and really help make your image pop.

The next two sliders are for Brightness and Contrast, and both can be adjusted to taste. The first adjusts the overall brightness of the image; the second adjusts the overall contrast of the image. The Contrast slider adjusts the image but tries to leave the darkest and lightest areas alone.

The last three sliders, Clarity, Vibrance, and Saturation, deal with sharpening and with the colors of the image.

Photoshop

Photoshop allows you to adjust your images on a pixel basis and probably has more photo-editing power than you will ever need, unless you are going to get serious about editing your photos. Adobe Photoshop requires a substantial investment, because the full version can cost as much as or more than a camera.

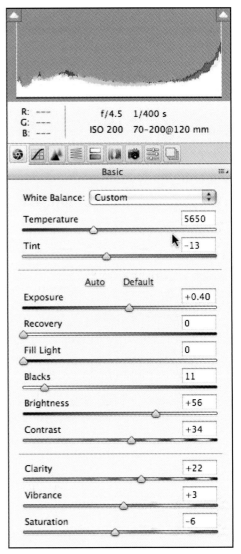

AA.2 The adjustments panel in Adobe Camera Raw

You can adjust the exposure of your images using Photoshop in ways too numerous to cover in detail here. One simple way to adjust the exposure of your images is to use the Exposure Adjustment tool.

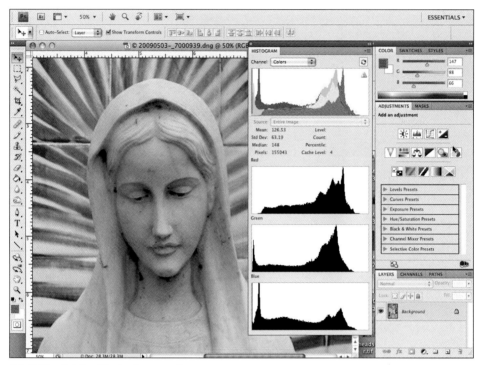

AA.3 The Adobe Photoshop workspace

Adobe Photoshop Lightroom

Adobe Photoshop Lightroom is intended specifically for photographers. Lightroom is built on the RAW processing technology that powers the Adobe Camera Raw module of Photoshop. Adobe Photoshop Lightroom is divided into five separate modules that mimic the workflow of a photographer, including sorting the images in the Library module, editing the images in the Develop module, and outputting images in different formats using the Slideshow, Print, and Web modules. When dealing with exposure issues, Lightroom has two places to edit your images.

Library module

The library mode in Lightroom is used mainly for sorting your images, but some quick adjustments can be applied when in this mode. The Quick Develop adjustments panel includes a quick exposure adjustment, which lets you adjust the exposure in rather large increments but works when getting a rough exposure adjustment.

AA.4 The Library module in Lightroom showing the Quick Develop adjustment panel

Develop module

The real power for adjusting your images in Lightroom is in the Develop module. This includes the same power that's available in Adobe Camera Raw, and the controls are set out in the same way. The adjustments made in the Lightroom Develop mode, as with the processing of any RAW file type, are not made to the actual file, but rather, they're a set of instructions that detail how to develop the image. This means that the original file can be used to create numerous different images without changing the RAW file.

AA.5 The Develop module in Adobe Lightroom

Adobe Photoshop Elements

Adobe Photoshop Elements is a scaled-down version of Adobe Photoshop aimed for those who don't need all the bells and whistles of the full version of Photoshop. Photoshop Elements has taken the most-requested features for photographers and simplified their usage for those who don't want to spend the money or time on Adobe Photoshop CS4. That doesn't mean the program isn't powerful, because it really is; it's built on the full Photoshop code. But it's easier to use than Photoshop and costs much less. Because Adobe Photoshop Elements uses the same code as Photoshop, it comes with a version of Adobe Camera Raw as well.

Photoshop Elements has a more user-friendly interface and many of the same tools as Photoshop, but they're presented in a different way. When it comes to adjusting the exposure of an image, Elements has its own set of controls, including the Adjust Color Curves adjustment. This gives you a real-time preview of what your adjustments are doing to your images.

AA.6 The Adjust Color Curves tool in Adobe Photoshop Elements

As you adjust the highlights, midtones, and shadows, the instant feedback helps you correct any exposure problems. If you want to get started using Photoshop, the best way to do it is with Elements. It has all the power you need but for a fraction of the price and without the steep learning curve usually associated with Photoshop.

Apple Aperture

Apple created Aperture as a professional-level photo-editing solution for Apple computer users. Aperture, now in version 2.13, offers a complete set of tools for adjusting the exposure of an image. This Adjustment palette gives you control over the White Balance and exposure of the image and a way to adjust the exposure by working directly on a histogram of the image. Aperture works with most camera manufacturer's RAW file types without having to convert them first. Apple has built RAW file type support directly into the operating system, so when new cameras are released, Apple can update the RAW file support for all its applications and operating system at the same time. Aperture and iPhoto use the same RAW file format definitions, which makes it easy for those using Apple to switch images between the professional Aperture and the consumer iPhoto photo applications.

Aperture offers much more than a tool for adjusting exposure; it offers tools for sorting and rating your images, lets you create Web galleries and collections, and allows users to create books that can then be professionally printed and shipped.

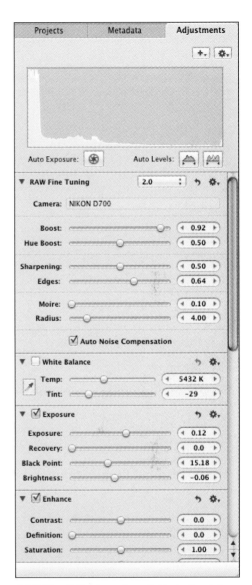

AA.7 The Adjustments palette in Apple's Aperture software

When working with exposure, the section of Aperture that I am interested in is the Adjustments palette. Aperture has two ways to look at the Adjustments palette: on the side of the display or as an overlay. Both show the same information, and the choice of which to use is dependent on your working style. The layout of the Adjustments palette is designed to help you get the best results from your images. If you shoot RAW, it starts with a RAW Fine Tuning section that lets you adjust the color and brightness and lets you sharpen the image.

You can adjust the White Balance by using the eyedropper tool to select a neutral point on the image or by adjusting the Temperature and Tint sliders. The image in the preview window is updated in real time, so it is easy to visually adjust the white balance by looking at the image and using the sliders.

The exposure adjustments include the Exposure slider along with the Recovery, Black Point, and Brightness sliders. These four controls are the main adjustments when it comes to adjusting your exposures and are very similar in function to the controls in Adobe Camera Raw. The four controls in this section are used to correct problems like overexposure and underexposure.

Here's what you can expect:

▶ **Exposure.** The Exposure slider can adjust the exposure for –2 to +2. This is the main control to adjust the overall exposure of the image and fixes most images if they are slightly underexposed or overexposed.

▶ **Recovery.** The Recovery slider is used to recover from blown-out highlights only. The effects from this work better on images that have areas where the highlights are blown out completely. It is best used in conjunction with the other exposure sliders.

▶ **Black Point.** The Black Point slider controls the shadow detail and can adjust the darkest parts of your image. Slide the black point to the left, and the dark parts of the image get lighter; slide it to the right, and the shadows get darker.

▶ **Brightness.** The Brightness slider increases the brightness of the scene without clipping the shadows or highlights.

Aperture has many more tools that can adjust the color, sharpness, tone, and saturation, and it even allows you to remove small spots and blemishes.

iPhoto

Apple's iPhoto application is loaded free on every new Apple computer and is part of the iLife suite of applications. This photograph sorting and editing software is surprisingly powerful for a consumer product. iPhoto is built to use the system-wide Camera Raw definitions the same way that Aperture does, making it a very powerful image editor. The main focus of iPhoto is in the sorting and storage of your images, but a creative editing feature lets you adjust the exposure of your images.

To edit a photo and adjust its exposure in iPhoto, just click the image you want to edit and click the Edit button on the bottom of the screen. This opens the image in full-screen mode, and when you click the Adjustment controls, the controls that allow you to edit your image are opened.

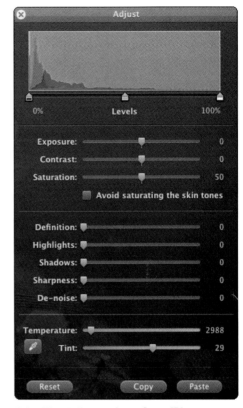

AA.8 The Adjust palette from iPhoto

The two most important elements in the Adjustments control widow are the histogram and the Exposure slider. The histogram display shows you the current histogram and updates as the exposure is changed. Sliding the exposure control to the right lightens the image and helps bring back details in underexposed images, while sliding it to the left darkens your images and helps to correct any overexposed images.

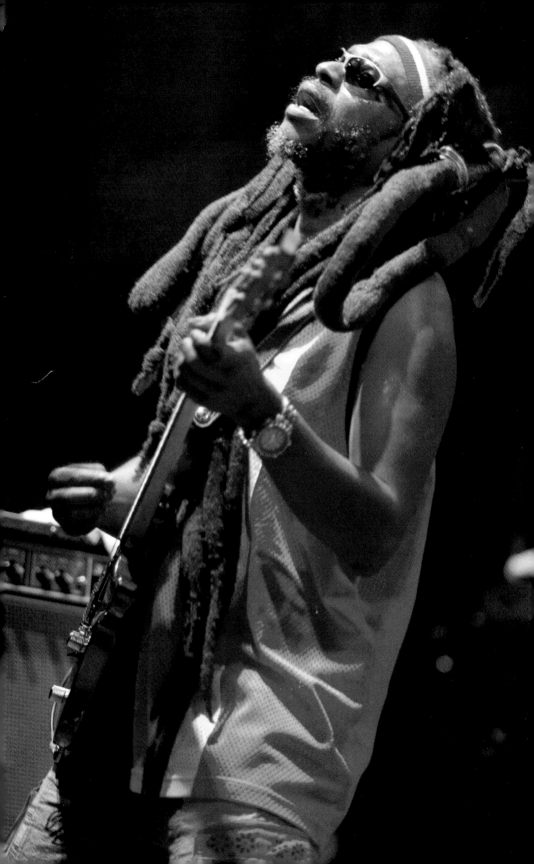

How to Use the Gray Card and Color Checker

Have you ever wondered how some photographers are able to consistently produce photos with such accurate color and exposure? It's often because they use gray cards and color checkers. Knowing how to use these tools helps you take some of the guesswork out of capturing photos with great color and correct exposures every time.

The Gray Card

Because the color of light changes depending on the light source, what you might decide is neutral in your photograph, isn't neutral at all. This is where a gray card comes in very handy. A gray card is designed to reflect the color spectrum neutrally in all sorts of lighting conditions, providing a standard from which to measure for later color corrections or to set a custom white balance.

By taking a test shot that includes the gray card, you guarantee that you have a neutral item to adjust colors against later if you need to. Make sure that the card is placed in the same light that the subject is for the first photo, and then remove the gray card and continue shooting.

 When taking a photo of a gray card, de-focus your lens a little; this ensures that you capture a more even color.

Because many software programs enable you to address color correction issues by choosing something that should be white or neutral in an image, having the gray card in the first of a series of photos allows you to select the gray card as the neutral point. Your software resets red, green and blue to be the same value, creating a neutral midtone. Depending on the capabilities of your software, you might be able to save the adjustment you've made and apply it to all other photos shot in the same series.

If you'd prefer to make adjustments on the spot, for example, and if the lighting conditions will remain mostly consistent while you shoot a large number of images, it is

advisable to use the gray card to set a custom white balance in your camera. You can do this by taking a photo of the gray card filling as much of the frame as possible. Then, use that photo to set the custom white balance.

The Color Checker

A color checker contains 24 swatches which represent colors found in everyday scenes, including skin tones, sky, foliage, etc. It also contains red, green, blue, cyan, magenta and yellow, which are used in all printing devices. Finally, and perhaps most importantly, it has six shades of gray.

Using a color checker is a very similar process to using a gray card. You place it in the scene so that it is illuminated in the same way as the subject. Photograph the scene once with the reference in place, then remove it and shoot away. You should create a reference photo each time you shoot in a new lighting environment.

Later on in software, open the image containing the color checker. Measure the values of the gray, black, and white swatches. The red, green and blue values in the gray swatch should each measure around 128, in the black swatch around 50, and in the white swatch around 245. If your camera's white balance was set correctly for the scene, your measurements should fall into the range (and deviate by no more than 7 either way) and you can rest easy knowing your colors are true.

If your readings are more than 7 points out of range either way, use software to correct it. But now we also have black and white reference points to help. Use the levels adjustment tool to bring the known values back to where they should be measuring (gray around 128, black around 50 and white around 245).

If your camera offers any kind of custom styles, you can also use the color checker to set or adjust any of the custom styles by taking a sample photo and evaluating it using the on-screen histogram, preferably the RGB histogram if your camera offers one. You can then choose that custom style for your shoot, perhaps even adjusting that custom style to better match your expectations for color.

 In addition to checking the color, you can also determine if you have exposure issues by looking at the three lightest grays. If they all look the same, your image is likely overexposed.

Glossary

Adobe RGB A color space created by Adobe to more closely match the output of inkjet printing devices. See also *color space* and *sRGB*.

AE lock Pressing the camera's AE lock button locks the current exposure and lets you recompose the scene without changing the exposure.

AF (auto focus) lock The focus can be locked either by pressing the Shutter Release button halfway down when the focus is locked, the camera can be moved, but the focus does not move. The focus stays locked until the shutter is released or the Shutter Release button is pressed. This allows the scene to be recomposed without changing the focus.

ambient light The natural light in the scene, also referred to as available light.

angle of view The amount of the scene in front of the camera that a specific lens sees.

aperture The lens opening that the light passes through before reaching the sensor in the camera. The aperture can be adjusted by controlling the diaphragm by changing the f-stop. This is expressed as f/number — for example, f/5.6.

Aperture priority mode In this mode, the photographer sets the aperture and the camera sets the shutter speed.

artificial light Any light that the photographer introduces into a scene.

autofocus The camera automatically adjusts the focus depending on which focus sensor is selected. The autofocus on most dSLRs is started by pressing the Shutter Release button halfway down.

autofocus illuminator A built-in light that illuminates the scene, helping the camera achieve focus when not enough ambient light is present.

backlighting A method of lighting where the main light is placed behind the subject. See also *silhouette*.

bounce light Light that is bounced off a surface before hitting the subject to create a more flattering light source. This is used mainly with a dedicated flash unit that can be aimed at a wall or ceiling.

bracketing A method in which multiple exposures are taken, some below and some above the recommended exposure.

buffer The camera's built-in memory that is used as temporary storage before the image data is written to the memory card.

bulb A shutter speed setting that keeps the shutter open as long as the Shutter Release button is held down.

camera shake The small movements of the camera that can cause blurring, especially when the camera is being handheld. Slower shutter speeds and long focal lengths can contribute to the problem.

CCD Charged Coupled Device, a type of sensor in some dSLRs.

Center-weighted metering A metering mode on a camera's built-in light meter. With Center-weighted metering, the entire scene is metered, but a greater emphasis is placed on the center area.

CMOS Complementary Metal Oxide Semiconductor. The type of image sensor in some dSLRs.

color cast An overall look or predominant color that affects the whole image. Color casts are usually brought about by an incorrectly set white balance. See also *cool* and *warm*.

color space A description of the range of colors that can be displayed or recorded accurately by the current device. See also *Adobe RGB* and *sRGB*.

color temperature A description of light color using the Kelvin scale. See also *Kelvin*.

colored gel filters Colored light modifiers that, when placed between the light source and the subject, change the color of the light hitting the subject.

compression Reducing image file size by either removing information (lossy compression) or writing the information in a form that can be recreated without any quality loss (lossless compression).

Continuous Auto Focus mode A mode in which the camera continues to refocus while the Shutter Release button is held halfway down. This is the best focus mode for moving subjects.

contrast The difference between the highlights and the shadows of a scene.

cool A descriptive term for an image or scene that has a bluish cast.

dedicated flash A flash unit that works with the camera specifically in the camera's hot shoe.

depth of field (DOF) The area of acceptably sharp focus in front of and behind the focus point.

diaphragm An adjustable opening in the lens that controls the amount of light reaching the sensor. Opening and closing the diaphragm changes the aperture.

diffused lighting Light that has been scattered and spread out by being bounced off a wall or ceiling or shot through a semi-opaque material, creating a softer, more even light. Diffused lighting also can be sunlight shining through the clouds.

digital noise See *noise*.

equivalent focal length The focal length of lenses attached to cropped sensors needs to be translated from the 35mm standard due to their reduced size. The fast way to determine the equivalent focal length is to multiply the focal length by 1.5.

exposure The amount of light that reaches the sensor. See also *proper exposure*.

exposure compensation A method of adjusting the exposure so it differs from the metered reading.

exposure metering Using the light meter built into the camera to determine the proper exposure. See also *Metering modes*.

fast A description referring to the maximum aperture of a lens. Lenses with apertures of f/2.8 and higher are considered fast lenses. See also *slow*.

fill flash A method where the flash is used to reveal details in shadow areas that would usually be lost.

filter A glass or plastic cover that goes in front of the lens. Filters can be used to alter the color and intensity of light, add special effects like soft focus, and protect the front elements of the lens.

flash A device that produces a short bright burst of artificial light. The word *flash* can be used to describe the unit producing the light or the light itself.

flash exposure compensation An adjustment that changes the amount of light produced by a flash independently of the exposure settings.

flash sync The method by which the flash is fired at the moment the camera shutter is opened.

flat A description of an image or scene that has very little difference between the light values and the dark values. An image or scene with low contrast.

focal length The distance from the optical center of the lens when it is focused at infinity to its focal plane (sensor), described in millimeters (mm).

focal plane The area in the camera where the light passing through the lens is focused. In dSLR cameras, this is the image sensor.

focus The adjustment of the lens to create a distinct and clear image.

focus lock The focus is set and does not change even if the scene is recomposed.

front lighting A method of lighting where the main light is placed directly in front of the subject.

f-stop A measure of the opening in the diaphragm that controls the amount of light traveling through the lens. See also *diaphragm*.

high contrast A description of an image or scene where the highlights and shadows are at the extreme differences in density.

high key A description of a photograph with a light tone overall.

histogram A basic bar graph that shows the number of pixels that fall into each of the shades from pure black to pure white. The histogram view on most dSLRs shows the values of the red, green, and blue color channels as well as the overall tone of the image.

hot shoe The camera mount on top of the viewfinder that accepts flash accessories. Each camera manufacturer produces different flash units, and those that are made for one brand of camera do not work on another brand's body.

image rotation The ability of the camera to recognize the orientation in which the photo was taken and to display the image in the correct orientation when viewing it on the LCD.

ISO International Organization for Standardization. An international body that set standards for film speeds. The standard is also known as ISO 5800:1987 and is a mathematical representation for measuring film speeds.

ISO sensitivity The light sensitivity of image sensors in digital cameras are rated using the standards set for film. Each doubling of the ISO makes the sensor twice as sensitive to light, meaning that in practical purposes, an ISO rating of 200 needs twice as much light as an ISO of 400.

JPEG Joint Photographic Experts Group. The most commonly used and universally accepted method for image file compression. The JPEG is a lossy form of compression, meaning that information is lost during the compression. JPEG files have a .JPEG file extension. See also *lossy*.

Kelvin Abbreviated with K, it is a unit to measure color temperature. The Kelvin scale used in photography is based on the color changes that occur when a theoretical black body is heated to different temperatures.

LCD (Liquid Crystal Display) The type of display used on most digital cameras to preview your photos and display menus and shooting data.

light meter A device used to measure the amount of light in a scene. The readings from the light meter can be used to determine what settings produce a proper exposure. All dSLR cameras have a built-in light meter that reads the intensity of the light being reflected back from whatever is in the scene.

lossless A form of computer file compression that allows the original data to be reconstructed without losing any of the information. This is useful when you want to ensure that no changes are made to the information. See also *compression* and *TIFF*.

lossy A form of computer file compression that reduces the file size by removing data. The file is not an exact match to the original file but close enough to be of use. This form of compression suffers from generation loss. Repeatedly compressing the same file results in progressive data loss and image degradation. See also *compression* and *JPEG*.

low key A description of a photograph with a dark tone overall.

macro lens A specialty lens that allows for extreme close-ups, creating life-size images.

Manual exposure mode In this mode, the photographer determines the exposure by setting both the shutter speed and the aperture.

megapixel A description referring to the number of pixels that a digital camera sensor has; 1 megapixel is equal to 1 million pixels.

memory card The removable storage device on which image files are stored.

Metering modes The method the camera uses to determine what light to use in the metering process. See also *Scene metering*, *Center-weighted metering*, and *Spot metering*.

middle gray A tone that represents 18 percent reflectance in visible light. All reflective light meters, including the one in your camera, are calibrated to give an average reading of 18 percent gray.

noise Extra unwanted pixels of random color in places where only smooth color should be. Noise is created when the signal from the image sensor is amplified to match the ISO characteristics of film. The higher the ISO in a digital camera, the more noise is created. Noise is also created when taking long exposures.

noise reduction Software or hardware used to reduce unwanted noise in digital images. See also *noise*.

normal lens A lens that produces images in a perspective close to that of the human eye.

overexposure Allowing more than the recommended amount of light to reach the sensor, causing the image to appear too light and with less detail in the highlights.

panning A method that involves moving the camera in the same direction and speed that the subject is moving, resulting in an image where the subject is in acceptable focus while the background is blurred.

pixel A contraction of the words *picture elements* that describes the smallest unit that makes up a digital image.

prime lens A lens with a single focal length (not a zoom lens).

Program auto mode In this mode, the camera sets the shutter speed and aperture to achieve the correct exposure. The photographer can adjust these settings for more control over the exposure, giving a higher level of user control over the exposure.

RAW A file type that stores the image data without any in-camera processing. Every camera manufacturer has a different RAW file format. RAW files need to be processed before they can be used.

rear-curtain sync The ability to fire the flash at the end of the exposure instead of at the beginning. This freezes the action at the end of the exposure.

red eye A condition that occurs when photographing people with a flash that is too close to the lens. The light is reflected from the person's retina (which is covered with tiny blood vessels, thus the red) back toward the camera's lens.

red-eye reduction A flash mode that fires a short burst of light right before the photograph is taken, in hopes of causing the subject's pupils to contract and lessening the amount of light that can be reflected back.

reflector Any surface that can be used to redirect light. Specialty reflectors for photography come in different sizes, shapes, and colors and are designed to reflect light onto the subject.

resolution The number of pixels counted either vertically or horizontally in a given area.

saturation In color, it is the intensity of a specific hue.

self-timer The ability of the camera to take an exposure after a predetermined amount of time when the Shutter Release button has been pressed.

Scene metering This metering mode takes the whole scene into account, Each camera manufacturer has a different method for metering. Check your camera manual for the method used in your camera. See also *Metering modes, Center-weighted metering,* and *Spot metering.*

sharp A way to describe a well-focused image.

shutter A movable cover that controls the amount of light that is allowed to reach the sensor, by opening for a specific length of time designated by the shutter speed.

Shutter release button The button that is used to move the shutter out of the way so a photograph can be taken.

shutter speed The amount of time that the shutter is open and letting light reach the image sensor.

Shutter speed priority mode In this mode, the photographer sets the shutter speed and the camera sets the aperture.

side lighting A method of lighting where the main light source is to the side of the subject.

silhouette An image or scene where the subject is represented by a solid black object against a lighter background. See also *backlighting.*

slow A description referring to the maximum aperture of a lens. Lenses with a maximum aperture of f/8 are considered very slow. See also *fast.*

Spot metering A metering mode where the only area that the camera uses to meter the light is a small area in the center of the scene.

sRGB A color space created by Hewlett Packard and Microsoft to more closely match display devices. See also *Adobe RGB* and *color space.*

stop A term of measurement in photography that refers to any adjustment in the exposure. When stop is used to describe shutter speed, a one-stop increase doubles the shutter speed, and a one-stop decrease halves the shutter speed. When stop is used to describe aperture, a one-stop increase doubles the amount of light reaching the sensor, and a one-stop decrease halves the light reaching the sensor.

telephoto lens A lens with a focal length longer than normal.

TIFF Tagged Image File Format. A lossless file format for images that are universally acceptable by image-editing software. See also *lossless*.

tonal range The shades of gray that exist between solid black and solid white.

top lighting A method of lighting where the main light is placed above the subject.

tungsten light A light source that produces light with a color temperature of approximately 3200K.

underexposure Allowing less than the recommended amount of light to reach the sensor, causing the image to appear too dark and a loss of detail in the shadows.

Variable aperture lens A lens that changes the maximum aperture depending on the focal length.

warm A descriptive term for an image or scene that has an orange or red cast.

white balance An adjustment to the colors that the camera records to match the lighting of the scene.

wide-angle lens A lens description that refers to lenses with shorter-than-normal focal lengths.

zoom lens A lens that has a range of focal lengths.

INDEX

Guides to go.

Colorful, portable *Digital Field Guides* are packed with essential tips and techniques about your camera equipment. They go where you go; more than books—they're *gear*. Each $19.99.

978-0-470-46714-5

978-0-470-52128-1

978-0-470-52126-7

978-0-470-39236-2

978-0-470-45405-3

978-0-470-53490-8

Also available

Canon EOS Rebel XSi/450D Digital Field Guide • 978-0-470-38087-1
Nikon D40/D40x Digital Field Guide • 978-0-470-17148-6
Sony Alpha DSLR A300/A350 Digital Field Guide • 978-0-470-38627-9
Nikon D90 Digital Field Guide • 978-0-470-44992-9
Nikon D300 Digital Field Guide • 978-0-470-26092-0
Canon 50D Digital Field Guide • 978-0-470-45559-3

Available wherever books are sold.

Now you know.

Wiley and the Wiley logo are registered trademarks of John Wiley & Sons, Inc. and/or its affiliates.
All other trademarks are the property of their respective owners.